A gift from My elient stein A mike ynes stein and daniely And daniely And daniely And daniely Alexand 1980.

THE IMPRESSIONISTS AND THEIR ART

THE IMPRESSIONISTS AND THEIR ART

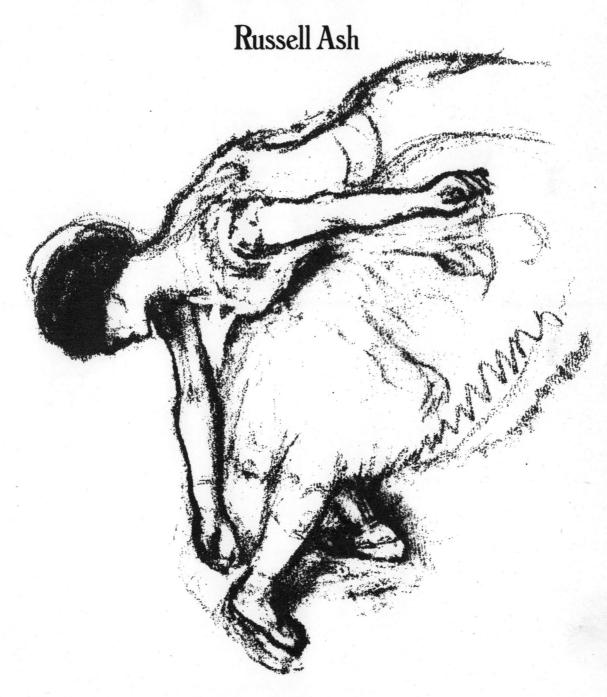

ORBIS PUBLISHING · LONDON

FOR FELICITY

Title page illustration: Dancer, charcoal and pastel sketch by Degas

© Orbis Publishing Ltd, London, 1980

All rights reserved. No part of this publication may be reproduced, stored in a retrieval system, or transmitted, in any form or by any means, electronic, mechanical, photocopying, recording or otherwise, without prior permission of the publishers. Such permission, if granted, is subject to a fee depending on the nature of the use.

Printed in Czechoslovakia ISBN 0 85613 292 6 50 126

CONTENTS

Chapter One SOCIAL AND ARTISTIC BACKGROUND 6

> Chapter Two THE EARLY YEARS 15

Chapter Three THE FRANCO-PRUSSIAN WAR 22

Chapter Four IMPRESSIONISM IN THE 18705 25

Chapter Five IMPRESSIONISM COMES OF AGE 33

> Chapter Six POST-IMPRESSIONISM 37

Chapter Seven THE LAST YEARS 41

Chapter Eight THE IMPRESSIONIST HERITAGE 44

FURTHER READING 46

THE PAINTINGS 47

INDEX 191

SOCIAL AND ARTISTIC BACKGROUND

If one wants to characterise them with a single word that explains their efforts, one would have to create the new term of *Impressionists*. They are Impressionists in the sense that they render not a landscape but the impression produced by a landscape. (Jules Castagnary, in *Le Siècle*, 29 April 1874)

On 27 December 1873 a group of French artists in Paris - mostly painters, but including some sculptors and engravers - formed themselves into a Société Anonyme, an otherwise untitled cooperative organization the members of which had the common aim of exhibiting their works in a location other than the Paris Salon, which was at that time the official showplace for French art. Exhibits at the Salon were selected by a jury appointed by the Académie of Fine Arts, a section of the Institut de France. The photographer Nadar (the pseudonym of Félix Tournachon) lent the Société his studios at 35 Boulevard des Capucines. The exhibition of 165 subjects opened on 15 April 1874 and ran for exactly a month. Ten days after the opening, Louis Leroy, a minor journalist, published in Charivari a viciously scathing attack on the show and its 30 exhibitors. It was written in the form of a satirical dialogue between Leroy and an elderly landscape painter, Joseph Vincent, who as he proceeds round the studios, becomes increasingly incensed by almost everything he sees. At first, bewildered by the lack of detail in some of the paintings, he wonders if perhaps his spectacles are dirty; he goes on and his rage grows as he is confronted by more and more outrageous works, until, unable to take any more; he performs a Red Indian wardance in front of an astonished attendant, crying dementedly, 'Hi-ho! I am impression on the march, the avenging palette knife . . .'

Leroy's article was titled 'Exhibition of the Impressionists'. This was partly because the word 'impression' is used several times to describe the general effect of some of the paintings (as contrasted with a detailed rendering of a subject), and the 'impression' they accordingly make on their viewers (as exemplified by the dramatic reaction of M. Vincent), but particularly since one of them bore the title, *Impression, Sunrise*, by the then virtually unknown painter Claude Monet (although the precise identity of this picture is still disputed; see page 92).

As many of the paintings on show conveyed an 'impression' of the observed scene, the use of the word was scarcely original. There is actually plenty of evidence that a number of the artists whose work was displayed, as well as their critics, had been using the term in this context for several years. However, Leroy's uncompromising assault gave a coherent and memorable tag to what by 1874 could rightly be regarded as a new artistic movement, and despite the objections of certain of its exponents, 'Impressionism' is the name by which this revolution in painting has been called ever since – sometimes loosely – to describe the overall style of painting, but most accurately to refer to the work of a small and dedicated group of painters who adopted personal styles within an Impressionist frame of reference and followed them, often with considerable modifications, throughout their working lives.

Among the artists represented at this, the first of eight Impressionist exhibitions held between 1874 and 1886, apart from Monet, were Edgar Degas, Berthe Morisot, Auguste Renoir, Camille Pissarro, Alfred Sisley, Armand Guillaumin and Paul Cézanne. Several others, although often regarded as Impressionists, declined to exhibit, including Henri Fantin-Latour and Edouard Manet.

All came from widely dissimilar social backgrounds, from Degas, the son of a wealthy upper-class Parisian banker, to Renoir, whose father was a poor tailor in the industrial city of Limoges. The factors which united them were that they were all close in age, having been born between 1830 and 1841, and were therefore exposed to the same range of social and artistic influences; they all studied in Paris – several of them under the same teachers; they were all on terms of close friendship, though varying in intensity at times according to their geographical dispersal and various personal vicissitudes – Berthe Morisot married Manet's brother; and most important of all, they shared a common antipathy for the state of French art at the beginning of the second half of the nineteenth century.

Leroy and other hostile critics firmly believed that this antipathy was illfounded, if not actually seditious. The notion most popular in their day was that the paintings of the Impressionists, which M. Vincent had found so 'outrageous', were the daubs of ill-trained young revolutionaries, possibly even anarchists hellbent on overthrowing all France's cherished institutions, starting with the Académie. The usual critical reaction was to attack and deride their work with sophisticated humour as that of a bunch of misguided upstarts. Pissarro was, in fact, left wing and did have anarchist sympathies, but one would hardly be aware of them except in the drawings he produced for anarchist journals after 1885. Nor do the less extreme beliefs of any of the other Impressionists, which represent most of the spectrum of nineteenth-century political thought, come out in more than a handful of paintings (particularly Manet's).

Outside the discussions they are known to have had in various Parisian cafés, the Impressionists were largely apolitical. They produced no manifestos to proclaim their motives, preferring to let their canvasses and friendly critics speak for them, and through their choice of subject matter made it virtually impossible to convey any political message: even Pissarro the socialist, when he depicted peasants at work, instilled no sentiment in his paintings, unlike his predecessor, Millet, whose paintings of the same themes are pervaded with social realism. In fact, apart from their letters and occasional journals, the Impressionists themselves left few written records, and it has been only in the present century that the many elements in their story have been painstakingly pieced together to enable a clear view to emerge; the image that recurs is simply one of dedication to artistic ideals and a preoccupation which enabled them in the face of often extraordinary adversity to devote themselves to lifetimes of patient, hard work.

Thus although 1874 was a landmark in the history of Impressionism, this was no overnight sensation: the Impressionist period proper occupies about twenty years from the mid-1860s to the mid-1880s, although in altered form some of its originators and their followers kept Impressionism alive well into the twentieth century. The 1874 exhibition was the movement's first public manifestation, but even this had been attained only after a number of years of patient and unrewarding effort. By 1874, indeed, one of the most promising members of the group, Frédéric Bazille, was already dead, a victim of the Franco-Prussian War of 1870–1. All were now in their late thirties or forties and had completed periods of formal art training in one or more of the Parisian schools and studios. All were far

removed from the stereotype of the artistic radicals that their vehement critics would have their readers believe them to be: quite apart from their lack of political involvement, they neither looked nor acted like revolutionaries. Although there had been, and still were artists who fitted the popular caricature image of the bohemian artist, the Impressionists were not among them. Cézanne, it is true, was either extrovert or naive enough to wear his paint-stained smock in public, but the rest, as depicted in Fantin-Latour's paintings Homage to Delacroix (page 64) and A Studio in the Batignolles Quarter (page 65), are indistinguishable from any contemporary group of respectable middle-class tradesmen, and, but for the artistic trappings of the two paintings, might have been taken for clerks or civil servants. None openly flouted convention in their private lives or even in their attitudes toward the artistic establishment until they were faced with no realistic alternative. Several of them lived with mistresses but were extremely discreet; Cézanne's family knew nothing of the woman with whom he had been living and by whom he had a son, and he in common with most of his associates ultimately married his partner. Cézanne, with several of the other Impressionists, and especially Manet, was determined to achieve official recognition for his work and resolutely sent canvas after canvas to the Salon, only to have them all returned with the dreaded 'R' ('refused') stamped on the back.

Cézanne's struggle for acceptance mirrored that of his colleagues, all of whom sought some measure of conventional respectability, but the task was uphill. In aspiring to be painters at all, let alone respected painters, they almost all faced considerable parental opposition. All but the greatest artists of the day were regarded on a social level not much above that of a domestic servant, and without the official, and hence public, acknowledgement that acceptance by the Salon conferred, few artists could hope to earn more than a bare subsistence living from their painting. In consequence, artists operating outside the establishment system, and especially artists producing works as shockingly new as those of the Impressionists, faced not only poverty of an often appalling degree, but also ridicule from those who, as far as the world in general believed, were the arbiters of artistic sensibility. As far as most of their contemporaries could judge, the Impressionists confronted these problems against all apparent reason. Clearly, despite occasional suggestions to the contrary from ill-informed critics, they were not artistic incompetents; all had sufficient academic training to have been able to turn their hands to more popular subjects and styles, so why, in mature adulthood, should they have chosen to follow an artistic course which decreed that they could often not find a buyer for a painting priced at little more than the cost of this book - paintings once scorned by critics and public alike, and yet which today are frequently sold for staggering sums, often in excess of \$1 million?

What, then, was the appeal of the Impressionist movement, that it could command such loyalty from its proponents and vituperation from its opponents? The answer is simple, but the implications of it are complex and far-reaching. Impressionism was something so completely new and strange that it demanded different techniques for viewing and comprehending it – techniques that in 1874 apparently few individuals outside the Impressionist circle possessed.

Impressionism was different in terms both of subject matter and technique. Characteristically, the Impressionists painted everyday scenes, both landscapes, for which they are perhaps best known, and portraits. They totally rejected those themes that French Salon artists up to their day had concentrated on – heroic subjects, vast religious or history pieces painted to a prescribed formula so that any viewer could immediately identify the event depicted, or landscapes in which some familiar mythological scene was enacted, so that the landscape itself was subordinated to a background rôle. To the Impressionists, the landscape was a sufficient theme, and in order to render it faithfully they chose to work in the open air, shunning the use of studios in most instances. It may seem strange today to conceive of painting a landscape anywhere but on the spot, but prior to the time of the Impressionists, with a few notable exceptions, there was a long tradition of studio painting, sometimes, but not invariably, based on sketches done in the open air. The freshness of the quick sketch was often totally lost when it was 'worked up' into a full-scale painting, and it was partly this loss of immediacy that caused the Impressionists to place high value on their open-air work. Additionally, in casting the studio tradition aside, they were able to represent the changing effects of light at different times of the day and at different seasons. Not all followed this principle, however. Degas, for instance, continued to paint indoors (although he is reputed to have so admired Monet's ability to capture the feel of an open-air subject that he remarked that his paintings made him 'want to turn up his coat collar'), while Manet and Fantin-Latour were both at one time unconvinced by the value of *plein-air* painting. Here, as with many other facets of the Impressionist 'revolution', old and deeply ingrained traditions died hard.

Spontaneity was a byword of the Impressionist style, particularly as demonstrated by Monet, Renoir, Pissarro and Sisley. Seizing on a scene, or an interesting play of light, the Impressionist painter would attempt to create the immediacy of the scene on canvas. While the immediate nature of this technique could result in the forceful and emotive rendering of a fleeting image-Monet, for example, often worked for only 15 minutes on a subject before he abandoned it when the subtle nuances of the light changed - it led inevitably to the most frequent charge levelled against the Impressionists, that their work was 'unfinished'. Indeed, compared with the time-honoured and laborious techniques of detailed preparation, arrangement of models and props to almost mathematical formulae, preliminary sketches and perhaps months of detailed painting, the work of these artists lacked the 'finish' of the works of previous masters, but they also lacked their often dry execution and rigid formality. The reaction against the overworked nature of academic painting, which came about, not entirely coincidentally, at the time when photography was emerging as a more faithful recorder than the painter, was one of the facts of artistic life that Impressionism overthrew - although it was a long time dying. On the other hand Degas is quoted as saying:

No art was ever less spontaneous than mine. What I do is the result of reflection and study of the great masters; of inspiration, spontaneity, temperament – temperament is the word – I know nothing.

The Impressionists placed great emphasis on bright, primary colours (red, blue and yellow), applying them directly to the canvas rather than mixed on the palette, most typically using dashes of paint without any attempt to disguise the brush-strokes. Inevitably, this technique together with the absence of preliminary sketches meant that the carefully delineated image was generally repudiated – although in later life Renoir was to return to his formal, contoured style, and Degas was always primarily a draughtsman. Avoiding dark earth hues and in most cases black (although, again, Renoir did use black), the Impressionists often created the effect of different colours by a process known as 'optical mixture', whereby the viewer's eye registers two juxtaposed colours as a single colour (yellow and blue as green, for example). This technique was to be carried to its ultimate conclusion by the immediate followers of Impressionism, the Neo-Impressionists led by Seurat, who applied small spots of colour in a scientifically ordered arrangement to achieve this goal.

This was one of the outcomes of the Impressionists' endeavours to resolve a

range of problems which had taxed artists for centuries but which were more capable of being realized at this time in view of the many advances in the scientific study of light and colour, particularly in the research of the French chemist Eugène Chevreul. Chevreul, as director of the dyeing department at the Gobelins tapestry factory in Paris, carried out research into the apparent deterioration of certain colours in the tapestries. His book, *The Principles of Harmony and Contrast of Colours and their Application to the Arts*, was first published in 1839 and may even have influenced Delacroix's understanding of colour. Chevreul found that it was not a process of fading that resulted in these peculiarities, but rather in the way the colours had been juxtaposed. He therefore, for the first time, laid down a system of laws relating to the changes observed when certain colours are used in close proximity. Chevreul gives an instance of this effect:

Red, the complementary of green, being placed next to green, increases the intensity of green and in turn is increased in intensity, particularly in the area of juxtaposition.

This effect can also be extended to all manner of areas where colour is used, for example, in clothing, interior design and painting.

Distinct from the broad principles of Impressionism there were also many individual differences between the practitioners. On occasions so much common ground existed in their techniques that it is virtually impossible to distinguish between the works of, say, Renoir and Monet in the late 1860s. On the other hand, the Impressionist movement was composed of painters whose backgrounds and personalities were intricately involved in the expression of their art. The story of Impressionism is thus a number of independent stories with a certain amount of overlapping. Similarly, there are intimate connections with artists of previous generations and with succeeding ones, so Impressionism can be understood only in its historical context: it did not arrive spontaneously, nor did it die before it had wrought profound changes on a new wave of artists.

The whole story is so intricate that it is virtually impossible to state categorically when Impressionism started and when it finished. We can, however, see a pattern in its emergence and consider some of the causes. The scene focuses on that most crucial institution in French art in the nineteenth century, the Académie of Fine Arts and its showplace, the Salon.

The original Académie Française had been abolished by the painter Jacques Louis David (1748-1825) and replaced by the Institut. In post-Revolutionary France it had undergone several major changes, but essentially maintained the same functions. Originally, in the seventeenth century, it served primarily as a teaching body and the only organization allowed to hold public art exhibitions. It acted as an official arbiter of artistic taste, and ranked its members in a strictly hierarchical system, placing the greatest emphasis and awarding the most coveted prizes to those artists who, through their work, lauded the glory of the monarchy. After the French Revolution of 1789, this glorification was transferred to the Republic. The power of the Académie and its intense conservatism led to the term 'academic' coming to mean dry, old-fashioned and conventional, and despite continual bombardment from opposing factions, this position, once established, was self-propagating and unshakeable. David was the leader of the Neoclassical movement in France. This style of art, which sought to utilize subjects from Greek and Roman history to promulgate contemporary political and moral ideals, had originated in Italy in the eighteenth century and had been introduced into France by David at precisely the time when the newly-established Republican virtues sought artistic expression. David was an arch-Republican who as a Deputy voted for the execution of Louis XVI, and through his undisputed position as the leading artistic propagandist of the day established a style of art

which continued unchanged into the nineteenth century. The Neoclassical style, emphasizing finely detailed drawing, almost to the exclusion of all other aspects of technique, was perpetuated by David's pupil, Jean Ingres (1780–1867), who, in carrying his master's banner forward, came face-to-face with a threat to the established order in the form of Romanticism.

This movement, led by Eugène Delacroix (1798–1863), was more strongly concerned with subject matter, often unrestrained, exotic and sometimes bizarre, and, like Impressionism, was opposed to the Neoclassical obsession with minute detail, which its followers viewed as 'the flaw of perfection', the dogmatic, excessive concern with line and the deployment of subjects supposedly derived from Antique examples. Thus, by the middle of the nineteenth century Ingres and Delacroix were engaged in artistic battle, often depicted in caricatures of the day as a joust between line and colour.

Meanwhile, another movement was gaining ground as a reaction against both classical and romantic art. This was the so-called realism of such artists as Jean François Millet (1814–75) and Gustave Courbet (1819–77), whose depictions of peasant life, and especially its hardships, were despised by those who clung to the idea that art should be elevating and seek only noble subjects. After the Revolution of 1848, there was a brief swing in favour of Millet's brand of social realism, but it was short-lived. Jean Millet and other realists formed a group of artists who worked in the rural tranquillity of the Barbizon region of the Fontainebleau Forest, attracting the following comment from Count Nieuwerkerke, the Superintendent of Fine Arts: 'This is the painting of democrats, of those who don't change their linen, who want to put themselves over on men of the world; this art displeases and disgusts me.'

The reaction against Courbet led to his rejection from the Salon (so-called after the Salon d'Apollon, the room in the Louvre where the official Académie exhibitions were originally held) and to his decision to organize a private exhibition. This and a similar protest by Manet were instrumental in demonstrating to the Impressionists the possibilities of independent exhibitions.

The Salon was, according even to some of its proponents, such as Ingres, 'literally no more than a picture shop'. Artists were driven to adhere to its rigid standards as the only means of obtaining institutional, and hence public recognition of their works, and the only worthwhile way of selling it or gaining lucrative official commissions. In slavishly following this system, a dull routine was inevitable; as Jules Champfleury was to remark in 1869, the 'universal cleverness of hand makes two thousand pictures look as if they had come from the same hand'.

In the absence of aristocratic patrons since the Revolution of 1789, the clients for these paintings were the new bourgeoisie, who demanded pictures they could understand – pretty flower pieces, anecdotal or historical narrative works, mythological and religious themes, and perhaps the mildly erotic nude. Landscape was little regarded; landscapists were at the bottom of the Académie hierarchy, with history painters at the top, and often an eminent painter of an epic subject would concentrate on his heroic figures while the routine landscape background was executed by an anonymous hack.

It was against this background that the Impressionists were to emerge, by the late 1850s or 1860s, all deeply committed to artistic careers, albeit in an environment that offered little freedom of individual choice; in the absence of a private income, the choice was obvious – paint according to the Académie rules or starve.

A range of factors further influenced the artistic development of the Impressionists: the training they received in the schools and studios of Paris; the work of earlier artists they saw and copied, principally in the Louvre; contemporary artists of the previous generation with whom they sympathized and from whom they received advice and tuition; their social contacts – especially in the popular cafés where a wide range of intellectuals gathered; their studies of science in relation to art (chiefly colour and optics); and their rarely equalled mutuality. Seldom in the history of art was there such a high degree of cross-pollination of ideas, of unselfish aid not only in aesthetic and artistic matters but also in practical daily life – financial help, hospitality and uniquely powerful bonds of friendship between the members which not only fostered their work, but in some instances enabled them to survive. The methods by which these various influences were assimilated will be considered with respect to individual artists, but it is worth considering some of the general features here.

Apart from their objections to painting indoors, painting after dark was impossible, and so the evenings found the Impressionists in various cafés in the company of writers, poets and journalists who sought material for their literary work in the vibrant atmosphere these venues generated. It was there that the Impressionists met each other, discussed artistic and other problems and also encountered those writers who were to disseminate their views and analyse their endeavours. Louis Edmond Duranty, later a major propagandist for Impressionism, was a frequent visitor to the Brasserie des Martyrs where he heard Courbet's outspoken views which he conveyed in his short-lived review, *Réalisme*. Attacking both the reconstructions of Neoclassicism and the imaginative world of the Romantics, he demanded of contemporary painters: 'The man of antiquity created what he saw; create what *you* see!' (*Réalisme*, 10 July 1856). This meeting place and especially the Café Guerbois became the arenas of Impressionist debate, where new ideas were discussed and even fought over.

The nineteenth century was an age of scientific progress. There was a proliferation of new discoveries and inventions, scientific periodicals, industrial exhibitions and an obvious public interest in the fertile possibilities offered by the technological advances of the day as evidenced by the emergence of totally new concepts and genres of literature, including science-fiction. To painters such as the Impressionists, discoveries relating to the properties of light and optics were especially relevant, and it is known that several of them subscribed to journals which featured articles on these subjects. Notable among these investigations would have been those of Gustav Kirchoff and Robert Bunsen on the spectrum, and, as previously mentioned, the research of Eugène Chevreul.

There was also a wave of interest in optical toys such as the zoetrope (made after 1860) and the praxinoscope (patented in 1877) which created the illusion of movement, and the kaleidoscope and stereoscope which produced respectively multi-coloured patterns and apparently three-dimensional images. These and other recreational and scientific devices prompted further enquiries into the psychology of colour and optical effects.

Most important among these were the newly-invented techniques of photography which were beginning to have a considerable impact on painting. Although the cry 'From today, painting is dead!', heard in the early days of photography, had not come true, it is unquestionable that the visual effects achieved by photographers, both deliberately and through aberrations in early equipment and materials, had major influences on the way in which artists perceived the world. Bazille's *Family Reunion* (page 63) was probably based on a group photograph, and elements of Manet's *The Execution of the Emperor Maximilian* (page 54) are derived from photographic portraits. There is, however, only fragmentary evidence for the Impressionists' widespread use of photographs as reference aids, mainly because at the time they worked there was much rivalry and suspicion between photographers and painters, which led to painters' caution in the overt use of the equipment. What is more certain is that the blurring effect of movement on slow-speed emulsions, variations in depth of focus, halation (the fogged appearance caused by a ring of bright light round an object through reflection on the film surface), distortion of detail, and unusual angles of vision and frame cut-offs all played a part in the Impressionists' reappraisal of their visual repertoire. A street scene by Monet shown at the 1874 exhibition featured a crowd of indistinct figures described by Leroy as 'black tongue-lickings'. 'Do I look like that when I walk along the Boulevard des Capucines?' he asked rhetorically. He might have been answered by the explanation that the human eye can not register all the details of an entire scene en masse, but only as, in his own terminology, an 'impression'. The camera showed Monet how the mechanical recording of this impression might be transmitted to canvas to achieve an effect more true to optical reality than the classically minute rendering of an entity that no retina can comprehend as a whole. (The suggestion that Monet's later concern with the depiction of certain subjects, such as haystacks, as sequential images was derived from his knowledge of zoetrope or cinematographic pictures is, however, rather far-fetched.)

In addition to their own perception, heightened by their awareness of the sciences of colour and optics and photography, the Impressionists derived a good deal from the perception and techniques of earlier artists. Most studies of Impressionism feature a range of 'precursors', and of course, since their artistic education was diverse and their quest for truth considerable, the list of 'influences' would be interminable. Many of the Old Masters had something to offer the Impressionists: Spanish painters such as Velasquez, El Greco and Goya suggested certain Impressionist methods. Quevedo, a contemporary writing of Velasquez (1599-1660), referred to his 'few scattered brush-strokes that here represent truth', an almost prophetic view of one of the Impressionists' ideals. Rubens, working in the same period as Velasquez, employed a method of depicting shadow by painting with translucent colour, rather than black which was traditional - again anticipating an Impressionist technique. Frans Hals utilized separate brush-strokes to enliven the surface of his paintings, and his style and especially the informality of his portraits were notable influences on Manet, who saw his paintings during a visit to Holland. Nicolas Poussin, another seventeenthcentury artist, so much influenced Cézanne that he declared that he 'wanted to do Poussin again, from Nature'. The rich paintings of Watteau, Boucher and Fragonard all influenced Renoir. In particular (although Monet and Pissarro were later to express reservations about the degree of his influence), the rôle of Turner, especially indirectly through his effect on the paintings of Delacroix, was, as Paul Signac later wrote, 'unquestionable'. Delacroix himself, largely through his awareness of optical mixture and contrast, is an obvious Impressionist precursor. Writing of landscapes he once remarked how his contemporaries had 'profited enormously by their example'. He was referring not only to Turner, but also to John Constable, the English painter whose method of painting skies could later be compared with the Impressionists in technique and whose works were popular in France just prior to the early days of Impressionism. Constable's aspiration to depict 'light, dews, breezes, bloom and freshness', marks him out as a forerunner of the Impressionists. Like them, he fused art and science, indeed regarding painting as a science, an investigation of such laws of nature as the effects of reflection and refraction in modifying colour. He continued to use the traditional technique of making preliminary sketches out of doors and executing the finished painting in the studio, and in this differs from the Impressionists, but along with Richard Parkes Bonington and other British topographical artists, Constable ('the father of our school', as Delacroix called him) pointed a direction which Impressionism followed.

A more direct range of influences can be observed in considering that generation of painters older than the Impressionists, but alive in their formative years and ready to offer friendship and guidance to their juniors. Among these, Jean Baptiste Camille Corot (1796–1875) stands out as a major influence on Cézanne in his landscapes and Renoir in his nudes. Courbet, who we shall consider in greater detail later, was described by Fantin-Latour as 'the leader they were all to follow', and affected Monet through his coastal scenes, Renoir with his nudes and Pissarro in his snowscapes.

Eugène Boudin (1824–98), described by Baudelaire in 1859 as a painter of the 'magic of air and water', is often grouped with the Impressionists, and was certainly a key influence. Writing of his pastel studies at the 1859 Salon, Baudelaire referred to their being 'sketched from what is most fleeting, most imperceptible in form and colour, from waves and clouds'. Boudin himself stated that 'three strokes of the brush after nature are worth more than two days labouring at the easel'.

Boudin's comment further emphasized the Impressionists' desire to seek truth in nature itself, rather than in the studio. The move to open-air painting was enhanced by a growing vogue for rural life which came about as a reaction against the increasing urbanization of Europe in the eighteenth and nineteenth centuries. Although the urban scene, especially crowded thoroughfares and railway stations, offered visual challenges to the Impressionists, and the bustling gaiety of Parisian nightlife provided Degas with all the images of contemporary life he could paint, the most characteristic Impressionist painting is the landscape. The countryside was glorified by such novelists as George Sand, in the paintings of the realists and in the upsurge of popularity of such leisure pursuits as picnics and boating parties, both of which became classic Impressionist themes. Nowhere were the artistic possibilities of the countryside more thoroughly explored than in the Barbizon region of Fontainebleau. Far enough from Paris to remain unspoiled by urban expansion, yet close enough to allow easy access, it offered artists solitude in a peaceful forest and reasonably priced accommodation in the unremarkable village. From about 1836 onwards it became a centre for a group of painters including Millet, Theodore Rousseau (1812-67), a leading realist painter, Narciso Diaz de la Peña (1807-76) and Charles Daubigny (1817-78).

THE EARLY YEARS

In the nineteenth century one could positively speak of a brotherhood of artists. Even painters of widely divergent views met and discussed the burning artistic questions of the day, and saw each other's work at the relatively few exhibitions that were held (one-man exhibitions were virtually unknown in the early nineteenth century, and the national academies generally controlled the major annual or biennial shows). In the main art centres of Europe – Paris, Rome, London, Düsseldorf – most artists knew one another. But the Impressionists were especially closely associated. Although in some instances several years passed before introductions were made, by the 1870s all the bonds of friendship and mutual support had been forged, resulting in their working and even living together, providing financial assistance in especially bleak periods, and constantly offering encouragement and support. Although all the members of the Impressionist circle followed artistic courses determined by personal temperament, it was through these ties that the unique features of Impressionism were developed.

Camille Pissarro (1830–1903) was, by a few years, the oldest of the group. Born in St Thomas in the then Danish West Indies of a Creole mother and a Portuguese Jewish father, he had studied in Paris in his youth before working in his father's store. Savary, his teacher in France, had actually encouraged him to draw out of doors – then an almost unheard of practice – and back in St Thomas he spent many hours sketching banana plantations, coconut trees and other exotic subjects. Inspired by thoughts of becoming a painter, he left for Caracas in Venezuela in the company of a Danish painter, Fritz Melbye. Acknowledging his son's intentions, Abraham Pissarro agreed to let him study art in Paris, to which he returned in 1855, the year of the Great Universal Exposition. There he visited Corot, whose work Pissarro greatly admired and whose style – although regarded by most as rather bizarre in its sketchy treatment of landscape – he adopted. He enrolled in and studied briefly at the Ecole des Beaux-Arts, and by 1859 was sufficiently developed and confident to send a landscape (painted in the open air) to the Salon where it was accepted and exhibited.

However, by 1863 he had further developed his Corot-influenced style and had departed from artistic orthodoxy to such an extent that his works were no longer acceptable to the Salon, although they were shown in that year at the infamous Salon des Refusés. He occasionally studied in the informal studio known as the Académie Suisse, also previously attended by Manet and Courbet. Monet worked there too, and soon made his acquaintance, describing Pissarro as 'tranquilly working in Corot's style'. He was also starting to assimilate some of the techniques of Courbet. At the same time, he established his important contact with Cézanne. In 1864 and 1865, a somewhat less reactionary Salon jury admitted his paintings which he signed as a 'pupil of Corot', although he later fell out with

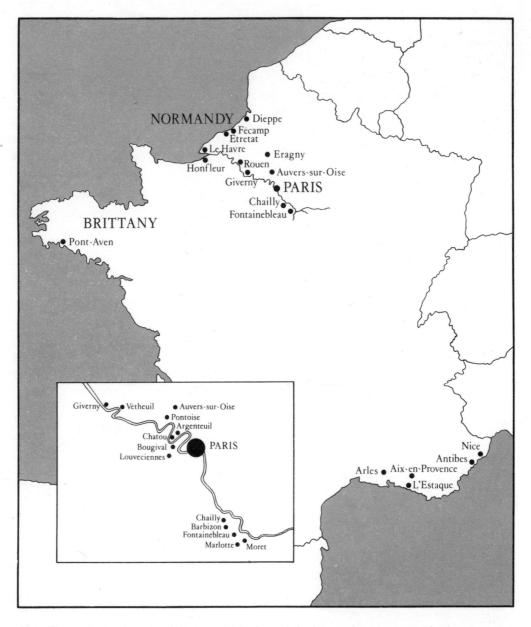

Map of France, showing places where the Impressionists lived or worked and (inset) the concentration of these locations around Paris and the river Seine

nim. By 1866, after over a decade of patient study, Pissarro's painting had developed to such an extent that it excited the praise of a number of critics, among them Emile Zola, the writer and - initially, at least - a defender of the Impressionists. In his personal review of the Salon paintings of that year, Zola wrote:

M. Pissarro is an unknown, about whom probably no-one will talk . . . Thank you, sir; your winter landscape refreshed me for a good half-hour, during my trip through the great desert of the Salon . . . you have the arrogant clumsiness to paint solidly and to study nature frankly . . . an extreme concern for truth and accuracy . . . sir, you are an artist that I like!

At this time, Pissarro settled in Pontoise with his mistress, Julie Vellay. He frequently visited Paris and saw his friends at the Café Guerbois. The artistic principles that they developed became his personal credo, he once remarked, 'my life is bound up with the life of Impressionism'. He was the most consistent of all

and the most loyal – the only Impressionist to show his paintings at all eight of their exhibitions. He was, however, frequently less imaginative than his colleagues and his work suffered when he tried, not always successfully, to assimilate the examples of a wide range of artists with whom he came into contact Corot, Millet, Courbet, Renoir, Monet, Seurat and others all impinged on his style, and often the result was an unhappy fusion, an uncertain and incoherent style applied to often dull and repetitious subjects. His real strength lay in the example he set others – particularly Cézanne (and later Gauguin and Van Gogh) – and his rôle as the father figure of Impressionism, always ready to offer advice and encouragement. Cézanne was to describe him as 'humble and colossal' and 'a man worth consulting and something like God himself' - as he aged, he even came to resemble a biblical patriarch. He was constantly experimenting and on the eve of the Franco-Prussian War, as he was later honest enough to admit, he was 'full of ardour; I did not have the slightest idea, even at the age of forty, of the profound aspect of the movement that we pursued instinctively'. He concluded that 'it was the air' and it was his continued pursuit of the intangible properties of air and light that occupied him for another thirty years.

Most closely allied to Pissarro, though ten years younger, was Claude Monet (1840-1926), often described as the 'most Impressionist of Impressionists', and generally regarded as the central figure in the movement. While Pissarro was exhibiting his first paintings at the Salon, Monet was producing caricatures of citizens of his home town of Le Havre. It was there that he met Eugène Boudin. It was Boudin (whose marine paintings were displayed in the same shop as Monet's caricatures) who encouraged him to apply his obvious talents to more serious art. Boudin had been able to study in Paris by obtaining a money grant from the city of Le Havre, which Monet's father had attempted to obtain for him. Although he failed to do so, Monet went to Paris to study - but with very little money. Almost immediately he encountered the financial problems that were to trouble him throughout his early working life, almost driving him to suicide. When he declined to enrol in the Ecole des Beaux-Arts, his father cut off his already meagre allowance. It was thus at the informal - and cheap - Académie Suisse that he began his studies, and there he met Pissarro. He was soon conscripted into the army, however, and served for a brief period in Africa (following the example of Delacroix, who had painted many spectacularly colourful works in Algeria) until, following a serious illness in 1862, he returned to Le Havre. Bought out of the army he returned to his studies. At this time he was reunited with Boudin, and encountered a Dutch painter, Johann Jongkind (1819–91). Some art historians have seen in Jongkind's work all the important early influences on Impressionism, and he was even, though perhaps rather extravagantly, dubbed by Paul Signac 'the first Impressionist'. Certainly, as Monet admitted, 'it is to him I owe the real training of my eye', and Jongkind was a significant precursor of the Impressionist movement, mainly through his watercolour landscapes. His working life was interrupted by bouts of wildly erratic behaviour and alcoholism, and he eventually died in a lunatic asylum.

2

Monet's father allowed him to return to Paris where he enrolled in the studio of Toulmouche, a painter of sentimental subjects, from whom he was unlikely to learn anything (a critic describing Toulmouche's work wrote: 'It's pretty, charming, highly coloured, refined – and it's nauseating!'). Toulmouche probably acknowledged the lack of rapport, and directed Monet to the studio of Charles Gleyre, whose teaching methods were notoriously easy-going, ranging from total neglect to the odd sharp criticism and occasional encouragement to paint in the academic style. In his studio Monet met Frédéric Bazille. Against the advice of their teacher, they, together with Renoir and Sisley, spent long periods between 1863 and 1865 at Chailly near Barbizon, painting in the open air and developing individual and collective aspects of their style.

By the end of the 1860s, Monet was well advanced in the adoption of his characteristic techniques – his use of large brushes, swift strokes and the application of dabs of unmixed pure colours. His fascination with colour became, as he described it, 'my day-long obsession, joy and torment'. He began also to explore the artistic potential of movement in nature – thawing ice, fog, mist, smoke and rough seas – and especially the way in which the qualities of light alter from hour to hour. When in 1866 he painted *Women in the Garden* (page 87), he astonished his visitor, Courbet, by suspending work until the lighting conditions most closely matched those of the previous day's session. His concern with depicting these changes became the most vital aspect of his mature style.

Auguste Renoir (1841–1919), who met Monet at Gleyre's studio, was one of five children of a poor tailor from Limoges. Originally apprenticed as a porcelain painter, he left when the factory was forced to close in the face of competition from printed porcelain. After spells as a painter of fans and window blinds, he entered Gleyre's studio in 1862, where he was probably even more unpopular with his teacher than Monet, due to his preoccupation with colour. In 1864, Gleyre, whose eyesight was failing and who was suffering financial difficulties (through his generosity in charging his students modest fees), was compelled to close his studio, leaving Renoir - along with his friends, Monet, Sisley and Bazille - without tuition. When the group began painting together in the open air at Chailly, Renoir made the acquaintance of the Barbizon painter, Diaz, who recognized his talent and allowed him to buy paints on his account. At the Salon of 1865, Renoir's portrait of Sisley's father, William, was shown. The following year, in the company of Sisley, he went to the home of Jules Le Coeur at Marlotte near the Fontainebleau Forest. There he began a liaison with Lise Tréhot, the sister of Le Coeur's mistress, Clémence, and painted her frequently - his fulllength portrait of Lise was exhibited at the Salon of 1867. During this period Renoir was greatly influenced by Courbet, following him in his treatment of everyday scenes, use of dark colour and occasional use of the palette knife. Always short of money, he was compelled to take a commercial commission which involved painting a ceiling decoration for the home of Prince Bibesco in 1868. (Later he was to gain a reputation for his commissioned portraits of upper-class and titled sitters, painted for ready cash, but nonetheless often charming and displaying all his skill and Impressionist techniques.)

In 1869 Renoir worked with Monet at La Grenouillère, near Chatou, and it is interesting to see how similar their styles became at this time. In the works then produced they both exhibit the classic Impressionist concern with the colour of shadows, bright primary colour and lack of any attempt to disguise their free brush-strokes, so that these paintings of 1869 may be regarded as the first true Impressionist paintings. It was also one of Monet's most depressingly impoverished periods, as he wrote, 'Renoir brings us bread from his own home or we should die of hunger. For a week now we have been without bread, without fuel to cook by, and without light. It is dreadful.'

Alfred Sisley (1839–99), although born of British parents (his father was a wealthy silk dealer), lived most of his life in France, and, like Monet, Renoir and Bazille, he studied at Gleyre's studio between 1862 and 1864. He then worked at Chailly and Marlotte, having two landscapes accepted by the 1866 Salon. The influence of Corot, Daubigny and Courbet can be seen in his work, which consisted largely of landscapes, ranking with Monet as one of the foremost Impressionist landscape painters, especially in his river scenes. One of the purest Impressionists, he adhered to their original principals throughout his life.

Frédéric Bazille (1841-70), the last of the Impressionist group that formed in Glevre's studio, was the son of a prosperous wine-grower from Montpellier who divided his studies between medicine and art. He became interested in painting at an early age through his family's association with Alfred Bruyas, a noted collector of works by Delacroix, Corot and Millet, and also Courbet, who Bazille, aged 13, met during his visit to Bruyas. He had worked with Monet on the coast at Honfleur, painting similar scenes and also coming into contact with Boudin and Jongkind. Between 1865 and 1866 he shared a studio with Monet, supporting him in a period of dire poverty by buying his painting Women in the Garden (page 87) for 2500 francs, payable in 50-franc monthly instalments. In 1867 he worked on his large Family Reunion (page 63), deploying his subjects in the formal manner of a posed photograph, from which it may be derived. This painting was shown at the Salon of 1868. The following year, Berthe Morisot saw his View of the Village at the Salon and commented, 'Bazille has done something I consider fine . . . There is a lot of light and sun. He is attempting what we have so often tried, putting a figure out of doors; this time he seems to me to have succeeded."

Berthe Morisot (1841-95) was the daughter of the Prefect of Bourges. With her sister she was a pupil of Joseph Guichard, who instructed them in painting by the traditional method of copying Old Masters in the Louvre. Unlike most women of her class, for whom painting was regarded as a genteel pastime, she showed great enthusiasm for it and clearly intended that it should play a greater part in her life than a simple drawing-room activity. When, in 1861, she expressed a desire to paint out of doors, Guichard (whose masters had been the strangely incompatible duo of Ingres and Delacroix) was unwilling to accede, and referred her to Corot. Their professional relationship developed, and though usually reclusive, Corot regularly dined with her family. His major lesson to her was to pay less regard to formal teaching and instead to 'consult nature herself', which the other Impressionists were discovering for themselves was the best teacher of all. In 1863, they spent the summer on the River Oise between Pontoise and Auvers, painting landscapes, two of hers being shown at the Salon in 1864. She later met Manet who, disliking professional models, had her pose for him in The Balcony (page 56). He painted her on several other occasions; a full-length seated portrait was shown at the 1873 Salon.

However, an intense rivalry developed between Morisot and another female artist, Eva Gonzalès, whom Manet also painted, and considerable friction was generated in her relationship with Manet. It was, however, through her encouragement that Manet began to change his predilection for the studio and to paint out of doors. Berthe Morisot's position in the history of Impressionism is not only important, but is of particular interest as an illustration of the rôle of women in nineteenth-century art. In many ways she was obliged to remain an outsider – it was thought unsuitable for her to attend the male-dominated and sometimes boisterous meetings at the Café Guerbois, and other Impressionists had to report the outcome of their discussions there to her privately. Similarly, her subject matter was dominated by aspects of life which the male Impressionists seldom treated; like Mary Cassatt in later years, her paintings are characteristically scenes of family life, women and children.

Edouard Manet (1832-83) started his art training in 1850 after a brief period as a naval cadet. After several years of study in France and travels throughout Europe, he painted his *Spanish Guitar Player* (1860) which was exhibited at the Salon in 1861 and generally well received. It was praised by Baudelaire who referred to Manet's 'decided taste for modern truth . . . sensitive, daring imagination'. Manet later included Baudelaire among other friends in his *Music in the Tuileries Gardens* (page 51), which was probably based on photographic material. This and the other works were regarded as too daringly modern in their depiction of contemporary life, and in their vivid use of colour, to be acceptable to the Salon, and so were privately exhibited in 1863, drawing many visitors, among them such admirers as Delacroix. This was also the year of the celebrated Salon des Refusés. So many paintings, about 60 per cent of those submitted, were rejected by the conservative jury that there was an outcry from artists and critics. In an attempt to appease them, and to win favour through a display of liberality, Emperor Napoleon III agreed to allow the rejected works to be shown separately. The artists involved were, of course, faced with a dilemma: either they could withdraw their paintings, thereby avoiding any embarrassment, but in so doing tacitly acknowledging the jury's verdict, or they could have them shown, thus emphasizing that the jury had declared them sub-standard. Three works by Manet were shown at the Salon des Refusés, including his *Déjeuner sur l'Herbe* (page 49), which caused a scandal.

In 1865 Manet was outraged to discover that his paintings were confused with those of Monet, who had exhibited his seascapes of Honfleur at the Salon in that year. Manet's *Olympia* (page 52), shown at this time, was received with a storm of protest partly because of the voyeuristic nature of its subject matter. In 1867 Manet organised another exhibition for which he painted his *Execution of the Emperor Maximilian* (page 54), but owing to the political controversy surrounding the event depicted, he was unable to show it. In this same year, so many paintings were again rejected by the Salon that, after the rejection of the request for a repeat of the Salon des Refusés, the idea was put forward for a private group show. By this time most of the Impressionists were on close terms and agreed to show together, but through organizational problems the project was not carried out.

By the late 1860s, Manet had become the acknowledged leader of the group of artists who met at the Café Guerbois (where so heated did the discussions become that on one occasion he was involved in a duel). Throughout this period, and subsequently, he stands in an unusual, sometimes paradoxical position which in some respects sets him apart from the Impressionists, in other respects making him their most articulate supporter. They were to follow his lead on many matters, such as his advocacy of contemporary subject matter and his promotion of private exhibitions. Stylistically he was not allied to the Impressionists until later, and in many respects he was a traditionalist – following many of the techniques of the Old Masters, especially those of the Spanish School, and he continued to submit works to the Salon, never exhibiting with the Impressionists in any of their eight independent shows.

Another somewhat ambiguous member of the Impressionist circle was Henri Fantin-Latour (1836–1904). He began painting under the tutelage of Lecoq de Boisbaudram, then in the Ecole des Beaux-Arts, before returning to his determined pursuit of excellence through copying in the Louvre. He had visited Courbet's exhibition and shared this enthusiasm with James Whistler, the American painter who also stands as a fringe Impressionist. Fantin-Latour was an associate of Monet and Renoir, whom he encouraged to learn from the example of copying in the Louvre. His work was frequently rejected by the Salon jury, and although he is reported to have been unconcerned, he must have been irritated by the excuse given on one occasion, typical of the rigid attitudes of the Salon, that 'he had treated life size a subject appropriate for representation one half or one third its natural format'. On another occasion, in the face of hostile criticism, he destroyed a painting (*The Toast*) after it had been shown at the 1865 Salon. The previous year his *Homage to Delacroix* (page 64) had been exhibited at the Salon. Painted in memory of Delacroix, who had died in 1863, it included a group of his admirers, among them Baudelaire, Monet and Whistler. This type of formal group portrait, together with flower paintings, were among his best works, but in following his inclinations toward detailed renderings, he drifted away from the goals of Impressionism, particularly its aim of spontaneous depiction of nature.

Edgar Degas (1834–1917), though also a close associate of all the Impressionists, viewed himself as 'the classical painter of modern life'. He was through inclination and training opposed to many of the Impressionist ideals, including painting out of doors. His dealer, Ambroise Vollard, reported him saying:

You know what I think of people who work out in the open. If I were the government, I would have a special brigade of gendarmes to keep an eye on artists who paint landscapes from nature. Oh, I don't mean to kill anyone; just a little dose of bird-shot now and then as a warning.

The son of a wealthy banker, he abandoned law to study at the Ecole des Beaux-Arts in 1855, where he assimilated the seemingly incompatible influences of Ingres and Delacroix, as well as Courbet, although the blend of line, colour and realism derived from their work is evident in his paintings and pastels, the medium to which he turned partly as a result of his failing eyesight. He began by painting historical subjects, such as *Semiramis Building Babylon* (page 70), although the poses of his models and his techniques were essentially modern. In the 1860s he began to paint racehorses, moving on from them to the scenes of contemporary life for which he is best known, and adopting the Impressionist technique of seizing some ephemeral moment, usually the fleeting gesture of the women – dancers, milliners, bathers and laundresses – who became his favourite subjects.

Paul Cézanne (1839–1906) was also a close associate of the Impressionists in this early period, but very much the outsider stylistically. Throughout, his was a constant struggle for acceptance by the Salon which consistently rejected everything he submitted, regarding every work as an insult. He even appealed in 1866 for the re-establishment of the Salon des Refusés, but without success. He was constantly encouraged by Pissarro, whom he had met at the Académie Suisse, and by Zola, who came from his home town, Aix-en-Provence. Zola's support was acknowledged in Cézanne's portrait of his father reading *L'Evénement*, a newspaper to which Zola was a contributor.

It was Zola who first recognized the common ground that existed between the Impressionists, singling out from the Salon of 1868 Monet, Pissarro, Manet, Jongkind, Corot, Courbet, Bazille, Degas, Morisot and Boudin, and praising them to the exclusion of other established painters. But more than a decade of work had brought them to a point of contact and artistic maturity, with some, most notably Monet and Renoir, fully committed to the movement and its methods. The next stage of development might have been totally different, but for the fact that as 1870 started, they were only six months away from the disruptive effects of the Franco-Prussian War.

THE FRANCO-PRUSSIAN WAR

At the 1870 Salon works by Degas, Manet, Morisot, Pissarro, Renoir, Sisley and Fantin-Latour were shown. Both subjects submitted by Monet were refused (resulting in Daubigny's resignation from the jury), and, as usual, so was Cézanne's entry. On 18 July of that year, war was declared between France and Prussia. The most immediate tragedy for the Impressionists was the death of Bazille, killed in action at Beaune-la-Roland on 28 November.

Most of the products of Pissarro's working life since 1855, some 1500 paintings, and including some by Monet which he was storing, were seized by the Prussians who occupied his house at Louveciennes where he had settled in 1869. Some of his works were so little regarded that the canvases were used as duckboards in the muddy garden, and as aprons by the army butchers who turned his studio into an abbattoir. However, the value of some was clearly appreciated. Certain paintings, carried off as the spoils of war to become, as a friend of Pissarro's wrote to him, 'ornaments in Prussian drawing rooms', were to reappear at art sales in Berlin 50 years later.

Pissarro himself fled with his family, via the home of the painter Ludovic Piette in Brittany, to England where they stayed with his married half-sister, Emma, in south London. His mother later joined them. Shortly afterwards he married his mistress Julie Vellay, then pregnant with their third child. (He had procrastinated over marrying her throughout the previous ten years of their liaison, largely due to opposition from his parents, who objected not only to the fact that Julie was a former servant in their household, but also that she was not Jewish.)

Back in France, Manet was conscripted into the artillery division of the National Guard under the command of the academic painter Ernest Meissonier, an artist whose meticulously detailed historical works could not have been more alien to Manet's controversial modern style. Degas, working on the coast at the outbreak of war, returned to Paris and enlisted in the infantry, but as he suffered from partial blindness which made it impossible for him to fire a rifle, he was transferred to the artillery. Renoir also served in the army, in the Pyrenees, where he almost died of dysentery. Cézanne, always something of an outsider, managed to ignore the war, avoiding military service and staying in L'Estaque near Marseilles where he continued to devote himself to his painting. Berthe Morisot remained in Paris, even when it was besieged by the Prussians, describing the dreadful conditions there in letters to her sister which were carried out by balloon.

Like Pissarro, Monet went to London. (Sisley, who was English by birth, was not conscripted and may have spent some of this period in London, but the evidence is inconclusive.) London became a haven for refugees from the French studios. Some took the opportunity to settle permanently and became established among the leading painters of the day, such as Lawrence Alma-Tadema who, although Dutch by birth, had been working in Paris until the outbreak of war. Finding his paintings to the taste of the British public, he stayed in England for the rest of his life, attaining fame, wealth and a knighthood.

Monet left Camille, his former model and mistress and now his wife of only a few months, with Boudin's family. She was later to join him in London. In the group of expatriate French artists he met Daubigny, the Barbizon painter who, although over twenty years Monet's senior, had great sympathy with the aims of the young Impressionists. His encouragement took several practical forms: he later inspired Monet to build a houseboat on which he painted on the Seine, and in London he was responsible for introducing him to the art dealer Paul Durand-Ruel (1831–1922), who had opened a gallery in Bond Street and was sufficiently well disposed toward both Monet and Pissarro to buy several of their paintings, thereby saving them from total poverty – although, it may be noted, he was unable to sell any of them to the British art-buying public who were as conservative as the French.

Through Durand-Ruel, Monet made contact with Pissarro once again, and together they resumed their painting and visited museums and galleries. The question of the influence of the works of such English artists as Constable and Turner during this sojourn has vexed art historians for many years. In fact, it has probably been overrated. Pissarro later wrote:

Monet and I were very enthusiastic over the London landscapes. Monet worked in the parks [mainly Hyde Park], whilst I, living at Lower Norwood, at that time a charming suburb, studied the effect of fog, snow and springtime [around Norwood, Crystal Palace and Dulwich]. We worked from nature . . . we also visited the museums. The watercolours and paintings of Turner and of Constable, the canvases of Old Crome [John Crome], have certainly had influence upon us. We admired Gainsborough, Lawrence, Reynolds, etc., but we were struck chiefly by the landscape painters, who shared more in our aim with regard to open air, light and fugitive effects.

He also remarked that

Turner and Constable, while they taught us something, showed us in their works that they had no understanding of the analysis of shadow, which in Turner's painting is simply used as an effect, a mere absence of light. As far as tone division is concerned, Turner proved the value of this as a method, among methods, although he did not apply it correctly and naturally.

Monet was similarly critical of Turner, chiefly because of 'the exuberant romanticism of his fancy'.

Few of Constable's more 'Impressionistic' oil sketches were on view outside private collections until the 1885 bequest to the Victoria and Albert Museum, and the great range of Turner's work was not yet on show to the public, so the number of paintings by either that Monet and Pissarro could have seen would have been limited.

The previous year, working with Renoir at La Grenouillère, Monet had developed that most characteristic Impressionist technique of applying tiny, rapid dashes of paint. In England, Pissarro, who was always willing to assimilate some new method, adopted this and his work was accordingly modified. Monet's views of London, such as his *The Thames below Westminster* (page 90), and Pissarro's *Lordship Lane Station, Lower Norwood, London* (page 120), both painted in 1871, stand out as their finest works of this period.

Daubigny, the older friend and mentor of both Monet and Pissarro, had been accepted by the British artistic establishment, largely through his association with the Barbizon group which was then enjoying a vogue. But, despite his continued encouragement and his valuable introduction to Durand-Ruel (which was to be crucial in the later public acceptance of the Impressionists), Monet and Pissarro were regarded as too avant-garde, as unacceptable to the selection committee of the English Royal Academy (from which they were rejected in 1871) as they had been to the Académie Française – and as unsaleable.

Pissarro wrote bitterly from London to Théodore Duret (later a leading historian of the Impressionist movement), 'here there is no such thing as art; everything is treated as a matter or business'. Indeed, not long after this date, an arch-Academician like Alma-Tadema was able to command the enormously high price of £10,000 for a canvas, while at the same time Durand-Ruel was paying £200 for a Monet. A Pissarro sold in 1878 was to fetch the insultingly low price of £5 – less than the value of its frame.

Back in Paris, at the time of the Commune of 1871, Courbet was made Curator of Fine Arts and set about abolishing the Ecole des Beaux-Arts, the Rome Academy (an annexe of the French Académie) and the Fine Arts section of the Institut. He was also involved with a group of revolutionaries who destroyed the Vendôme Column, erected to commemorate the victories of Napoleon. When French troops re-established order in Paris, he was arrested. The bloodbath that followed the Commune was documented by several artists, including Manet who produced a brilliant lithograph, *The Barricade*.

Monet returned to France via Holland, painting a number of landscapes *en* route in 1871–2. War-torn Paris with its attendant social and economic problems was relatively unattractive and most of the Impressionists moved to the countryside. Renoir joined Sisley painting in the region of Louveciennes and Marly. Monet went to Argenteuil, and Pissarro returned to Pontoise where he was joined by Cézanne and others. All resumed their work with renewed enthusiasm.

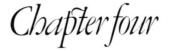

IMPRESSIONISM IN THE 1870s

In Paris, Durand-Ruel resumed his business which had been transferred to London for the duration of the Franco-Prussian war. He continued to acquire paintings by members of the Barbizon school, which was at last achieving a greater measure of popularity: works once regarded with the same horrified reactions with which many now greeted the Impressionists were becoming familiar and respectable to the art-buying public. Through his new-found association with Pissarro and Monet, Durand-Ruel made contact with Sisley and Degas and began handling their work. It was at this time that he began dealing in Manet's paintings. (Manet had remained in Paris and, like many of his colleagues, ostracized Courbet when he was released from prison; Monet, however, remained loyal to his former mentor.) When Durand-Ruel held an exhibition of paintings in 1872 in his London gallery, it included works by Manet, Sisley, Degas, Renoir, Monet⁻ and Pissarro – the most representative range of Impressionist works shown collectively to that date.

In the same year, the attitudes of the Salon were as entrenched as in the pre-war period, and only works by Manet and Morisot were accepted. Manet visited Holland and was greatly attracted by the paintings of Frans Hals. Degas, at about this time, began to discover the visual attractions of the theatre, particularly the ballet, and started producing those works depicting dancers for which he is perhaps best known. He also visited relatives in New Orleans, where he painted his *Cotton Exchange*, thus becoming the first of the Impressionists to work in North America.

Meanwhile, back in France, Pissarro and Cézanne worked together in Pontoise, and exerted a mutual influence. Cézanne was always indebted to Pissarro's instruction, and even late in life signed himself as 'pupil of Pissarro'. He painted there *The House of the Hanged Man* (page 135) which incorporated a number of now standard Impressionist techniques.

Sisley and Monet both worked in Argenteuil which offered a classic Impressionist landscape – tranquil rural views and a river which in the summer was filled with pleasure boats. None of the Impressionists sought the romantic drama of mountains or rugged scenery, although some achieved remarkable effects in painting snow scenes – Monet, however, regarded snow as 'the leprosy of nature' and fields ablaze with poppies, or sun-drenched river landscapes, became his most typical subjects. Following a visit to Argenteuil by Renoir, as in La Grenouillère before the war, Monet and Sisley both adopted their characteristic small, comma-shaped dabs of paint which have now become so familiar in their work.

As in the previous year, the Impressionists received many rejections from the Salon of 1873, but writing of the rejected artists in *L'Avenir National* the critic, Paul Alexis, was to comment accurately:

Without taking myself for a prophet, I foresee the emergence of a generation of radicals in art (I don't want to use the poorly defined word of 'realists'), sons of contemporary science, lovers of experimental truth and accuracy, who repudiate conventional 'beauty', the classical ideal and romantic attitudes, carrying only the banner of sincerity and life.

One of the few works of the group to be accepted was Manet's Le Bon Bock, a portrait of the engraver, Bellot, at the Café Guerbois. It was atypical: a somewhat sombre, homely and conventional portrait, obviously painted with his recent study of Hals in mind. Its acceptance, when so many truly Impressionist works were rejected, further reiterated the glaring fact that in order to gain the sort of recognition the Salon conferred, an artist had to compromise his art to align it with the jury's criteria of acceptability. Manet's continued acceptance of the status quo and willingness to modify his style to meet the Salon's standards isolated him from the Impressionists who took the opposite view - effectively that the Salon should modify its requirements so that they could freely pursue their chosen style without concession to the taste and judgement of others. These artists varied in their attitudes: Cézanne seemed deliberately to antagonize the jury by repeatedly submitting paintings so extraordinary and disturbing that he could not seriously have expected them to be accepted - especially when the jury was so conservative that they rejected the innocuous works of an artist such as Pissarro. Renoir, it seemed, was resigned to his fate.

All, with the exception of Cézanne, must have felt, however, that a repeat of the Salon des Refusés would serve no useful purpose. It was essentially a gratuitous gesture and only further emphasized the power of the Salon jury to arbitrate on the 'good' and the 'bad' in contemporary painting. In fact, the previous Refusés had been such a cause of dispute that the Académie had no intention of repeating it. When Cézanne agitated for its return, the official comment was, 'What he asks is impossible. It has been recognized how unsuitable the exhibition of the rejected was for the dignity of art. It will not be reestablished.' There was a growing feeling among some authorities that the 'dignity of art' was no better served by the Salon itself. Ingres described it thus: 'The Salon stifles and corrupts the feeling for the great and the beautiful. Artists are driven to exhibit there by the attraction of profit, and by the desire to get themselves noticed at any price.' But his comments were largely disregarded by the proponents of artistic orthodoxy. They preferred the works of artists like Gérôme, Meissonnier and Bouguereau which, in finely detailed classical paintings (many of which today, through their vulgar, pretentious and sentimental style would be regarded as classics of kitsch), represented the total antithesis of the art of the Impressionists.

In 1873 the often discussed question of organizing a private exhibition took on new importance; not only was the Salon unresponsive to the Impressionists, but a post-war recession had caused a dip in their already low prices and the need for sales of paintings was more pressing than ever. There were, however, many whose belief in the correctness of the Salon as the only proper exhibition and market-place was not to be altered: having had his *Bon Bock* displayed there, Manet pleaded with Morisot and Degas not to exhibit privately, writing, 'Why don't you remain with me? You can see very well I am on the right track.' Théodore Duret wrote to Pissarro:

You won't get anywhere with exhibitions put on by special groups. The public doesn't go to these exhibitions. There will only be the same nucleus of artists and admirers that you know already... dealers, art lovers will never look at you anywhere else.

Duret was unfortunately correct: at this time the Impressionists were appreciated by only a handful of connoisseurs, although their work was beginning to travel outside the confines of the 'nucleus' to which Duret referred. A young American resident in Paris, Mary Cassatt, although she had never met Degas, greatly admired his work and recommended the purchase of one of his pastels to Louisine Waldron Elder – later the wife of H.O. Havermeyer, a collector whose acquisition of Impressionist paintings became a major agency by which the Impressionists were accepted and admired in the United States of America.

Degas and Renoir were tireless in their devotion to the organization of the group exhibition, once the general decision had been taken to hold it. There were many points of difference which had to be resolved: were they, for instance, to admit painters who were also showing at the Salon, and should they restrict the number of entries as the Salon did, three being the maximum each artist was permitted to submit? In fact, although Pissarro attempted to introduce a complex set of rules and regulations - curiously based on the charter of a Pontoise bakers' union - he was defeated and the Société that was established was set up as a jointstock company along very simple lines. Salon exhibitors were not specifically prohibited, but as it transpired the Impressionists and their associates decided individually whether they would exhibit with the Société or submit to the Salon jury. The number of pictures each showed varied from Degas' ten to Cézanne's three. There was some discussion as to whether Cézanne should be admitted, as a public outrage at his works was feared. Degas opposed his admission, but Pissarro and Monet pressed for his acceptance, and since Salon-style censorship was one of the abuses they were attempting to counter, Degas was compelled to stand down.

Degas also attempted to broaden the base of the exhibition by introducing participants whose work was of Salon standard and well known to the public, such as that of James Tissot, then resident in London. Degas wrote to exhort him:

Exhibit. Stay with your country and with your friends. I assure you that the whole thing makes more progress and is better received than I would have thought . . . It may be that we will fall on our faces, as one says. But the merit will still be ours.

Renoir too was in favour of admitting a wider range of exhibitors in order to reduce the operating costs. Each exhibitor had to deposit 60 francs and was then due a dividend of admissions and any sales commissions which exceeded the expenses of staging the show. Tissot and others declined, however, and the exhibitors were limited to the Impressionist group and a range of other artists, almost none of whom are remembered today.

The studios loaned by Nadar were a suitably dramatic venue for the first group exhibition: Nadar was not only a talented and successful portrait photographer, but also a master of self-promotion. He appeared dressed entirely in red robes in his studios which were painted red inside and out – a startling contrast to the delicacy of many of the paintings hung there. The criticism of the paintings was generally intense, centring round the lack of 'finish'. The critic in *La Patrie* wrote:

Looking at the first rough sketches – and rough is the right word – you simply shrug your shoulders; seeing the lot you burst out laughing; but with the last ones you finally get angry, and you are sorry you did not give the franc you paid to get in to some poor beggar.

The ubiquitous comment, much heard in the present century in respect of abstract art, that 'a child could have done it better', was voiced by Émile Cardon:

Daub three-quarters of a canvas with black and white, rub the remaining space with yellow, scatter some red and blue dots at random, and you will have an impression of spring which will send the initiated into ecstasy . . . When it comes to the human figure . . . the artist's aim is no longer to render form, modelling or expression; it is sufficient to render the *impression* without a definite line,

without colour, without shadow or light. In order to put such a farfetched theory into execution, the practitioners fall into a senseless, mad, grotesque mess, fortunately without precedent in the history of art . . . A child's scrawls have a naïveté and a sincerity that makes you smile, but the excesses of this school are nauseating and revolting.

Jules Castagnary was one of the few whose criticism was not totally destructive. Writing of the way in which the Impressionists' progress had been effectively barred by the Salon, he described how it 'has for four or five years accumulated stupidities, piled up abuses of power, and compromised itself so extensively that today there is not a single person in France daring to speak in its favour'. This was, of course, a gross exaggeration: the Salon was still the unquestioned showplace of French art, and in this year attracted close to 400,000 visitors; about 3500 attended the Impressionist exhibition, many of them lured by the humorous articles of Leroy and others, for no reason other than to laugh at the paintings.

Castagnary was more precise in his prediction of impending change within the Impressionist movement:

Within a few years the artists who have today grouped themselves in the Boulevard des Capucines will be divided. The strongest among them will have recognized that while there are subjects which lend themselves to the rapid 'impression', to the appearance of a sketch, there are others and in much greater numbers that demand a more precise impression . . . Those painters who, continuing this course, will have perfected their draftsmanship, will abandon *Impressionism* as an art already too superficial for them.

The exhibition closed on 15 May. As might have been expected in the climate of derision, few paintings were sold and the 10 per cent commission on them with the admission fees and paid-up share capital of the *Société* was insufficient to allow its continued existence as a commercial enterprise. Before the year ended the company's affairs were wound up.

Meanwhile, the artists themselves dispersed to various places: Cézanne to his home town of Aix, Sisley to London, Pissarro briefly to Pontoise and then, again in dire financial difficulties, to his friend Ludovic Piette in Montfoucault in Brittany. He must have been deeply depressed. His nine-year-old daughter Jeanne had died of scarlet fever just before the exhibition, public opinion was positively against his work and he had virtually no income. His fourth child, Félix, was born at Pontoise on 24 July. Cézanne wrote in an attempt to cheer him up: 'I understand all the troubles you are going through. You really have not had a chance.' Armand Guillaumin, a somewhat younger fellow artist, assured him 'it will not be long until you occupy the place you deserve'. Théodore Duret summed up his situation, although he could have been writing about any of the Impressionists:

You have succeeded after quite a long time in acquiring a public of select and tasteful art lovers, but they are not the rich patrons who pay big prices. In this small world, you will find buyers in the 300, 400, and 600 franc class. I am afraid that before getting to where you will readily sell for 1500 and 2000, you will need to wait many years. Corot had to reach 75 to have his pictures get beyond the 1000 franc mark . . . The public does not like, does not understand good paintings; the medal goes to Gérôme, Corot is left behind. People who understand it and who brave the ridicule and disdain are few, and very few of them are millionaires. Which doesn't mean that you should be discouraged. Everything is achieved in the end, even fame and fortune, and while counting on the judgement of connoisseurs you compensate yourself for the neglect of the stupid.

Monet and Renoir, with Manet, returned to Argenteuil; it was there that Manet took up Berthe Morisot's advice to paint out of doors, while Monet, following Daubigny's example, built a houseboat from which he could paint. His financial circumstances continued to be as precarious as Pissarro's. Apart from those painters, such as Cézanne, Degas and Manet, who had independent incomes, only Renoir was genuinely able to support himself from his work – especially his portrait commissions; he was also more lighthearted and less prone to the periods of depression experienced by Pissarro and Monet. Back in his student days, Gleyre had told him, 'One does not paint for amusement.' 'But,' Renoir answered, 'if it didn't amuse me, I wouldn't paint.'

In order to raise money it was decided to hold an auction of paintings at the Hôtel Drouot. The year before, Daubigny had sold a number of works at such an auction and had achieved good prices. The sale took place on 24 March 1875 and included 73 Impressionist paintings. It was a total fiasco. As in the first exhibition, many visitors attended with the sole object of ridiculing the participants. The auctioneer was interrupted so often by hecklers that the police had to be called to maintain order. Gygès, a critic writing in the Paris-Journal, remarked: 'We had good fun with the purple landscapes, red flowers, black rivers, yellow and green women and blue children which the pontiffs of the new school presented to the admiration of the public.' Certainly, no new collectors were gained as a result of this event and the prices paid were pitifully low, Monet even having to buy back seven of his own pictures. Although he did not make any purchases at this ill-fated auction, one of the small group of loyal supporters and collectors was Victor Chocquet, a customs officer described by Renoir as 'a delightfully crazy creature who starved himself to buy pictures he liked'. He actually met Renoir at the Hôtel Drouot sale, and subsequently invited him to paint portraits of himself and Mme Chocquet, seated in front of their treasured Delacroix watercolours. Renoir in turn introduced him to Monet and Cézanne. Chocquet was to become the most vociferous supporter of Cézanne, and 'a kind of apostle' of the Impressionists, as Duret described him.

But the interest shown by Chocquet and a few other collectors was inadequate to enable the Impressionists to earn anything approaching a living from their paintings. In 1875 Monet was so desperately poor that he begged Manet for a 20franc loan, and offered 25 paintings to a collector for a total of 500 francs.

Despite the lack of success of the first exhibition, in 1876 it was agreed that a second should be organized. Several of the peripheral exhibitors in the first show withdrew. Manet, who never exhibited with the Impressionists anyway, also suffered the ignominy of rejection from the Salon in this year, and organized a private one-man exhibition, still a relatively rare event, which attracted many visitors.

The second Impressionist exhibition, held in the Durand-Ruel galleries, opened in April and included 252 works by 20 artists. Monet actually succeeded in selling a painting for 2000 francs. Other Impressionists who were well represented included Degas, Morisot, Pissarro, Renoir and Sisley. The response of the public and press was as disappointing as ever. One critic, Albert Wolff, it was reported, went so far as to demand his entrance fee refunded, and described the show in *Le Figaro* as the work of

five or six lunatics . . . a group of unfortunate creatures stricken with the mania of ambition . . . every year they return, before the Salon opens, with their ignominious oils and watercolours to make a protest against the magnificent French school which has been so rich in great artists . . . I know some of these troublesome Impressionists; they are charming, deeply committed young people, who seriously imagine that they have found their path. This spectacle is distressing.

Press comment appeared for the first time not only in France but in the United States from the pen of Henry James, in a Russian journal to which Zola contributed, and in Sweden in a piece written by August Strindberg. At the same time, Stéphane Mallarmé (1842–98), better known later as a Symbolist writer, but already a friend and outspoken supporter of Monet, became one of the first to attempt to analyse and explain the significance of Impressionism:

As no artist has on his palette a transparent and neutral colour answering to open air, the desired effect can only be obtained by lightness or heaviness of touch, or by the regulation of tone. Now Manet and his school use simple colour, fresh, or lightly laid on, and their results appear to have been attained at the first stroke, that the ever-present light blends with and vivifies all things. As to the details of the picture, nothing should be absolutely fixed in order that we may feel that the bright gleam which lights the picture, or the diaphanous shadow which veils it, are only seen in passing, and just when the spectator beholds the represented subject, which being composed of a harmony of reflected and ever-changing lights, cannot be supposed always to look the same, but palpitates with movement, light, and life . . . That which I preserve through the power of Impressionism is not the material portion which already exists, superior to any mere representation of it, but the delight of having recreated nature touch by touch. I leave the massive and tangible solidity to its fitter exponent, sculpture. I content myself with the reflecting on the clear and desirable mirror of painting, that which perpetually lives yet dies every moment, which only exists by the will of Idea, yet constitutes in my domain the only authentic and certain merit of nature – the Aspect.

Another important proponent of Impressionism in this period was Edmond Duranty (1833–80), who appears in Fantin-Latour's *Homage to Delacroix* (page 64) and whose book, *La nouvelle peinture*, published in 1876, was particularly praising of Degas, 'an artist of unusual intelligence... the inventor of social chiaroscuro', as he described him. Referring to Impressionism as 'a new branch on the old trunk of art', he remarked on the consummate ability of the Impressionists to depict the effects of light in their paintings:

From intuition to intuition, they have succeeded little by little in splitting up sunlight into its beams, its elements, and in recomposing its unity by means of the general harmony of the colours of the spectrum which they spread on their canvases. From the point of view of delicacy of eye, of subtle penetration of the art of colour, it is an utterly extraordinary result. The most erudite physicist could not quarrel with their analysis of light.

In 1876, Sisley, working in Marly, painted scenes of the widespread flooding which had occurred there, as in his The Flood at Port-Marly (page 130). Pissarro, back in Pontoise, painted a number of fine landscapes and some portraits. Monet stayed with the collector, Ernest Hoschedé, in his home at Montgeron and sold several landscapes to him. He then went to Paris where he met the American painter John Singer Sargent (1856-1925), who came under the influence of the Impressionist style. Monet also began work on a number of paintings of the Paris railway stations, of which Gare Saint-Lazare (page 96) is an example. The atmospheric effects produced by the sunlight flooding through the glass roof, the smoke and steam of the locomotives, and the crowds of people presented Monet with an unusual motif and a varied range of artistic possibilities. Although virtually penniless at the time, he wore his best suit and was mistaken by the superintendent of the station for an eminent Salon painter and granted every facility: trains were halted, platforms swept and boilers stoked to produce billows of steam. Increasingly it became Monet's practice to return to the same theme so that he could capture his 'impression' of the subject under different lighting conditions - thus he was to produce series images of Rouen Cathedral, the Thames, poplars, haystacks and waterlilies.

Paris continued to be the focus of Degas' work – the bustling cafés, theatres and other places of entertainment offered an array of subjects that ideally suited his temperament. He emphasized the difference between himself and the Impressionists by remarking, 'You need natural life, I, artificial life.' He was also more concerned with draftsmanship, which he saw as 'a more fruitful field than that of colour. But they wouldn't listen to me, and have gone the other way.' He believed too that painting from memory positively enhanced the result, since it thereby became tinged with the artist's imagination. However, in his constant striving for perfection, Degas found it almost impossible to part with a painting, preferring to keep it and continually rework details.

Renoir turned his attention to paintings in which he attempted to resolve the artistic problems posed by the effect of light filtering through the leaves and branches of trees, as in such works as The Moulin de La Galette (page 106) and The Swing (page 110), both of which were greatly admired and bought by Gustave Caillebotte, a wealthy collector and amateur painter who himself showed works at the second exhibition. Caillebotte also wrote his will at this time, appointing Renoir as his executor and bequeathing his art collection to the Louvre. He named Degas, Monet, Pissarro, Renoir, Cézanne, Sisley and Morisot as artists whose collective exhibition he wished to finance in 1878, but his gloomy prediction of his own death was not fulfilled and he was therefore able to involve himself in the organization of the exhibition he had planned somewhat earlier, in 1877. This therefore became the third Impressionist exhibition, and the first at which the title 'Impressionist' was used - although contrary to Degas' wishes. It was held near Durand-Ruel's galleries, in a rented apartment. Victor Chocquet spent most of the show defending the exhibitors' work against the verbal attacks of critics, who were especially vehement in their denigration of Cézanne. There were more visitors than previously, but the prices attained at a subsequent auction were as low as ever.

At about this time several new members joined the Impressionist group, among them Mary Cassatt (1845–1926), the daughter of an American banker, and an admirer of Degas, who was responsible for introducing her to the circle. Widely travelled, she studied art under several teachers in Italy and France, but in her early career was so opposed by her father that she was compelled to submit her paintings to the Salon under her first and middle names, Mary Stevenson. When Degas urged her to disregard the Salon, as she told her biographer

I accepted with joy. Now I could work with absolute independence without considering the opinion of a jury. I had already recognized who were my true masters. I admired Manet, Courbet and Degas. I took leave of conventional art. I began to live.

Another newcomer was Paul Gauguin, godson of Gustave Arosa, who was one of Pissarro's patrons and a collector of Impressionist paintings. Pissarro gave instruction to Gauguin, who was then working for a bank, but it was Cézanne's later influence that was most formative.

At the beginning of 1878, Monet was, as ever, in the direst poverty. He was able through loans to settle his most pressing debts, but still wrote to Zola

Can you help me? We haven't a single *sou* in the house, not even anything to keep the pot boiling today. On top of this my wife is ailing and needs care, for as you probably know, she has given birth to a splendid boy. Could you lend me two or three *louis* [1 *louis* = 20 francs], or even only one?

His state was scarcely relieved when in 1878, following his bankruptcy, the Impressionist paintings acquired by Hoschedé were sold at auction. Works by Monet, Manet, Renoir, Pissarro and Sisley went for disastrously low prices, further depressing the market for their paintings.

The same year, Théodore Duret published *The Impressionist Painters*, a pamphlet in which he described the work of Monet, Sisley, Pissarro, Renoir and Morisot, who he regarded as the leading figures in the Impressionist movement. He pointed out that influential critics such as Zola and Duranty had praised their paintings, and that shrewd collectors such as Chocquet had been buying them.

One day, he foresaw, their work would be widely appreciated: 'We will never alter our original opinion. But you people have made a mistake, and you *will* alter yours!'

This change of attitude was not going to come about overnight, however, and in the meantime several of the Impressionists faced continued financial hardship. The pastrycook, Eugène Murer, later an enthusiastic amateur painter, acquired a sizeable collection of Impressionist works in exchange for meals. Pissarro became thoroughly despondent about his circumstances, and was on the verge of renouncing painting. Sisley and even Cézanne faced similar problems. Cézanne's allowance had been halved when his father discovered that Paul, although he was then aged 40, had a mistress and a son. Renoir tried to alleviate his predicament by sending a fairly conventional portrait to the 1878 Salon, justifying his action by explaining:

There are in Paris scarcely fifteen art-lovers capable of liking a painting without Salon approval. There are 80,000 who won't buy an inch of canvas if the painting is not in the Salon . . . my submitting to the Salon is entirely a business matter. Besides, it is like certain medicines; if it doesn't do any good, it doesn't do any harm.

Through his decision to 'submit to the Salon' again in 1879, along with Sisley and Cézanne, whose works were not accepted, Renoir did not take part in the 1879 Impressionist exhibition, though the contentious term 'Impressionist' was dropped that year. Berthe Morisot, then pregnant, also did not enter anything, but her place was taken by Mary Cassatt, and, at Pissarro's suggestion, Paul Gauguin also exhibited. The show was unusually well attended, but came in for the customary range of insulting criticism. The paintings he saw there had such an effect on one young visitor, Georges Seurat, that he promptly gave up his studies at the Ecole des Beaux-Arts to set up a studio with a group of friends.

In writing of the Salon in the same year, the author Joris-Karl Huysmans referred to its antithesis, Impressionism, as producing 'an astonishingly just vision of colour; a disregard for conventions adopted centuries ago to reproduce this or that light effect; work in the open and search for true tonalities; movement of life; large brush-strokes; shadows established with complementaries; preoccupation with the whole rendered through simple means'.

The last year of the decade was marked by two personal tragedies: the deaths in 1879 of Monet's wife Camille, and Renoir's favourite model, Margot. The first four of their eight exhibitions had been held, but only slowly were they gaining any ground among critics and collectors. Generally, prices were still inadequate for any members of the group to earn more than a subsistence living from their work. Already, before the original members had firmly established their artistic principles, a new generation of painters, such as Paul Gauguin, was emerging, and as the 1880s began new challenges to Impressionism were beginning to be heard.

Chapter five

IMPRESSIONISM COMES OF AGE

The fifth Impressionist exhibition, held in 1880, was less representative than any of the previous ones: Renoir, Sisley, Cézanne and Monet were all entering works for the Salon, and opted out. Of the original group, Morisot, Degas and Pissarro exhibited, and newcomers Cassatt and Gauguin were included. Paul Signac (1863–1935), who was later associated with the Impressionists, visited the show and was evicted by Gauguin who caught him in the act of copying a picture by Degas. A one-man show of Monet's works was held at the same time at the offices of the magazine, *La Vie Moderne*.

The following year the sixth show was held, and Huysmans confidently reported that Impressionism had 'arrived', that 'the new formula quested for so long a time' was at last 'fully realized'. He went on:

One fact is dominant, the blossoming of Impressionist art which has reached maturity with M. Pissarro. As I have said many times, until the present the retina of the painter devoted to impressions had been overstrained. Although it did capture all the variations of colour of bright light, it could not express them . . . we almost abandoned hope. In other words, pure Impressionist art was heretofore stammering, but suddenly, miraculously, it has started to speak and does so quite coherently. Also, two artists who previously hesitated to walk on their own . . . now advance resolutely, Mlle Cassatt and M. Gauguin.

In this year, a change in the administration of the Salon jury resulted in Manet's being awarded a medal. There was another encouraging sign when, during a brief period of economic revival, Durand-Ruel made a number of purchases of canvases by Sisley, Monet, Pissarro and Renoir – although this minor boom was followed by a slump in 1882. However, Renoir was now the first Impressionist to achieve genuine financial success. His Salon success of 1879 (a portrait of the wife and children of the publisher Georges Charpentier) was followed by further lucrative portrait commissions and Salon acceptances. He took advantage of this relative wealth to travel to Algeria, and, after his marriage in 1881 to Aline Charigot, who he featured in his *Luncheon of the Boating Party* (page 114), he travelled to Italy, where he greatly admired the frescoes of Raphael and the Roman wall-paintings.

The seventh Impressionist exhibition, in 1882, was perhaps the most representative, featuring the work of Renoir, Pissarro, Monet, Sisley, Morisot and Gauguin, as well as Armand Guillaumin, who had been a regular contributor to the Impressionist exhibitions, but remained a peripheral figure in the movement. Degas, who had exhibited at the six previous shows, perversely demanded the admission of Jean François Raffaëlli, an artist with whom none of the others had any sympathy. Under threat of resignation by various members if he were included, it was decided that it would be more expedient to exclude Degas, who in withdrawing took with him his protégée, Mary Cassatt. This exhibition was probably attended by Signac and Seurat, two leaders of the emerging generation of artists to be influenced by Impressionism.

Remarkably, Cézanne succeeded in getting a painting accepted by the Salon through the so-called 'charity' system whereby each jury member could select a single work without opposition. Thus his friend, the jury-member Antoine Guillemet, facilitated what years of determination had not achieved - exhibition at the Salon. The irony was that not a single critic considered his painting worth mentioning. At the same Salon exhibition, Manet's celebrated Bar at the Folies-Bergère (page 62) was shown, and shortly afterwards he was made a Chevalier of the Légion d'Honneur. He wrote to a critic who had passed on to him the greetings of Count Nieuwerkerke, the Superintendent of the Académie, 'When you write to Nieuwerkerke, you may tell him that I appreciate the kind thought. but that he might have conferred the decoration. He could have made my fortune; and now it is too late to compensate for twenty years' lack of success.' It was indeed too late; already ill with locomotor ataxia, Manet died the following year. Jokingly, he had once written to Albert Wolff, 'I shouldn't mind reading, while I'm still alive, the splendid article you will write about me once I am dead.' In fact, the article Wolff wrote at the time of the subsequent sale of Manet's paintings would not have pleased him. He described the sale as 'one of the most charming follies of our times', mainly because a group of loyal collectors paid relatively high prices for both Manet's own work and the works of his friends which he had acquired during his lifetime.

In 1882–3, Durand-Ruel showed a range of Impressionist works in London, where they were generally criticized for being 'unfinished'. The Pre-Raphaelite painter William Holman Hunt felt it necessary to 'warn the world that the threat to modern art, meaning nothing less than its extinction, is Impressionism'.

Lack of sales at this show, and in general, contributed to a climate of pronounced depression and self-doubt among the Impressionists. The senior members of the movement were now in their forties and still failing to achieve the critical acclaim or increased prices that seemed concomitant with two decades of determined effort. They began individually to seek new directions and to reappraise their own stylistic evolution. Renoir returned to the meticulous, classical and decorative style of his predecessors in such paintings as The Umbrellas (page 118). As he later told art dealer Ambroise Vollard, 'Towards 1883 there occurred what seemed to be a break in my work. I had travelled as far as Impressionism could take me and I realized the fact that I could neither paint nor draw. In a word, I had reached an impasse.' In the succeeding decade his paintings, especially his nudes and portraits, took on a highly disciplined sculptural quality, influenced by Ingres, his recent studies of Raphael and Florentine painters, and his deliberate shaking off of the limitations it seemed he had imposed on himself. 'I could only really be myself, once I had got rid of Impressionism and gone back to studying in museums."

Monet, searching for fresh scenes to paint, moved in 1883 to Giverny, between Paris and Rouen, with the wife of his former patron, Hoschedé, whom he later married.

Gauguin, following the crash of the bank for which he worked, turned to painting as a full-time occupation and moved to Copenhagen with his Danish wife and children, but his work went unnoticed there. Writing to a friend he remarked, 'The young people who come after us will be more radical and you'll see that in ten years we will appear to have been extreme only for our own period.'

One of the 'young people' to whom he might have been referring was Georges Seurat (1859–91). A former student at the Ecole des Beaux-Arts, he admired and was influenced by both Ingres and Delacroix, and produced an enormous range of pencil drawings described by his friend Signac as 'the most beautiful drawings by a painter in existence'. He also made extensive studies of the colour theories of the American physicist O.N. Rood and Eugène Chevreul who, remarkably, was still alive; at the time of his hundredth birthday in 1886, there was widespread publicity and revived interest in his pioneering researches. Believing Impressionism had reached a dead end, Seurat proposed 'reconstructing' it by merging art and science to a greater degree than any of the Impressionists had ever considered. Seurat accordingly restricted his palette to four colours and their intermediaries, and white, but applied them in pure, unmixed form. A portrait by him was shown at the 1883 Salon, but his other works were rejected. His Bathers, Asnières (page 184), painted at this time, was refused by the 1884 Salon but shown by the Société des Indépendants, a new organization of which he was one of the founders, with Paul Signac and others. Bathers was in many respects an Impressionist painting, but his Sunday Afternoon on the Island of La Grande Jatte (page 187), which he finished in 1885, was, in his terminology, 'divisionist' - employing in a highly refined form the principle of optical mixture, whereby tiny spots of colour are juxtaposed, but appear as a single colour to the viewer. The term 'pointillist' came to be more commonly used to describe this style of painting, although the art critic Félix Fénéon invented the term 'Neo-Impressionism' in 1886 in a pamphlet, The Impressionists, in which he declared that Impressionism had been superseded by Seurat's new technique. Seurat met Pissarro who, ever eager to improve his style by applying valid new techniques, assimilated Seurat's colour 'laws' completely. His almost overnight change of technique astonished Pissarro's dealer, Durand-Ruel, and he was compelled to justify this dramatic shift by explaining that he desired

to seek a modern synthesis by methods based on science, that is, based on the theory of colours developed by Chevreul, on the experiments of Maxwell and the measurements of O.N. Rood; to substitute optical mixture for the mixture of pigments, which means to decompose tones into their constituent elements, because optical mixture stirs up luminosities more intense than those created by mixed pigments.

Pissarro entirely acknowledged his debt in this transition to Seurat, whom he described as 'an artist of great merit, who was the first to conceive the idea and to apply the scientific theory after having made thorough studies. I have merely followed his lead.' Pissarro's sudden switch from the spontaneous style of Impressionism, of which he had been the principal exponent, to the 'scientific Impressionism' of Seurat which demanded detailed preparation and preliminary sketches, followed by laborious studio work in applying the multitude of dots of paint, marks a further major break in the evolution of Impressionism. This shift is particularly evident in the contrast between Pissarro's 'scientific Impressionism' and the 'romantic Impressionism' of Monet, evocatively described in action in 1885 by Guy de Maupassant:

I often followed Claude Monet in his search of impressions. He was no longer a painter, in truth, but a hunter. He proceeded, followed by children who carried his canvases, five or six canvases representing the same subject at different times of the day and with different effects. He took them up and put them aside in turn, according to the changes in the sky. Before his subject, the painter lay in wait for sun and shadows, capturing in a few brush strokes the ray that fell or the cloud that passed . . . I have seen him thus seize a glittering shower of light on the white cliff and fix it in a flood of yellow tones which, strangely, rendered the surprising and fugitive effect of that unseizable and dazzling brilliance.

While the Impressionists, and now the Neo-Impressionists led by Seurat, sought new directions, the old problem of sales dogged them: Gauguin returned to Paris and had to take temporary employment as a bill-poster. Durand-Ruel's business was in difficulties and Mary Cassatt had to loan him money to keep it afloat. More importantly, she acted as the major proponent of Impressionism in her homeland, and encouraged wealthy American collectors such as Havermeyer to buy their paintings. An attempt was made to launch an eighth Impressionist exhibition, but Pissarro, through his insistence on the inclusion of Seurat and Signac, alienated Monet, Sisley and Renoir, who withdrew. As a result, Pissarro and his son Lucien (1863–1944) who, to their mother's dismay, with his four brothers took up painting, and those artists with whom he was now firmly allied, had their works exhibited in a separate room.

Meanwhile, Durand-Ruel was organizing an exhibition of 300 paintings by the Impressionists and their immediate precursors in the United States. Degas' nudes attracted a great deal of controversy, especially for their supposedly erotic content. Since they were clearly contemporary depictions of women engaged in activities such as bathing, as in *The Tub* (page 83), although they might display as much naked flesh as a classically painted nude, they were regarded as obscene. The greatest attention and criticism was, however, focused on Seurat's *Grande Jatte*. On the whole, the show was surprisingly well received, a writer in *The Critic* even announcing that 'New York has never seen a more interesting exhibition than this'.

Fénéon summarized the distinctions between the various exponents:

During the heroic period of Impressionism, the crowds always saw Edouard Manet in the first line \ldots yet in reality the mutation which transformed the bituminous author of *Le Bon Bock* into a painter of light \ldots was accomplished under the influence of Camille Pissarro, of Degas, of Renoir, and above all of Claude Monet; they were the heads of the revolution of which he became the herald.

But despite the inauguration of 'Impressionist dinners', few of these leaders and their original associates now met frequently. Cézanne inherited his father's estate in Aix and became almost a recluse, while Gauguin settled in Pont-Aven, Brittany. In February 1886, Vincent Van Gogh moved to Paris where his brother, Theo, worked as an art dealer. By this time, the Impressionists had become so much a part of the Parisian art milieu that he remarked, 'It is as necessary now to spend time regularly with the Impressionists as it used to be to study in a Paris studio.' There he met Pissarro, adopting his use of bright colours and even falling under the influence of his newly adopted Neo-Impressionist style for a short time.

Finally, in this period, Henri de Toulouse-Lautrec (1864–1901), an art student in Paris from 1882 and an associate of Van Gogh, began producing those scenes of Parisian life for which he is justly famous.

By 1886, the entire face of Impressionism had changed. Manet was dead; Pissarro, Renoir and Monet had all modified their styles; Seurat and the Neo-Impressionists had entered the scene, as had Gauguin and Van Gogh who, together with Cézanne, were to lead the Impressionist movement into the phase of its development which is today loosely described as 'Post-Impressionism'.

As Huysmans had observed, Impressionism had 'arrived'. There could be no denying its significance, now ranked by young artists such as Van Gogh as greater than that of the traditional studios in the training of a would-be painter. The techniques of Impressionism were beginning to spill over into the art world, affecting not only established notions about painting but literature and music as well, which began to apply similar ideas to provide a 'fleeting impression' of a scene. The small nucleus of collectors expanded progressively as it was realized, as had been predicted, that Impressionism had something important to offer; it was not just a passing fad, and although the derision of the critics never completely died away, it became drowned out by the praise of others, or transferred to the new artistic 'threats' from Post-Impressionism.

Chapter six

POST-IMPRESSIONISM

The term 'Neo-Impressionism' had been applied by Fénéon when the artists whose work he was describing were actually working in this style; it was, moreover, easily identifiable. 'Post-Impressionism', on the other hand, was not invented until 1910 - by the art critic Roger Fry, at the time of an exhibition in London - by which time the three artists regarded as its leading exponents -Cézanne, Gauguin and Van Gogh - were dead, while surviving artists who had followed them stylistically were called Fauves or Cubists. To add to the confusion, Seurat and the Neo-Impressionists, in reacting against Impressionism, to some stand as Post-Impressionists. Also, the principal Impressionists themselves - Degas, Monet, Renoir and Pissarro - all underwent such changes in the 1880s that it is fair to say that by 1886 the history of Impressionism was over, and that in living beyond then and into the twentieth century they too can be grouped with the Post-Impressionists. The only point of agreement in applying this much misused term is that it applies to paintings produced as a reaction against, or within Impressionism itself - whether by the original Impressionists or by succeeding artists - and spans the period between about 1885 and 1905. What Fry himself called 'a somewhat negative label' presents confusion, because unlike Impressionism, which had some sense of group identity, Post-Impressionism suggests the grouping together of a wide range of individualists, who in reality often worked in isolation.

The Impressionists had come together in response to a particular set of circumstances, and had only historical antecedents and contemporary painters from whom to derive their influences. In so doing they released art from the grip of historical example and offered their successors their own experience to use, adapt or oppose as they thought fit, and in most cases the response was manifested as a highly personal expression.

The question of why the Impressionist example was inadequate has many answers, some of which the Impressionists themselves provided and accordingly sought new directions; others were supplied in different ways by the Post-Impressionists. An overriding problem was the built-in limitation of painting out of doors. If the scene had to be recorded quickly, the degree of finish and even the size of the canvas were bound to be restricted. Also, it was questioned whether there was any scope for intellect or imagination, social comment or feeling in these landscapes or portraits which might have been achieved with greater accuracy with a camera, and, by the late 1880s, the snapshot camera placed this technique within the reach of all.

As early as 1880, Zola, although a supporter of Impressionism, had accused his friends of sketchiness, informality of composition and lack of serious content or attempt to express themselves or any social message through their work. Gradually Renoir had returned to more formal compositions and completed his

outdoor studies in the studio. Similarly, Monet began to add unifying areas of colour to his paintings to achieve greater harmony, and even Pissarro used the studio to contemplate and coordinate his compositions. The techniques they had evolved underwent re-examination, and out of the multitude of questions posed by Impressionism came answers from themselves and from the Post-Impressionists, answers that were to lead ultimately to the Fauves (led by Matisse and Derain) and the Cubists (by Picasso and Braque).

Cézanne had been in the Impressionist circle from the 1860s, but differed from them in his obsessive concern with structure and composition, an attempt to 'render perspective by colour alone', to represent three dimensions on a surface that in reality has only two, and 'to paint nature in cylinders, spheres, cones, all in perspective . . . for us humans, nature consists more in depth than in surface'. This geometrical representation of nature appealed particularly to the Cubists, while his understanding of colour and form was a strong influence on the Fauves. His often-quoted remark, 'when colour has its greatest richness, form has its plenitude', summarized his ideal, and differs from the Impressionist concern with the surface of the subject.

Cézanne's later life, in which his aims were most successfully realized through often laborious processes – portrait sittings of over a hundred sessions which were then abandoned, contrasting sharply with Monet's fifteen-minute impressions - was largely reclusive. In 1886, Zola published a novel, L'Oeuvre, which presented the central character, Charles Lantier, as an unsuccessful artist. Cézanne assumed this to be a slighting reference to himself, and broke off his relationship with Zola. In the same year, his father left him two million francs and he was able to devote the remainder of his life to painting without financial worry. He spent 1888 in Paris where he met Gauguin and Van Gogh, but returned to Aix which he seldom left until his death in 1906. There, like Monet, he completed numerous variations on the same theme, such as his Card Players (page 143) and Bathers (page 146). Works shown by Vollard in 1895 excited much public and press outrage, but the tide was steadily turning in his favour as more collectors and critics began to appreciate the qualities of his paintings. When the Chocquet collection was sold in 1899, his works attained high prices, and displays of his work at the Salon d'Automne in the last three years of his life established the esteem with which he has been held ever since – some authorities regarding him as the greatest painter of the last hundred years.

Paul Gauguin had been one of the first artists from outside the Impressionist circle to be strongly influenced by them. Born in Paris in 1848, he lived in Peru for a time, returned to France and became a sailor, and then a banker and stockbroker, and amateur painter. After he met Pissarro in 1875, he devoted more and more time to painting, in 1883 renouncing his business career to become a full-time artist. When he was wealthy he acquired paintings by Monet, Renoir and Cézanne, and learned much from Pissarro whom he regarded as his master. He also met and admired the work of Degas. He showed at the Impressionist exhibitions of 1880, 1881, 1882 and 1886, in the final year going to Pont-Aven, Brittany, where he met Emile Bernard (1868–1941); together they were credited with the invention of 'pictorial symbolism'.

Gauguin was already opposed to the naturalism of the Impressionists, remarking that art 'should not be concerned with the sensations of the eye, but should evoke the inner life of man in the mysterious centre of the mind'. This antinaturalistic approach, or 'synthetism', reflected his knowledge of non-Western art forms (primitive sculpture, Japanese and other Far- and Near-Eastern art). He attempted to portray ideas, moods and emotions in pictures which were in fact decorative syntheses of the notions from which they were derived. Notable for their simplified forms, flat areas of colour, lack of shadow and abstract design and colour, the synthetist works of Gauguin were developed during his second stay in Brittany, and then in Arles in the company of Van Gogh, who was similarly fascinated by the art of the Japanese print.

In 1888 Gauguin painted his celebrated Vision after the Sermon (page 162), which marked his break with the Impressionists, and diversified into a range of media, including murals, sculpture, ceramics and engraving. In 1891 he raised a small amount of money by selling all his paintings at auction, and travelled to Tahiti. His funds soon ran out, and he returned to France where he received an inheritance which he rapidly spent. Some of his Tahitian paintings were exhibited by Durand-Ruel, and, although they were a failure financially, greatly affected Pierre Bonnard and his associates. He returned to Tahiti in 1895, painting such masterpieces as Where do we come from? Who are we? Where are we going? (page 168) and 'Nevermore' (page 173). After a series of financial and other problems, an abortive suicide attempt and protracted illness, Gauguin travelled to Dominica where he died in 1903.

In Tahiti Gauguin had sought escape from what he regarded as the evil effects of civilization, and especially its influence on art, once commenting, 'primitive art proceeds from the spirit, and nature is its servant. So-called civilized art proceeds from sensuality and serves nature,' and on another occasion, 'barbarism is for me rejuvenation'. In 1888 he had told the painter Émile Schuffenecker, 'What does it matter if I am different from other people? Most will be completely baffled; a few will think I am a poet, but sooner or later I shall be appreciated.' He was appreciated by many who read his reflections on a wide range of topics – art, religion, philosophy – expounded in his essay, *Noa-Noa*, published in the *Revue Blanche* in 1897, and particularly by those artists such as Matisse and the Fauves who derived from his art the basis of their own. Despite reservations in respect of his technical inadequacies, few art historians deny Gauguin his rightful place as a great originator and a seminal influence on the evolution of modern art.

The characteristic work of Vincent Van Gogh is, through vast quantities of reproductions, perhaps the best known of all artists associated with the Impressionists. The dramatic events of his life have also made his the most memorable personality of all late nineteenth-century artists. In early life he worked for a picture dealer, as a teacher in England and as an evangelist among poor miners before taking up painting in his native Holland and in Belgium, afterwards living with his brother, Theo, in Paris from 1886-8. Falling under the spell of the Impressionists, who were all known to Theo, and especially influenced by Gauguin and Japanese prints, he began his five-year working life as though aware that his days were numbered: in 20 months in Paris he produced 200 paintings, maintaining this prodigious output until his death. On the advice of Toulouse-Lautrec he left Paris to seek the bright sunlight of Arles in Provence, painting the same countryside as Cézanne, but adding to it his own tormented interpretation in which paint was dashed onto the canvas in convoluted swirls, going far beyond the Impressionists in his violent and expressive use of line and colour. He wrote to his brother:

What I learned in Paris is leaving me and I am returning to the ideas I had before I knew the Impressionists. And I should not be surprised if the Impressionists soon find fault with my way of working, for it has been fertilized by the ideas of Delacroix rather than by theirs. Because, instead of trying to reproduce exactly what I have before my eyes, I use colour more arbitrarily so as to express myself forcibly.

As is well known, Van Gogh's violence came out not only on canvas but in his personal life. On Christmas Eve 1888, following an argument with Gauguin, he cut off his own ear. Subsequent months were spent in an asylum at Auvers-sur-Oise in the care of Dr Gachet, whose portrait he painted (page 155), and where in June 1890 he painted *The Church at Auvers-sur-Oise* (page 158). The following month he shot himself in the chest with a revolver, and died two days later at the age of 37.

Toulouse-Lautrec's early naturalism was succeeded in the late 1880s by a loose cross-hatching technique derived from Pissarro's pointillism of the years 1882–5, but in his subject matter Lautrec had much in common with the realist Degas. Both artists ignored the landscape topics so dear to the Impressionists and concentrated on depicting contemporary society, the low life, the theatres, the music halls and the cafés. They both came from privileged backgrounds, Toulouse-Lautrec even more so than Degas. In Degas' work there is an aloofness which is manifested by a cool and objective approach and a complete detachment from his subject; but Toulouse-Lautrec – alcoholic, syphilitic, crippled and therefore socially undesirable among his social equals – sought refuge amongst the undesirables of society. His paintings of the inhabitants of brothels, of women together in their most intimate moments, of dancers and entertainers, show an understanding which prevents them from becoming sentimental or moralizing. His quick hand captures so succinctly the very essence of the characters before him, and through a hint of tenderness he just avoids producing caricatures.

It was in the early 1890s, and especially in his lithographic work, that we see a mature style developing, characterized by simplification of certain elements in the paintings and strong, flat colours. One of Toulouse-Lautrec's most important legacies must surely be the way he created space and movement by the use of pattern and line alone.

It would be virtually impossible for painters such as Gauguin and Van Gogh and a diverse range of Post-Impressionists in France and elsewhere to have emerged without the liberating background of Impressionism to provide them with the means of expression – free use of colour and brush-stroke, new techniques of composition and above all independence of action removed from the prescribed formulas of the Salon. The Impressionists themselves, from the mid-1880s, and the younger generation of artists both sought new pictorial styles and an altered depth of meaning which in their evolution formed the link between the pioneering aspirations of Impressionism and the developments of modern art.

Chapterseven

THE LAST YEARS

By a curious irony of fate, most of the Impressionists outlived the artists who formed the nucleus of Post-Impressionism. Van Gogh died in 1890, Seurat in 1891, Gauguin in 1903 and Cézanne in 1906.

Berthe Morisot died in 1895. She was highly respected in her later years, and at the exhibition held the year after her death, Mallarmé was to describe her as

a magician whose work, in the opinion of several important artists she was closely associated with in their struggle to get Impressionism recognized, is quite as good as any of theirs. Her delightful work forms an integral part of the art history of the period.

Sisley lived and worked for most of the rest of his life at Moret-sur-Loing, where he concentrated on landscapes, especially river scenes. He never achieved notable success in his lifetime, but after his death in 1899 the prices of his paintings rose sharply and he gained considerable posthumous fame. The rest of the Impressionists were luckier: all lived long enough to see their paintings become widely appreciated and the years of struggle were rewarded by financial success.

Pissarro, the senior member of the Impressionist group, continued working for several years under the spell of Seurat's 'divisionist' technique, stating:

Surely it is clear that we could not pursue our studies of light with much assurance if we did not have as a guide the discoveries of Chevreul and other scientists. I would not have distinguished between local colour and light if science had not given me the hint; the same holds true for complementary colours, contrasting colours, etc.

However, he never completely shook off the Impressionist technique he had pioneered, nor totally adopted the Neo-Impressionist method, realizing as he went on that it 'inhibits me and hinders the development of spontaneity of sensation'. By the end of the decade, he had renounced it, writing to a friend:

I can't stay any longer among the Neo-Impressionists who give up life in favour of a diametrically opposite artistic position. This may suit people who have the right kind of temperament, but it doesn't suit me. I can't bear narrow so-called scientific theorizing. I have made any amount of efforts . . . but I have come to realize how impossible it is to follow my feelings, and in consequence render any sort of motion in paint; how impossible it is to render the lovely fleeting effects of nature, and to put any sort of individuality into my work; so I have had to give the whole thing up.

Returning to his former Impressionist technique, but with a palette comprising lighter colours, he spent his last years painting summer landscapes around Eragny, and scenes in Paris and Rouen, although after 1895 an eye disease compelled him to work indoors: many of his views of Paris were therefore painted from window locations. An exhibition of his work organized by Durand-Ruel in 1892 firmly established his success. It had taken a long time to arrive. As Théodore Duret wrote after Pissarro's death: Pissarro was good natured in character and calm in temperament. Life built up a great fund of philosophy in him. He endured the years of misery and disappointment with serenity, and when success came and he was able to have the good things in life, he changed none of his ways, and never sought the honours, decorations, and recompense which, in the eyes of most artists, appear to be the most precious things to receive.

Three years after Pissarro died, Cézanne, by then famous, entered after his own name in an exhibition catalogue the words 'pupil of Pissarro'.

Degas in later life became preoccupied by two major themes - dancers and nudes presented in informal, unnatural poses and often unflattering 'snapshots' of women bathing or drying themselves, the unusual angles and frame-cropping derived from his knowledge of Japanese prints and photography. These were worked first in oil and then, as his eyesight deteriorated, in pastel. He also turned to wax sculpture. He achieved immense popularity, particularly in the United States. In 1912 Dancers Practising at the Bar, which he had previously sold for 500 francs, was purchased for 435,000 francs – then the highest price ever paid for a work by a living artist. From about this time until his death, according to his dealer, Vollard, he 'spent his days wandering aimlessly around Paris, wearing a bowler hat, green with age, and enfolded in his inseparable Inverness cape. His eyes were getting worse and worse, and he always had to take a policeman's arm when he crossed the street.' His life's work ran parallel to that of the Impressionists. Although he exhibited with them and shared their overall aims, his methods of realizing them were different, and his subjects and results often strikingly at odds with those of his friends. Yet, as his biographer Paul Valéry concluded, 'He dared to attempt combining instantaneous impressions with endless toil in the studio, capturing the fleeting moment by studying it in depth'.

Renoir's chief concern in his last years was the painting of nudes with pink or pearly flesh. He returned to Impressionism inasmuch as he relinquished his outline technique of the 80s. However, he persisted in the use of non-descriptive colours for his compositions, which became predominantly red. His character dictated that his paintings should be primarily exercises in pleasure. 'For me, a picture must be a pleasant thing, joyous and pretty . . . There are too many unpleasant things in life for us to fabricate still more.' His love of life, and of the female form in particular, pervades his last works – even though, crippled by arthritis, he had to paint with brushes tied to his crabbed hands. He forsook the society portraits that had made him well known in favour of paintings of his maid and favourite model, Gabrielle, and portraits of his family, which include many of his second son, Jean, who later achieved fame as a film director.

Portraits of mothers and children were still the main subject matter of Mary Cassatt. She lived in Paris during the First World War and became an ardent suffragette. Like her mentor, Degas, she spent her last years almost completely blind, dying in 1926. Her chief contribution to the Impressionist movement had been the continued promotion of their work in her native country, but she also left an impressive body of work in a variety of media – oils, pastels and etchings – which show her debt to Degas and reflect the same influences of photography and Japanese prints.

Monet died in the same year. Settled in Giverny, he energetically devoted his last years to his own work and to his rôle as the acknowledged leader of the Impressionist cause, pioneering a scheme to buy Manet's *Olympia* (page 52) for the French nation. He witnessed the progressive growth of interest in his work and steadily increasing prices. In the late 1870s, in desperate poverty, he had begged the collector Chocquet to take two paintings for 40 or 50 francs. In 1883 he was getting more than 500 francs for a landscape and in 1889 a painting was sold for 9000 francs. His waterlilies series, a theme to which he returned many times, was averaging 7000 to 9000 francs in 1899. In the same year a painting that had been sold in 1881 for 72 francs made 2550. In recent times, 10 million francs have been paid for paintings by Monet.

Some immediate followers saw, particularly in the last works of Monet and Renoir, the ultimate decadence of the Impressionist masters, then in old age, but Vasily Kandinsky, pioneer of abstract art, regarded one of Monet's haystack pictures which he saw in Russia as presenting 'the unbelievable power unlike anything I had ever known, of a palette that surpassed my wildest dreams'. Just as the Impressionists themselves had built on foundations laid by the previous generation of painters who were still alive in their early years, so they too, after their long struggles and evolving techniques, had much to offer both their young contemporaries and artists of the present century.

Chapter eight

THE IMPRESSIONIST HERITAGE

The escalating prices of Monet's work and that of the other Impressionists, and the great regard in which they are held in this century, are the most obvious signs of the success of Impressionism. This success was slow in coming, and, indeed, by the time it arrived Impressionism in its purest form was almost a phenomenon of the past. There was clearly a time-lag between its introduction and its appreciation, the result in part of the optical realignment demanded by the unfamiliar nature of Impressionist painting. As Gauguin had predicted, the Impressionists appeared revolutionary only in their own time, and once new radical art forms, such as his own, appeared, those paintings which had formerly seemed so shocking to critics now enjoyed their praise. Gauguin went even further when he wrote, Impressionists studied colour exclusively in terms of decorative effect but without freedom, for they kept the shackles of representation . . . They look for what is near the eye, and not at the mysterious heart of thought . . . They are the official painters of tomorrow.' It was this apparent absence of intellectual content that resulted in the concern of the Post-Impressionists to make their art something more than the simple, fleeting depiction of nature, 'to make of Impressionism something solid and durable, like the art of the museums', as Cézanne described it.

As early as 1866, Bazille had emphasized the Impressionist concern with depicting contemporary subjects:

I have tried to paint, as well as I can, the simplest possible subjects. In my opinion the subject matters little provided that what I do is interesting in painting. I have chosen to paint our age because this is what I understand best, because it is more alive and because I am painting for living people. So of course my pictures will be rejected.

Manet's *Déjeuner sur l'Herbe* had been rejected three years earlier precisely because it was a contemporary painting, in style and content, but it also depicted a naked female who should, by the artistic standards of the day, have been painted in classical style in a classical environment. In the same year, Alexandre Cabanel's far more erotic *Birth of Venus*, an avowedly classical subject, was lauded by the critics, who voted it 'picture of the year', while the Emperor Napoleon III, who purchased the painting, elevated the artist to the Legion of Honour.

In their paintings of the contemporary scene, untinged with sentimentality, the Impressionists reacted against the classical and Romantic art of their predecessors, but this was not a prime objective. As Bazille had stated, the subject itself was largely unimportant and subordinate to the purpose of the painting.

In regarding the eye as an impartial measuring instrument, they saw no way in which it could fulfil the additional function of making any sort of judgement on a scene, so in choosing the subjects they did the Impressionists looked for neutral themes containing no social or moral message, and hence implicitly limited in its emotive appeal. As the first generation of artists to fuse science and art, they cannot perhaps be blamed for failing to add yet another revolutionary dimension to an art which was already brimming over with new concepts and techniques, and to have achieved what they did in the face of such opposition is success enough. The Impressionist genius, as was aptly stated, was: 'Only an eye – but what an eye!'

The Impressionists conferred free use of bright primary colours to succeeding generations, and it was this which they bequeathed to their immediate heirs, a diverse range of Impressionist-influenced artists in Europe and America, Post-Impressionists such as Van Gogh, and ultimately Matisse and the Fauves. If the Impressionists had not existed at all, or if, as often seemed likely early on, they had relinquished their fight against poverty and adverse criticism of their attempts, none of these subsequent artists could have made the gigantic leap across the divide between nineteenth-century academic painting and modern art. Their very simplicity, sometimes verging on naïveté, isolates their work from that of their predecessors and, as the following selection of reproductions clearly shows, left us with the greatest heritage of all – their own paintings, and those of the artists whom they influenced. That the Impressionists had certain limitations, which their successors often cruelly expounded, is undeniable. But their testament, to which these paintings bear witness, was one of the most important liberating forces in the history of art.

FURTHER READING

GENERAL WORKS

Bazin, G., Impressionist Paintings in the Louvre, London 1959

Bellony-Rewald, A., The Lost World of the Impressionists, London and Boston 1976

Cogniat, R., and others, A Dictionary of Impressionism, London 1973

Courthion, P., Impressionism, New York 1971; London 1973 Gaunt, W., The Impressionists, London 1970

Pool, P., Impressionism, London and New York 1967

Réalités, The Editors of (Preface by R. Huyghe), Impressionism, London 1977

Rewald, J., The History of Impressionism, New York and London 1973

Rewald, J., Post-Impressionism, New York 1978 (3rd revised edn); London 1979

Roskill, M., Van Gogh, Gauguin and the Impressionist Circle, London 1970

Royal Academy of Arts, Post-Impressionism, London 1979

Sérullaz, M., Phaidon Encyclopedia of Impressionism, Oxford and New York, 1978

MARY CASSATT

Bullard, E., Mary Cassatt: Oils and Pastels, New York 1976 Carson, J., Mary Cassatt, New York 1966

PAUL CÉZANNE

Schapiro, M., *Cézanne*, New York 1952; London 1953 Venturi, L., *Cézanne*, London and New York 1978

EDGAR DEGAS

Dunlop, I., Degas, London 1979

PAUL GAUGUIN

Goldwater, R., Gauguin, London and New York 1957

EDOUARD MANET

Courthion, P., *Manet*, London and New York 1963 Hamilton, G., *Manet and his Critics*, New York 1969

CLAUDE MONET

Cogniat, R., Monet and his World, London and New York 1966 Joyes, C., Monet at Giverny, London 1975; New York 1978 Seitz, W.C., Monet, London and New York 1960

PIERRE AUGUSTE RENOIR

Fosca, F., *Renoir*, London 1969 Gaunt, W., *Renoir*, London 1952 Pach, W., *Renoir*, New York 1950; London 1975

GEORGES SEURAT

Russell, J., Seurat, London and New York 1965

HENRI DE TOULOUSE-LAUTREC

Cooper, D., Toulouse-Lautree, London 1955; New York 1969

VINCENT VAN GOGH

Cabanne, P., Van Gogh, London 1969; New York 1975 Dunlop, I., Van Gogh, London 1974; Chicago 1976 Schapiro, M., Van Gogh, London 1968

THE PAINTINGS

EDOUARD MANET 49 FRÉDÉRIC BAZILLE 63 HENRI FANTIN-LATOUR 64 BERTHE MORISOT 67 HILAIRE-GERMAIN-EDGAR DEGAS 69 MARY CASSATT 86 CLAUDE MONET 87 PIERRE AUGUSTE RENOIR 104 CAMILLE PISSARRO 120 ALFRED SISLEY 127 ARMAND GUILLAUMIN 133 PAUL CÉZANNE 134 VINCENT VAN GOGH 149 PAUL GAUGUIN 160 HENRI DE TOULOUSE-LAUTREC 176 GEORGES-PIERRE SEURAT 184 PAUL SIGNAC 190

ACKNOWLEDGEMENTS

Photographs were supplied by the museums and galleries to which the paintings belong with the exception of the following:-

Cooper Bridgeman Library: pages 3, 59, 99, 112–113, 168–9, 186–7; IGDA: pages 49, 50, 52, 53, 55–58, 60, 61, 63–80, 82–89, 91–98, 100, 101–103, 105–111, 114–116, 118, 119, 121–124, 126–139, 141–144, 146–148, 150–155, 158–161, 163–167, 170–172, 174–185, 188–190.

The paintings reproduced on the following pages are © by SPADEM, Paris, 1980: 3, 69-85, 87-119, 133, 190, front and back jacket; the painting reproduced on page 86 is © by ADAGP, Paris, 1980.

EDOUARD MANET (1832–83)

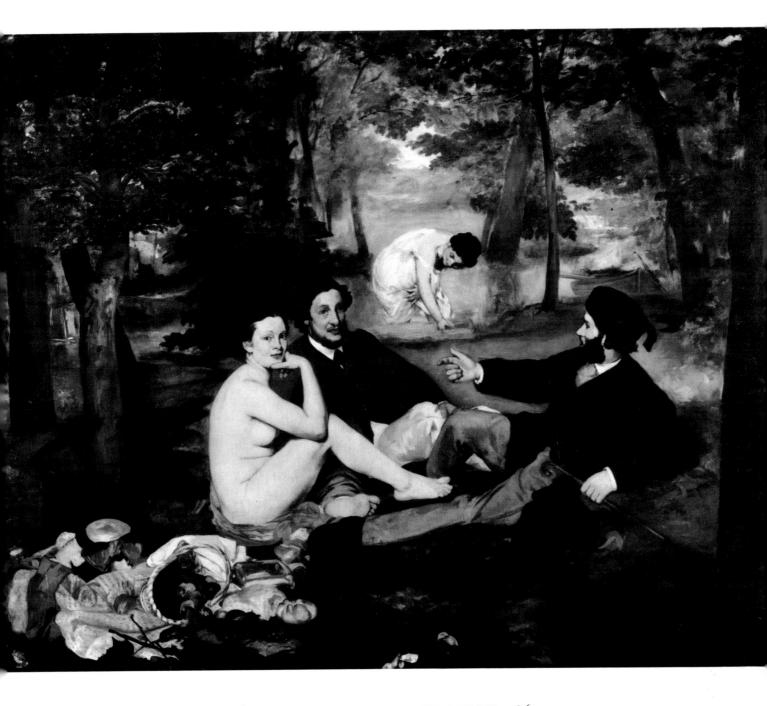

LE DÉJEUNER SUR L'HERBE (THE PICNIC), 1863

canvas, 208×264.5 cm $(82 \times 104^{1}_{4} \text{ ins})$ *Jeu de Paume, Paris*

One of Manet's best-known paintings, this was shown at the Salon des Refusés under the title *The Bath.* The uproar aroused by the picture resulted partly from the shock of the contrast between the woman's blatant nudity and the contemporary dress of the men, and also by Manet's audacious technique – the bright, fresh colour freely applied and the forms suggested rather than, as was traditional, delineated in fine detail. The irony of the outcry, which led to Manet's elevation to the status of hero among the young painters of the day, was that *Déjeuner* was based on a number of classical models, most notably a lost painting by Raphael, *The Judgement of Paris*, known through an engraving by Marcantonio Raimondi, and various similar compositions including Giorgione's *Concert champêtre* in the Louvre. Manet often copied compositions from paintings seen on his travels, but applied to them his own techniques. His models were Victorine Meurend, who also posed for *Olympia*, his brother Eugène, and his future brother-in-law, Ferdinand Leenhoff. This painting was bought by the singer Faùre, sold to Durand-Ruel and ultimately presented to the French nation.

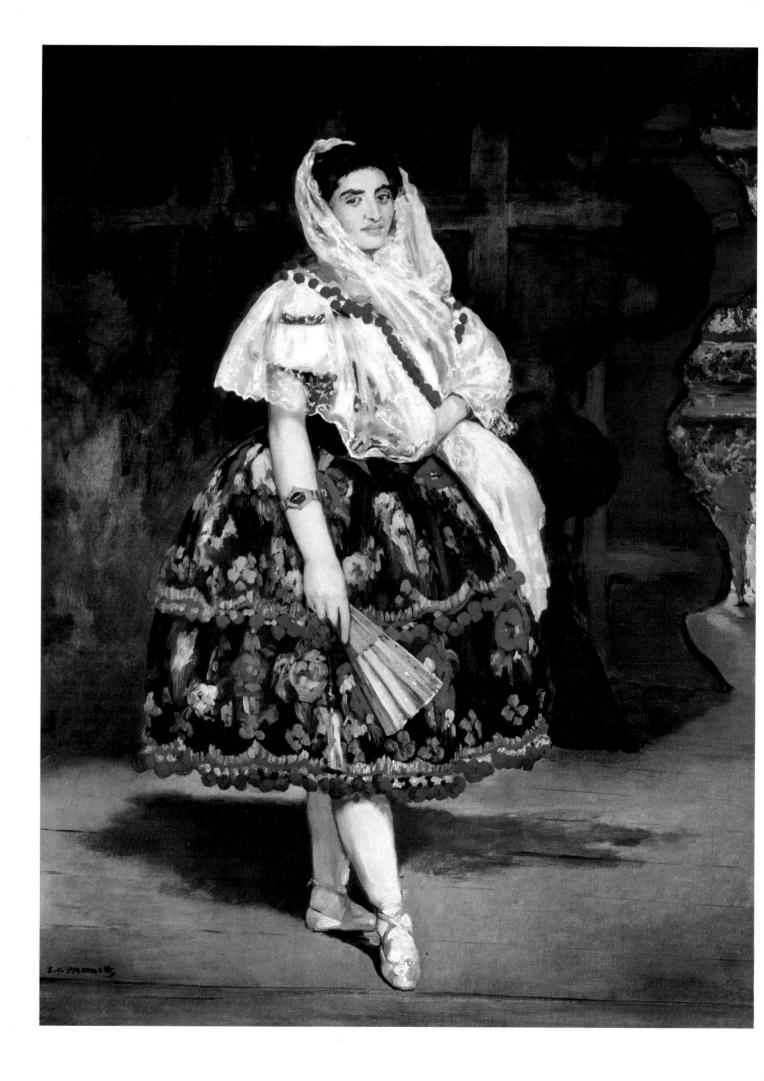

LOLA DE VALENCE, 1862

canvas, 123 × 92 cm $(48\frac{1}{2} \times 36\frac{1}{4} \text{ ins})$ Jen de Panme, Paris

At the time of the exhibition of this painting at Louis Martinet's gallery, Baudelaire wrote a four-line poem in which he compared the subject with 'the unexpected charm of a pink and black jewel'. He saw in Manet's work the influence of Spanish painters, particularly Goya, which had led to Manet's being dubbed 'the Parisian Spaniard'. Manet had then never been to Spain, although he had seen many works by Spanish masters in France, Austria and elsewhere. His subject was the leading ballerina of a visiting troupe of dancers who performed at the Paris Hippodrome. Delacroix was appalled by the hostile critical reaction to its exhibition at Martinet's, remarking 'I regret not to have been able to defend this man.' Like Delacroix, Manet was a devotee of the bold use of colour.

MUSIC IN THE TUILERIES GARDENS, 1862

canvas, 76.2×118 cm $(30 \times 46\frac{1}{2} \text{ ins})$ National Gallery, London

Charles Baudelaire became a close friend and defender of Manet at the time when he was at work on this painting. In his writings he had stressed the need for an artist who could show 'how great and poetic we are in our frock coats and patent leather boots'. He clearly recognized Manet's 'decided taste for modern life, a keen imagination, boldness and sensitivity', and accompanied him on his sketching trips to the fashionable Tuileries Gardens. This painting was completed in Manet's studio, and probably owes a great deal to photographic sources for its portraits, many of which have been identified, including the critic Astruc, the composer Offenbach, Fantin-Latour and, profiled against the large tree on the left, Baudelaire. Manet himself appears on the far left. The painting was acquired through a bequest to the Tate in 1917 and was transferred to the National Gallery in 1950.

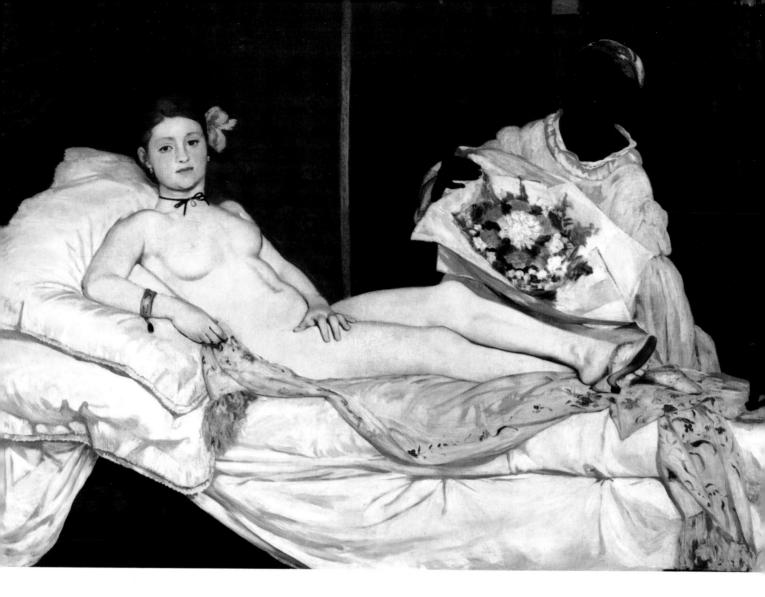

OLYMPIA, 1863 canvas, 130.5 × 190 cm $(51\frac{1}{2} \times 75 \text{ ins})$ *Jeu de Panme, Paris*

Inspired by a poem by Astruc and submitted to the Salon of 1865 at the insistence of Baudelaire, Manet's *Olympia* was accepted but received the same violent critical reaction that had greeted *Déjeuner*. As in many other works, Manet was inspired by eminent predecessors, here most notably by Titian's *Venus of Urbino* and Goya's *Nude Maja*, but to their composition he added his own highly individual techniques, updating the subject through the unconventional additions of the attendant negress and the black cat, and through his masterly handling of the contrasts between the flesh tones and the bed coverings and between the foreground and background. So shocking was the result held to be that the Salon organizers had to hang it out of reach of the angry crowds who flocked to see Manet's newest 'outrage'.

THE FIFER, 1866

canvas, 161 × 97 cm $(63\frac{1}{2} \times 38\frac{1}{4} \text{ ins})$ Jeu de Paume, Paris

Manet travelled to Spain in 1865 and the influence of the Spanish master Velasquez is evident in this work, painted on his return to France, in which he places emphasis on simplified planes and flat areas of colour presented against a plain background. The flatness of the colour led to Daumier accusing him of attempting to make painting into the 'faces on playing cards'. Despite the uncontroversial nature of the subject, it was refused by the Salon of 1866, which led to Zola springing to his defence in the newspaper *L'Evénement*, in which he declared that were he rich enough he would purchase all Manet's paintings as he was undoubtedly 'one of the masters of tomorrow'. The outcry caused by Zola's attitude led to his parting company with the paper.

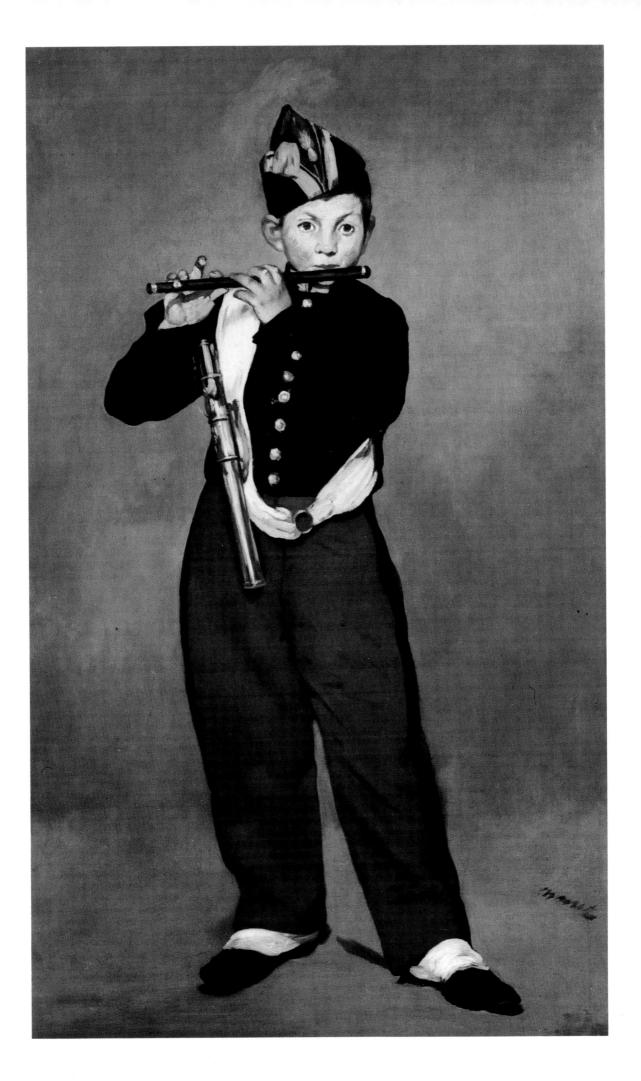

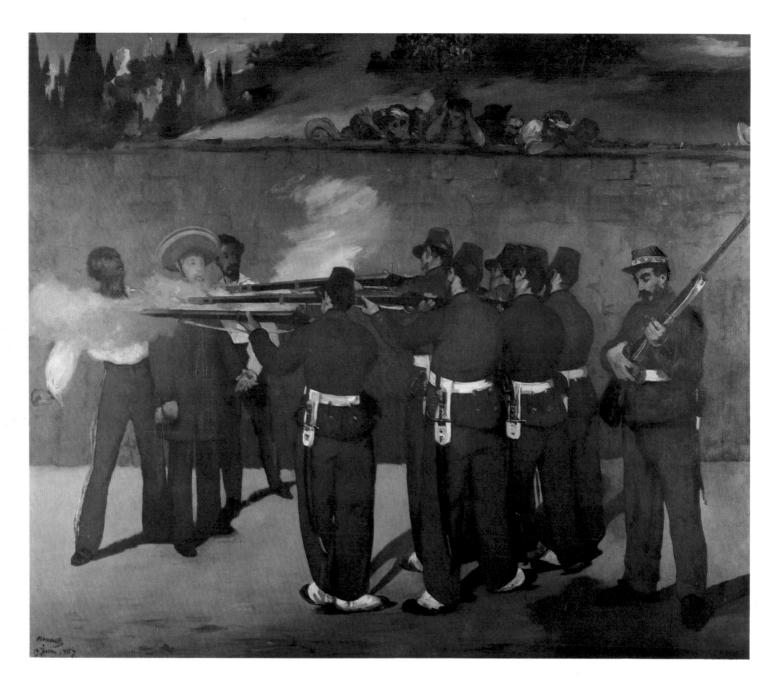

THE EXECUTION OF THE EMPEROR MAXIMILIAN, 1867

canvas, 252×305 cm $(99\frac{1}{2} \times 120$ ins) Städtische Kunsthalle, Mannheim

Goya's *The Third of May, 1808* provided certain compositional elements for Manet's remarkable painting of the execution of Maximilian following the revolution in Mexico, although many of the details, especially the portraits of those present, were copied from photographs. Painted as a criticism of France's involvement in Mexico, the political embarrassment surrounding the affair made it impossible for Manet to exhibit the painting.

EMILE ZOLA, 1868

canvas, 146.3 × 114 cm $(57\frac{1}{2} \times 45 \text{ ins})$ *Jeu de Paume, Paris*

After Zola's resignation from *L'Evénement*, he published a detailed and flattering review of Manet's work. In return, Manet painted his portrait. Although executed in Manet's studio, he features Zola's study as a background, with symbols of the new style of painting that

Zola promulgated – the Japanese screen and print by Utamaro, Goya's engraving of Velasquez' *The Drinkers* and a print of Manet's *Olympia*. Although accepted by the Salon of 1868, it came in for the usual vehement criticism.

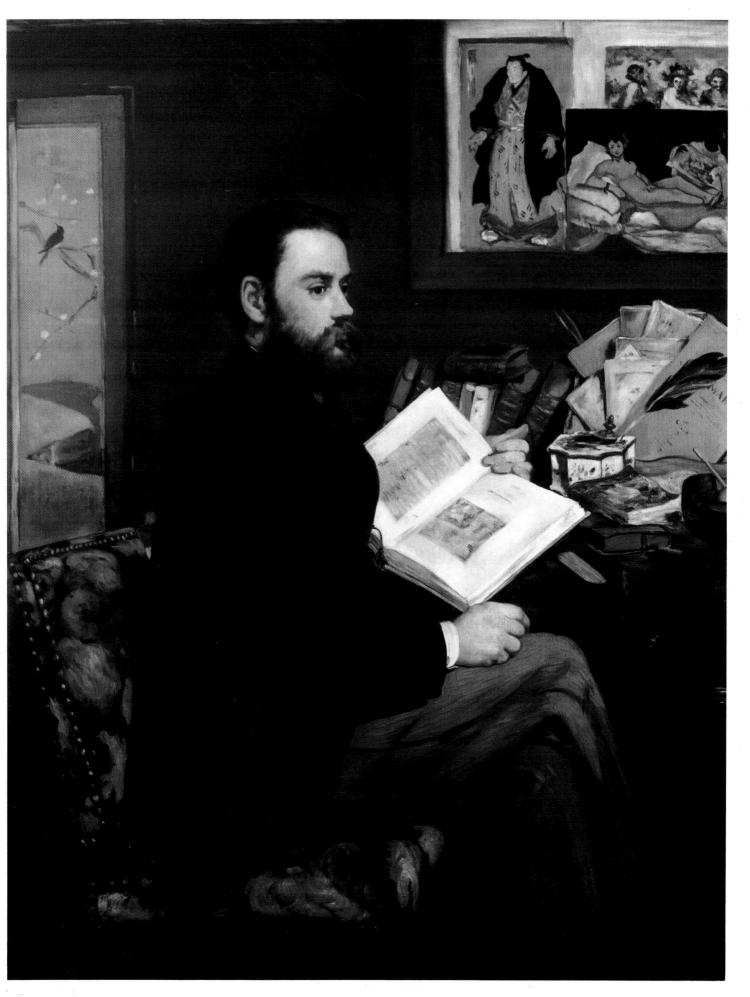

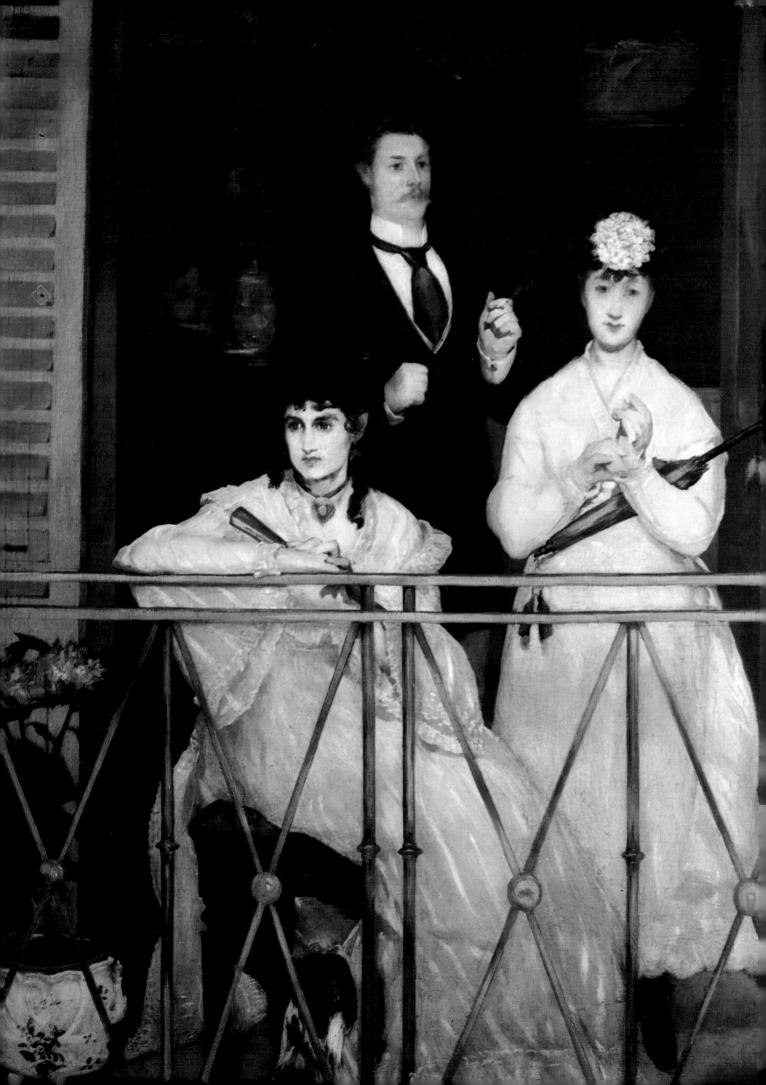

THE BALCONY, 1868–9

canvas, 170 × 124.5 cm (67 × 49 ins) Jeu de Paume, Paris

The Balcony derives from Goya's *Majas on a Balcony* (c. 1795, Metropolitan Museum of Art, New York). Berthe Morisot posed as the woman on the left; the other woman is the violinist Jenny Claus, while the painter Antoine Guillemet appears behind them. Manet's first sketches were made on seeing a similar scene in Boulogne in 1868, and the painting was completed in Paris the following year. Berthe Morisot was urged to see it hanging in the Salon of 1869 by Manet who was too nervous to go alone. She wrote, 'I appear strange rather than ugly; it seems that those looking at me have murmured the words "femme fatale".' The painting received the customary criticism and remained unsold at the time of Manet's death.

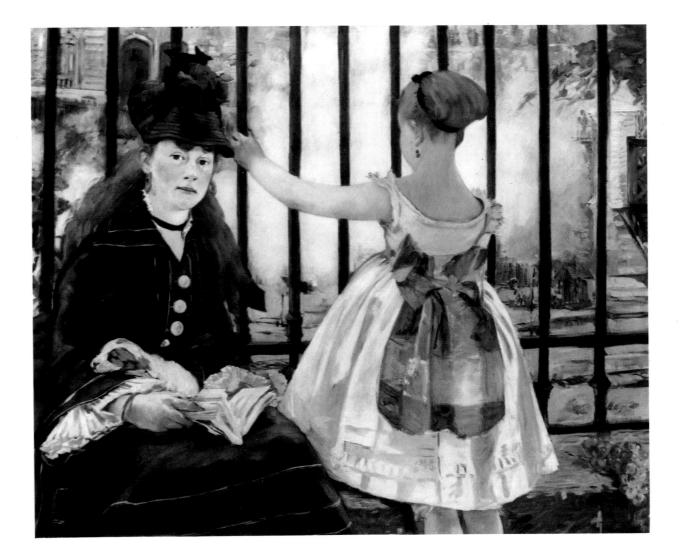

GARE SAINT-LAZARE, 1873

canvas, 93.3 × 114.5 cm (36½×44³/₄ ins) National Gallery of Art, Washington Gift of Horace Havermeyer in memory of his mother Louisine W. Havermeyer

Manet's technique of using bright, flat colour and contrasting areas of light and shade resulted in this painting being described by an American critic (who also ascribed it to Monet) as depicting a young woman and a child 'both cut out of sheet-tin apparently'.

Ironically, it was to enter a major American collection. Like Monet and the other Impressionists – and like Turner before them – Manet was fascinated by the atmospheric effects of the steam of locomotives and with their role as components of the contemporary scene. Here too Manet begins to show increasingly his acceptance of the Impressionists' lightened palette, free use of paint and concern with open-air painting.

LADY WITH FANS, 1873

canvas, 113.5 × 166.5 cm $(45\frac{1}{2} \times 65\frac{1}{2} \text{ ins})$ Jeu de Paume, Paris

Here in his portrait of Nina de Callias Manet continued his association with the techniques of the Impressionists, adopting their fragmented brush-strokes and informality of pose. The Japanese screen and fans which comprise the background further emphasize the increasing influence of Japanese art on that of the Impressionists.

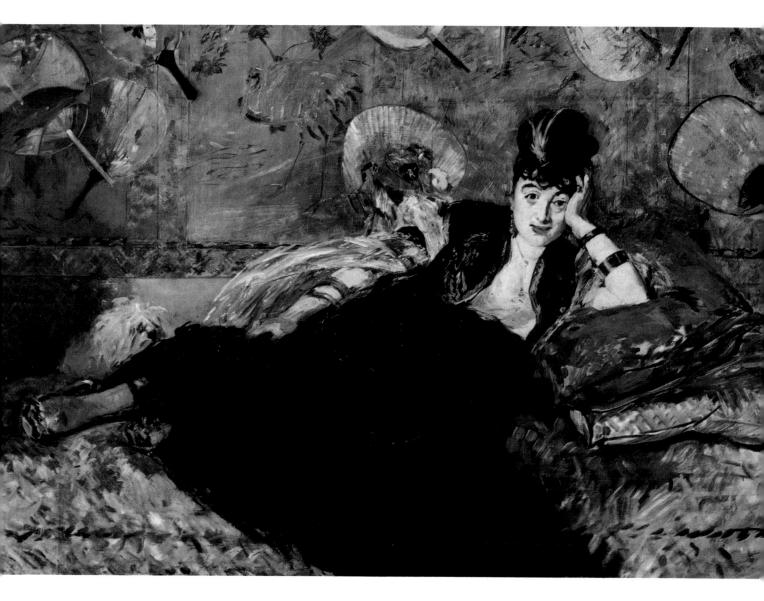

Opposite page

CLAUDE MONET IN HIS STUDIO BOAT, 1874

canvas, 81×104 cm (32×41 ins) Neue Pinakothek, Munich

It was at Argenteuil, where he worked with Renoir and Monet after the first Impressionist exhibition in 1874, that Manet finally became convinced of the value of painting in the open air. He also began using brighter colours. During their stay at Argenteuil, he painted several

portraits of Monet and his family. In this work Monet and his wife are shown on their floating studio, on which Monet painted many scenes along the River Seine, capturing 'the effects of light from one twilight to the next'. Manet was to describe Monet as 'the Raphael of water'.

58

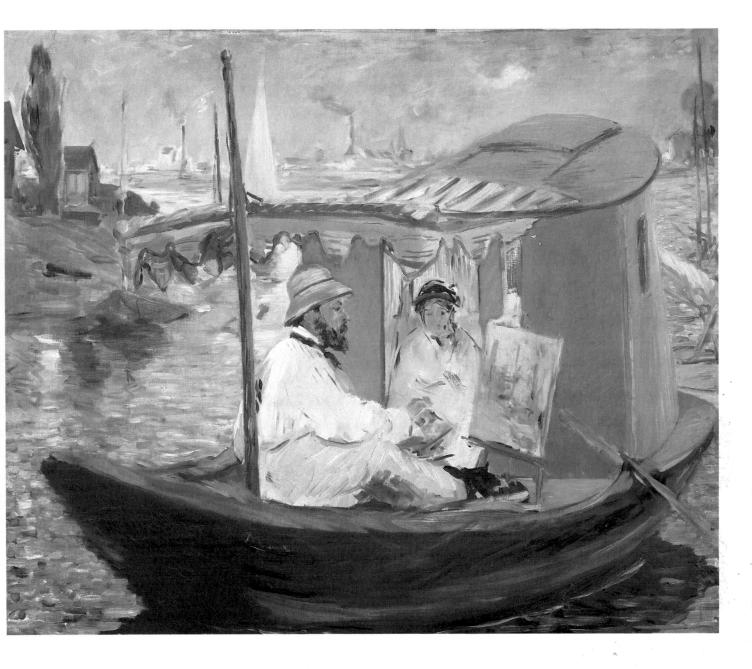

Overleaf

THE BLONDE WITH BARE BREASTS, 1878

canvas, 62.5×52 cm $(24^{1}_{2} \times 20^{1}_{2}$ ins) Jeu de Paume, Paris

One of Manet's few nudes painted after the scandals generated by *Déjeuner* and *Olympia*, the contrast brought about through his 'conversion' to Impressionism is evident. In this and other later works, like Degas, he has painted his subject (whose identity is uncertain) partly disrobed, emphasizing gesture and expression rather than posing her formally. He accents the picture by introducing red flowers in her hat, though his general key (i.e. overall colour tone) is noticeably brighter by this period.

Page 61

THE WAITRESS, 1878–9

canvas, 97 × 77 cm (38 × 30 ins) National Gallery, London

Manet was inspired by the bustling life of the Parisian cafés, here depicting a scene at the Cabaret de Reichshoffen. Part of a larger painting which he cut in two, it is a treatment of a highly contemporary subject – waitresses were only just being employed in Paris then.

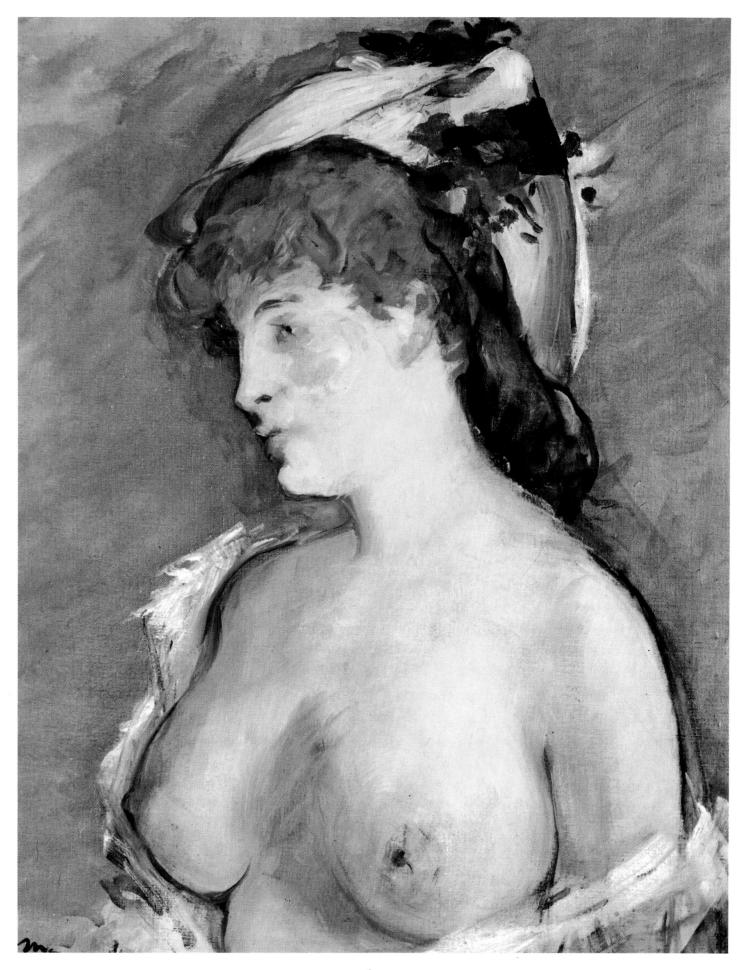

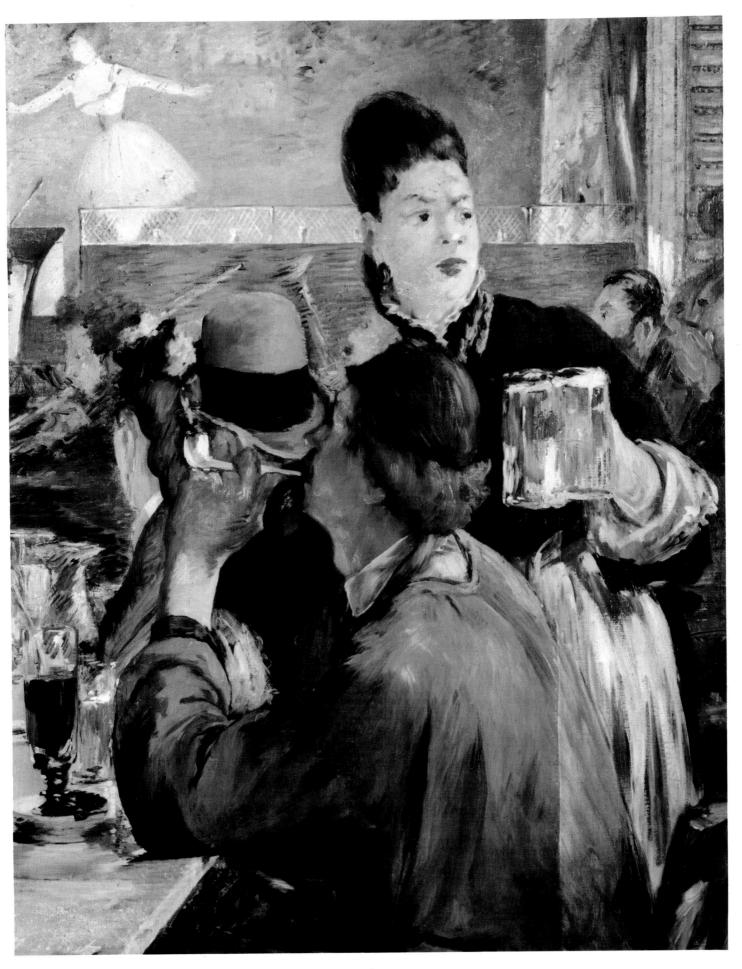

A BAR AT THE FOLIES-BERGÈRE, 1882

canvas, 95.5×130 cm $(37_2^1 \times 51$ ins) Courtauld Institute Galleries, University of London

Manet's last major work displays his skill in portraying all the complexities of light and perspective imposed by this scene of the cabaret at the Folies-Bergère, depicted as it were by the viewer approaching the bar and witnessing the panorama displayed in the reflection in the mirror behind the waitress. A friend who watched Manet at work on this masterpiece later described his methods: 'The model, an attractive girl, posed behind a table loaded with bottles and food . . . Manet, although painting his pictures from the model, by no means copied nature; I realize how splendid his simplifications were. The head of the woman is modelled, but his modelling was not obtained by means revealed by nature. Everything was abbreviated. The tones were clearer, the colours more lively, the values closer. This formed a tender and *blond* harmonious whole.' The painting was shown at the Salon of 1882 and received the criticism he had by now become used to; as ever, the unconventional subjectmatter was more savagely attacked than his original techniques which were never fully appreciated in his lifetime.

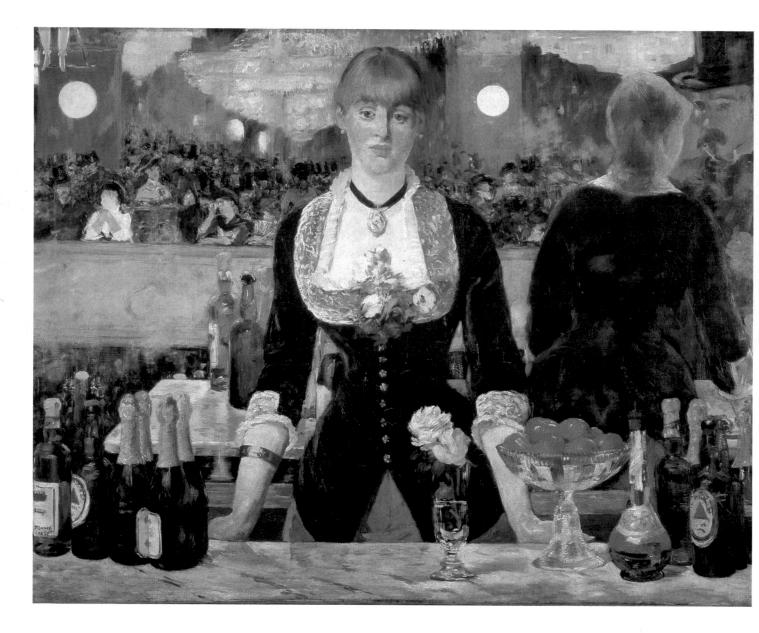

FRÉDÉRIC BAZILLE (1841-70)

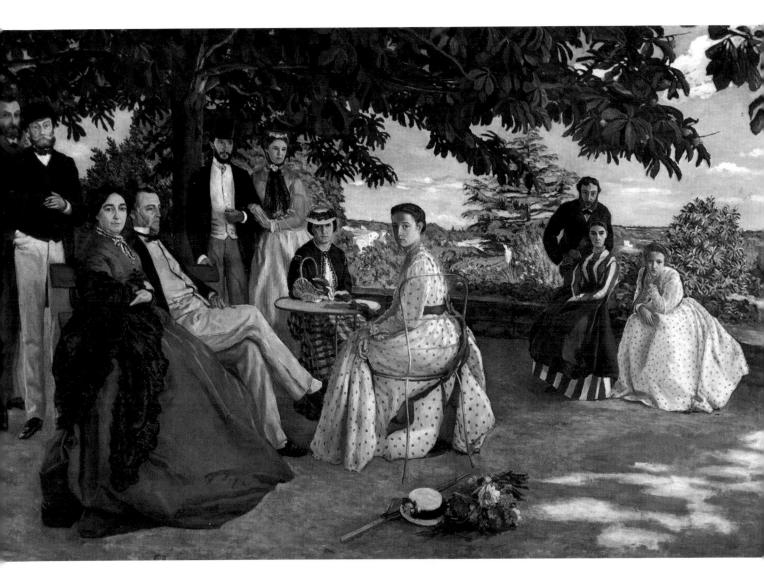

FAMILY REUNION, 1867

canvas, 152×230 cm $(59_4^3 \times 90_2^1 \text{ ins})$ Jeu de Paume, Paris

Bazille divided his life in Paris between studying medicine and art. In 1867, on a visit to his home town of Montpellier, he executed this large canvas showing members of his family. His parents are seated on the bench on the left, his cousins, uncle and aunt behind; he depicts himself diffidently in the shade on the far left. The painting was exhibited at the Salon in 1868 and was retouched the following year. Barely a year later Bazille was killed in the Franco-Prussian War. It is probable that Bazille employed photography in his work, and this may have contributed to the somewhat stiff formality of the group. However, it is known that it was largely painted out of doors and is thus an early example of the Impressionist ideal of open-air portraiture. It was painted at the same time as his friend Monet's *Women in the Garden* (page 87) which achieves greater naturalness and which Bazille bought from Monet, bringing him temporary relief from his financial difficulties.

HENRI FANTIN-LATOUR (1836–1904)

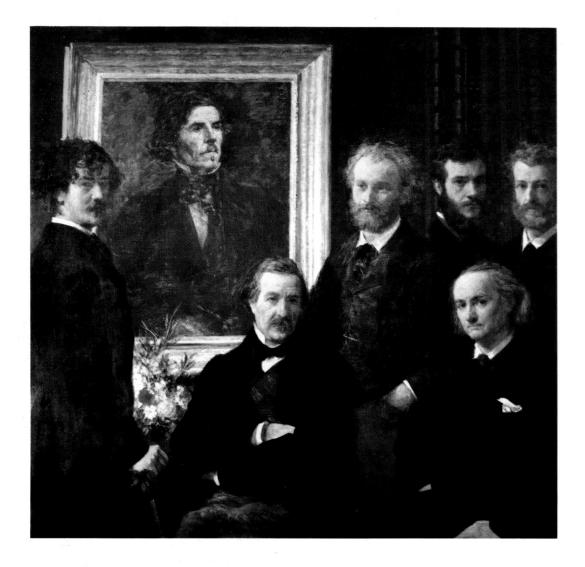

HOMAGE TO DELACROIX (detail), 1864

canvas, 160 × 250 cm (63 × 98 $\frac{1}{2}$ ins) Jeu de Paume, Paris

The Impressionists acknowledged their debt to Delacroix and, when he died in 1863, Fantin-Latour conceived the notion of painting a large group portrait featuring artists and writers who revered the master, gathered around his likeness. In the complete painting, in addition to himself, he included the painters Alphonse Legros, Manet (standing centre), Félix Bracquemond and Whistler (far left). Whistler's friend, the Pre-Raphaelite artist Dante Gabriel Rossetti, was to have appeared but would not leave London for the sittings. The writers Baudelaire (seated, centre) and Champfleury, both of whom had previously been painted in Courbet's allegorical *The Painter's Studio*, and Edmond Duranty, a stalwart defender of Impressionism, were also shown. The result, though formally posed and, in Fantin-Latour's opinion, rather too sombre, stands out as an early declaration of solidarity

among the leading proponents of the aspiring generation of artists and their supporters. It was shown in the Salon of 1864 where, through Baudelaire's influence, it was hung in a favourable location.

THE STUDIO IN THE BATIGNOLLES QUARTER, 1870

canvas, 204 × 273.5 cm $(80\frac{1}{4} \times 107\frac{1}{2} \text{ ins})$ Jeu de Paume, Paris

Showing, left to right, the German painter Otto Scholderer, Manet, Renoir, Astruc, Zola, Edmond Maître (a musician), Bazille and Monet, Fantin-Latour's painting was so-called after the Batignolles Quarter, the location of the Café Guerbois where they met and discussed their artistic aims. The painting was shown at the Salon in 1870. Manet, who appears seated at the easel, had by this time become the idol of the new generation of artists, leading to the publication of a caricature of the painting titled 'Jesus painting among the Disciples, or the Divine School of Manet'. Like the *Homage to Delacroix*, this portrait, although stiffly posed, serves as a valuable record of the participants in the early years of Impressionism – particularly since Bazille (the tall figure on the right) was killed in action later in the year. Degas was known to have been included in sketches for the painting, but why he, and Pissarro and Sisley, were omitted from the final version is not known.

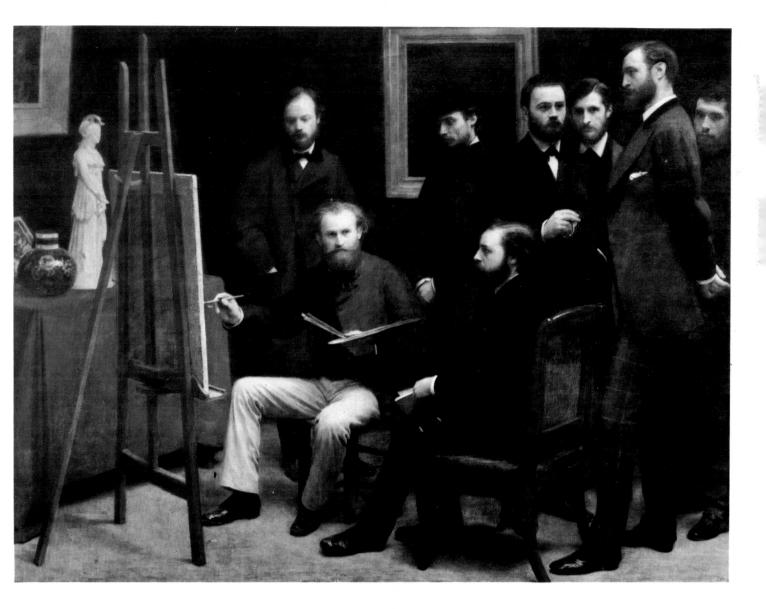

A TABLE CORNER, 1872

canvas, 160×225 cm $(63 \times 88\frac{1}{2} \text{ ins})$ Jeu de Paume, Paris

A sketch for this painting, now in the Musée des Beaux-Arts, Lyons, shows that the painting departed considerably from Fantin-Latour's original conception. Initially it was to have been a tribute to Baudelaire, who died in 1867 and whose portrait was to have appeared in the background behind a group of admirers, in the style of his *Homage to Delacroix* (page 64). It was altered when a number of sitters failed to appear – one of them even being replaced by the rhododendron on the right. The result is an informal group portrait of a number of writers, including the poets Paul Verlaine and Arthur Rimbaud (seated on the left).

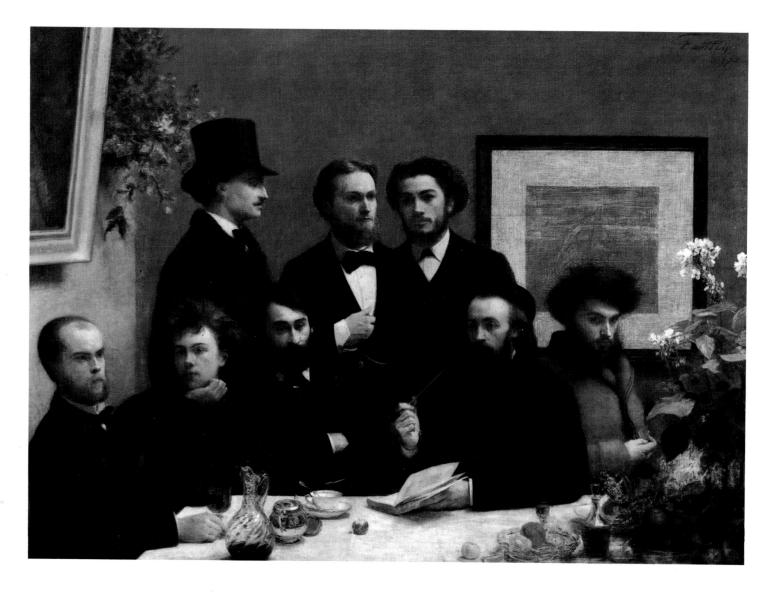

BERTHE MORISOT (1841–95)

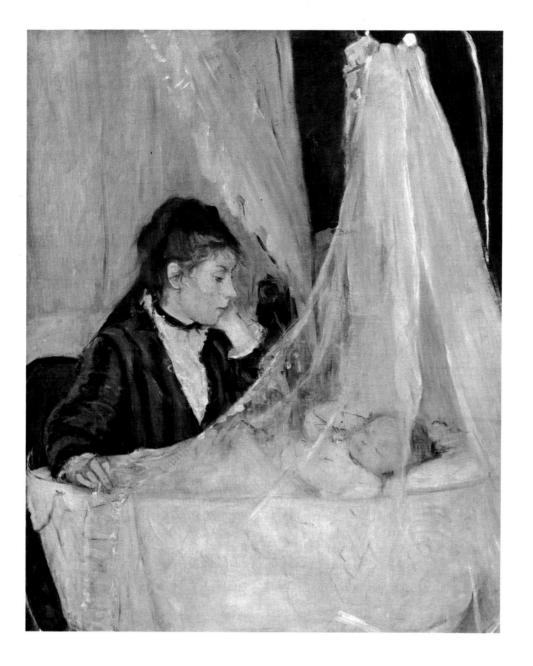

THE CRADLE, 1873

canvas, 56 × 46 cm (22 × 18 ins) Jen de Paume, Paris

Berthe Morisot and her sister Edma studied together until Edma married a naval officer, after which she gave up painting to devote herself to her family. She appears as the contemplative subject of this painting which Berthe showed at the first Impressionist exhibition in 1874 – the only woman to appear with them. Apart from her absence from the 1879 exhibition, when her daughter Julie was born, she loyally showed at all eight exhibitions from 1874 to 1886. (Through her association with Manet, she had met his younger brother Eugène whom she married in 1874.) As Paul Valéry aptly commented, her subject-matter was largely prescribed by her sex and social rank. She tended to concentrate on middle-class family life, so that 'her paintings taken all together remind one of what a woman's diary would be like if she expressed herself in colour and design instead of in writing'. In *The Cradle* she achieves a subtle and harmonious result with a simple sentimental subject, displaying considerable skill in the delicate contrasts of colour and texture between the gauze drapery and the pink ribbon trimming.

THE BUTTERFLY HUNT, C. 1873

canvas, 46 × 56 cm (18 × 22 ins) Jeu de Paume, Paris

A visit to her sister Edma and her family at Maurecourt inspired Berthe Morisot's depiction of them at play catching butterflies in the orchard. The ingenuous charm of this and similar paintings meant that at the Hôtel Drout sale in 1875 her works achieved the highest prices – almost 500 francs for some canvases, while many of Renoir's (who was more desperately in need of money) failed to reach 100 francs. Although she followed the Impressionist style, her individualistic methods are exemplified in this painting, most notably her use of bolder, freer brush-strokes. In later life her work departed more dramatically from that of her associates.

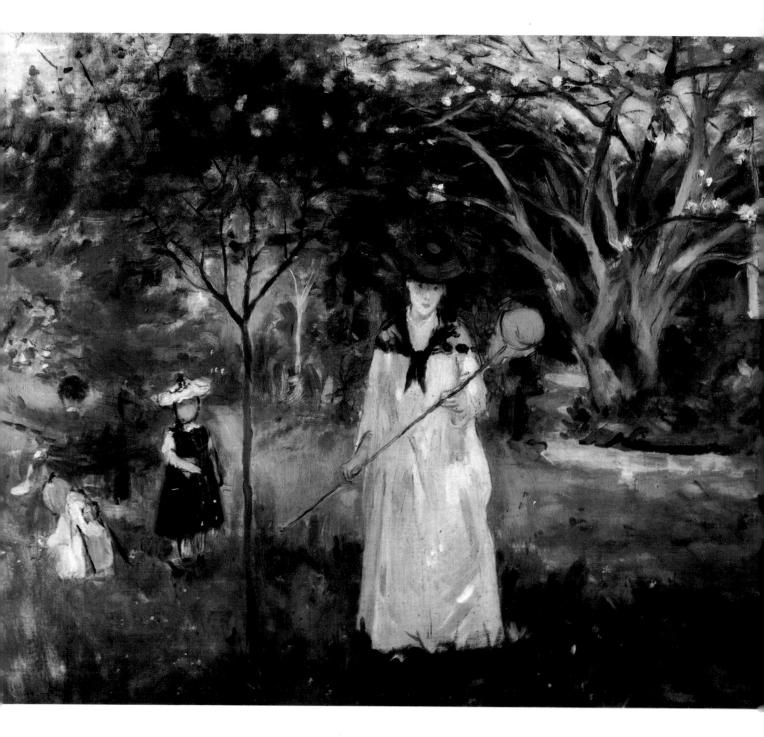

HILAIRE-GERMAIN-EDGAR DEGAS (1834–1917)

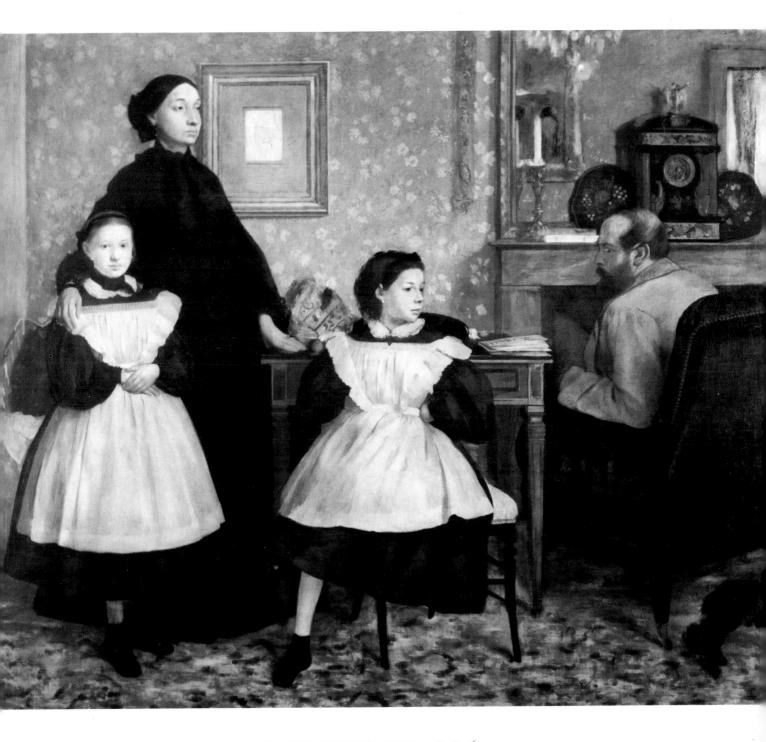

THE BELLELLI FAMILY, 1858–60

canvas, 200×250 cm $(78\frac{3}{4} \times 98\frac{1}{2}$ ins) Jeu de Paume, Paris

Degas was in Florence in 1858–9 where he set to work making numerous sketches of his aunt Laura, with whom he was staying, her husband the Baron Bellelli and their daughters Giovanna and Giulia. Returning to Paris, Degas used the sketches as the basis of this lifesized portrait. The family is in mourning for the death of Degas' grandfather, whose portrait

hangs on the wall behind. Laura, who is pregnant, gazes vacantly, symbolizing her detachment in a tense and unhappy marriage to the Baron, who sits moodily at his desk. She holds one daughter protectively, while the other sits independently in the centre. Perhaps this portrait was too revealing. It lay rolled up in his studio until after his death when it was bought for the French nation.

SEMIRAMIS BUILDING BABYLON, 1861

canvas, 151×258 cm $(59\frac{1}{2} \times 101\frac{1}{2} \text{ ins})$ Jen de Panme, Paris

At the time when his friend Manet, who had a horror of historical painting, was beginning to produce his controversial contemporary subjects, Degas was still preoccupied with themes derived from the works of classical writers, the Bible and, in this instance, the opera. It shows Semiramis, the daughter of the goddess Derceto, an Assyrian youth and the wife of Ninus (the mythical founder of Nineveh) founding the town of Babylon. As with his other historical works, usually conceived on a large scale, Degas made innumerable sketches and studies, many of which have been preserved. But he was never completely satisfied with the results of his finished paintings and, unlike the other Impressionists, he had no necessity to sell his paintings until later in life, so his incentive to complete them was never pressing. During the period 1859-65 he gradually tired of the limitations of such academic subjects

and turned increasingly to paintings of the contemporary scene, especially racehorses, dancers, laundresses and nude bathers and to portraits which, as his father had prophesied, were to be one of his strengths.

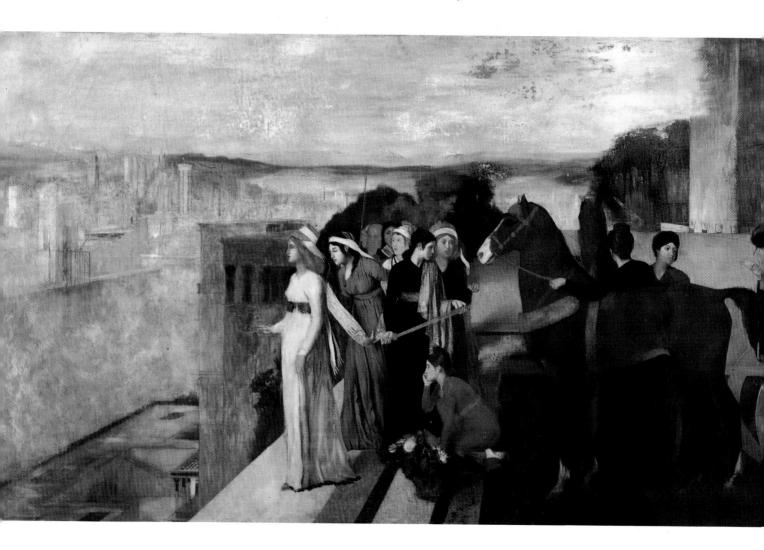

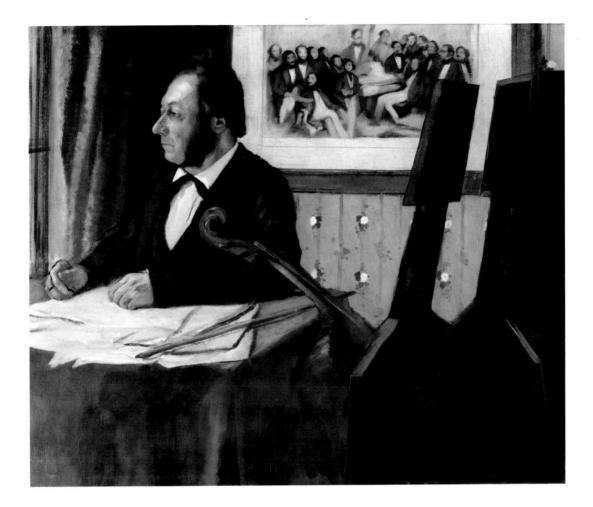

THE CELLIST PILLET, 1868–9

canvas, 50.5 × 61 cm (20 × 24 ins) *Jeu de Paume, Paris*

As Degas moved toward portraiture, it was natural that he should find subjects among musicians. Since the age of 20 he had had a season ticket to the Opéra, which permitted him to go behind the scenes. He was a devotee of the classical music of the day, though not of Wagner who appealed to many of the other Impressionists. He got to know a number of musicians in the Opéra orchestra, particularly at the restaurant of Mère Lefebvre where they congregated. He painted portraits of several members, including Pillet, as well as featuring him in a group portrait of the orchestra in the background of which the truncated bodies of ballet dancers are shown in anticipation of the dominant subject of his subsequent years.

Overleaf

DANCE FOYER AT THE OPÉRA OF THE RUE LE PELETIER, 1872

canvas, 32×46 cm $(12\frac{1}{2} \times 18$ ins) *Jeu de Paume*, *Paris*

As a result of his studies of Japanese prints, Degas adopted the asymmetrical grouping shown in this work, where the central area, which would traditionally have been the focal point of the painting, is empty, as though in anticipation of the dancer's progress into it. Shown at Durand-Ruel's gallery in London in 1872, it excited the English critic Sidney Collin to write: 'It is a scheme of various whites, gauzes and muslins, fluttering round the apartment, and the ballet-master in white ducks and jacket in the middle; and all the little shifts of indoor light and colour, all the movements of the girls in rest and strained exercise, expressed with the most perfect precision of drawing and delicacy of colour, and without a

shadow of a shade of that sentiment which is ordinarily implied by a picture having the ballet for its subject.'

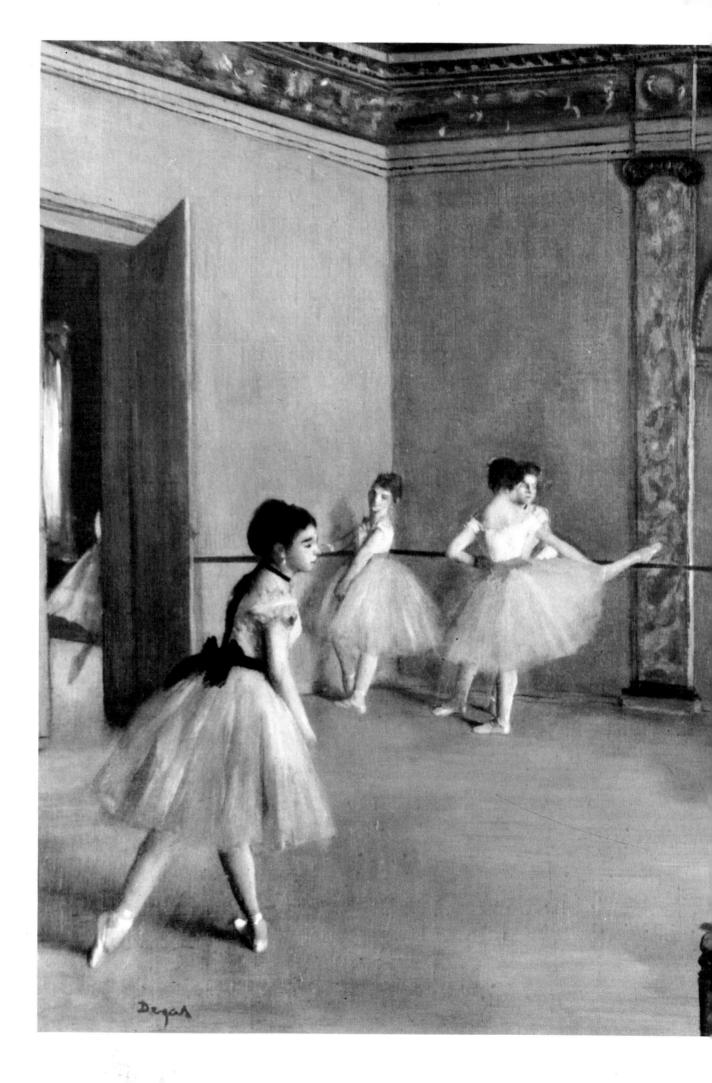

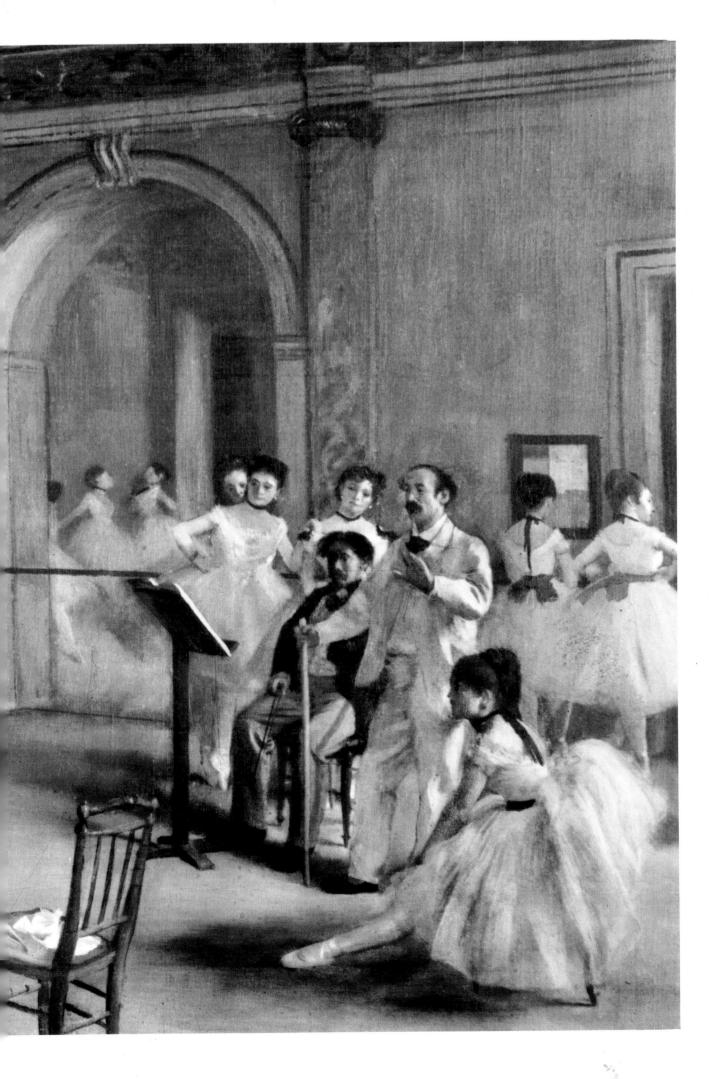

AT THE RACES, IN FRONT OF THE STANDS, C. 1879

canvas, 46×61 cm (18×24 ins) Jeu de Paume, Paris

Degas became interested in painting racehorses during his stay in Normandy, an area noted for horse breeding and training. His early studies were based on English sporting prints and often featured horses with all four legs outstretched and off the ground – an error most artists made until photography later showed this to be impossible. Degas had little interest in outdoor subjects in general, or racing in particular, but it provided him with the opportunity to depict colourful movement and fleeting attitudes.

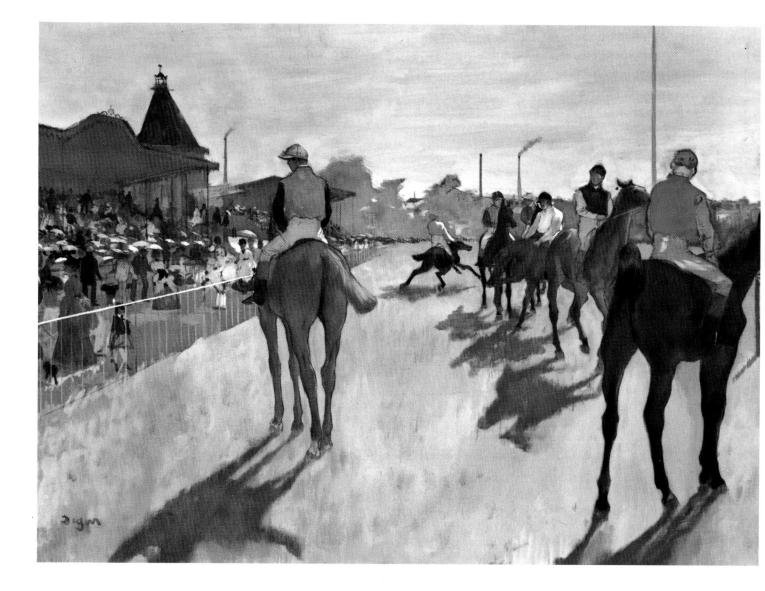

THE PEDICURE, 1873

paper on canvas, 61×46 cm (24 × 18 ins) Jeu de Paume, Paris

Degas travelled to New Orleans at the end of 1872, where he stayed with his mother's family, the Mussons. Joanna, the daughter of his sister-in-law Estelle by her first marriage, appears in this painting. As ever, he was dissatisfied with the result, particularly because he found it difficult as a visiting relative to get his subject to pose naturally. The unusual choice of this somewhat unflattering scene is a prelude to his later works portraying women engaged in their toilette. It emphasizes his relegation of subject-matter to a subordinate role beneath its value as a record of some transient everyday event in which gesture and expression become dominant features.

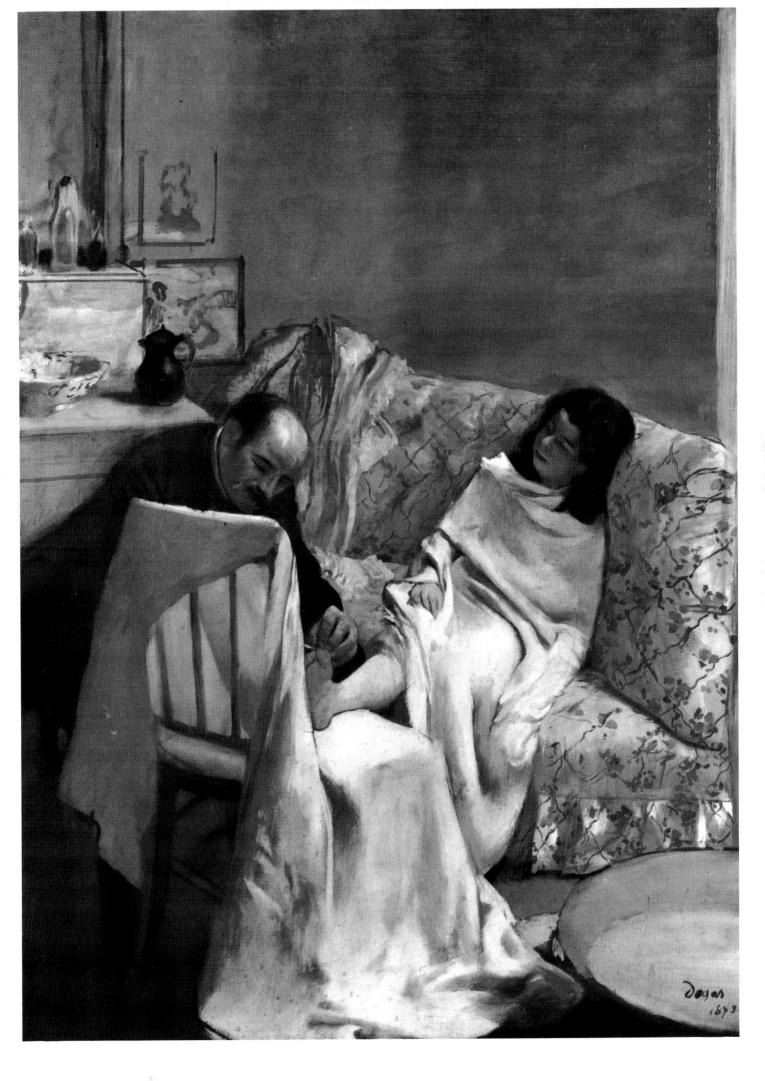

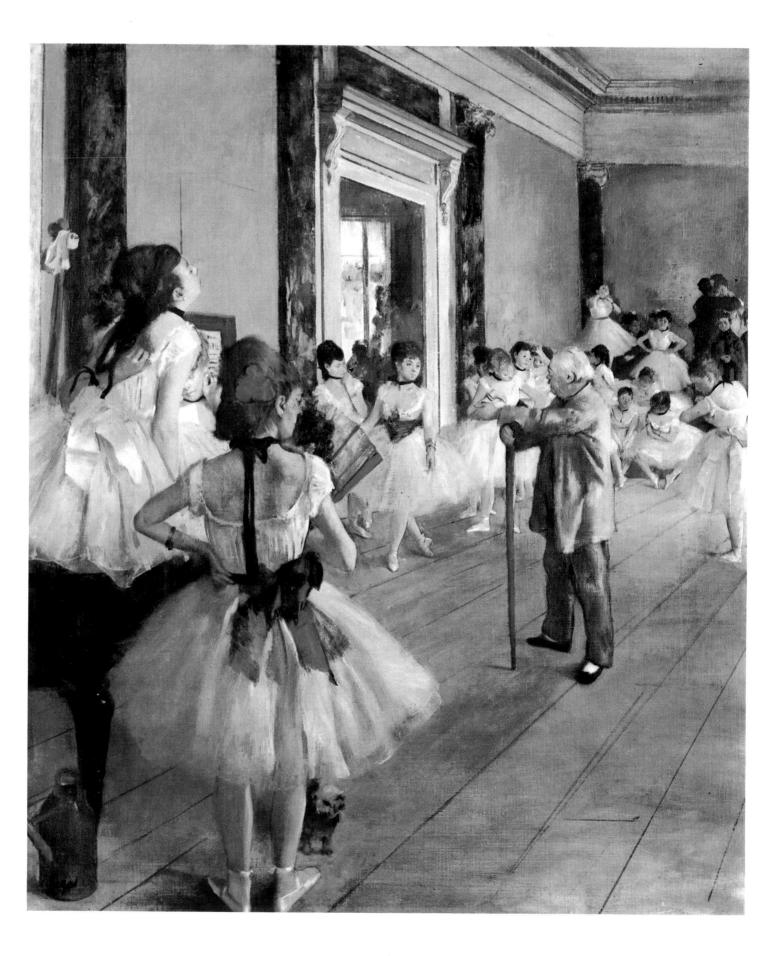

THE DANCING CLASS, *c*. 1874

canvas, 85×75 cm $(33\frac{1}{2} \times 29\frac{1}{2}$ ins) *Jeu de Paume, Paris*

Here in his painting of the ballet-master Jules Perrot taking a class of *rats* (the young members of the company), we can see all the skill of observation and rendition Degas displays in his best-loved paintings of ballet dancers. Both on stage and behind the scenes, dancers were invariably presented in idealized and sentimental poses, aimed largely to appeal to the followers of the great ballerinas of the day. Degas broke with this tradition in his portrayals of dancers at rest and offered such informal details as here – the dancer scratching her back, others adjusting their costume, the watering-can on the floor (used to settle the dust) and the little dog. He makes valuable use of the floorboards to indicate the perspective of the practice-room, and delights in representing the texture of the dresses and the highlights of the coloured sashes and hair decorations. All these elements come together with the immediacy of a photograph to convey the impression of an inadvertent glimpse into the room, but in reality every detail was carefully constructed and calculated to harmonize with the composition. This painting was shown at the first Impressionist exhibition in 1874.

Overleaf

ABSINTHE, 1876 canvas, 92 × 68 cm $(36\frac{1}{4} \times 26\frac{3}{4} \text{ ins})$ *Jeu de Paume, Paris*

Degas and Manet, along with other Impressionists, followed the engraver and painter Marcellin Desboutin in transferring their allegiance from the Café Guerbois to the Nouvelle-Athénes. It was there that Degas painted Desboutin with the actress Ellen André posing as a down-and-out woman with a glass of absinthe (a type of liqueur so potent that it is now

outlawed). In his picture Degas portrays a scene that is as familiar today – two lonely people, killing time over a drink, preoccupied with their own thoughts or observing other customers. The anonymity and lowly status of the woman might have been regarded by any other artist than Degas as the basis of some social comment, but he was far less concerned with the moral implications inherent in his work than with its composition. He also

deliberately painted women as he saw them, without any attempt to idealize or sentimentalize, for which he has often been called a misogynist. As with his more familiar ballet paintings, Degas places his subjects off-centre and uses the broken angles described by the tables as a novel compositional device. *Absinthe* was probably shown at the second Impressionist exhibition in 1876, after which it was purchased by Captain Henry Hill of

Brighton, England, who was a great admirer of Degas' work. When it came up for sale at auction in 1892, it was hissed by the audience and came in for a good deal of criticism by those who saw the subject as degrading or at best supplying a 'moral lesson'.

Page 79

THE STAR OR THE DANCER ON STAGE, 1878

pastel, 60×44 cm $(23\frac{1}{2} \times 17\frac{1}{2} \text{ ins})$

Jeu de Paume, Paris

Degas was largely responsible for reviving the use of pastel, a medium that had been popular in the eighteenth century, becoming arguably its greatest exponent. Although he began using pastels in about 1869, as his eyesight progressively deteriorated, he employed them more and more until they became his principal method. Not only did they offer an alternative when he could no longer see fine pencil lines or confidently mix oil colours, but they had advantages over oil in allowing him to work quickly and did not require time to dry or need varnishing. He did constantly experiment with a wide range of techniques and the use of fixatives enabled him to build up layers of colour to dramatic effect. Additionally,

Degas found a ready market for his pastels which from an early date entered private and institutional collections in America and Europe, among them this unusual work featuring a single dancer seen in performance from above with the other dancers waiting in the wings. He succeeds in representing the effect of the harsh brilliance of the foot-lights beneath the dancer, casting her upturned face and tops of her arms into shadow.

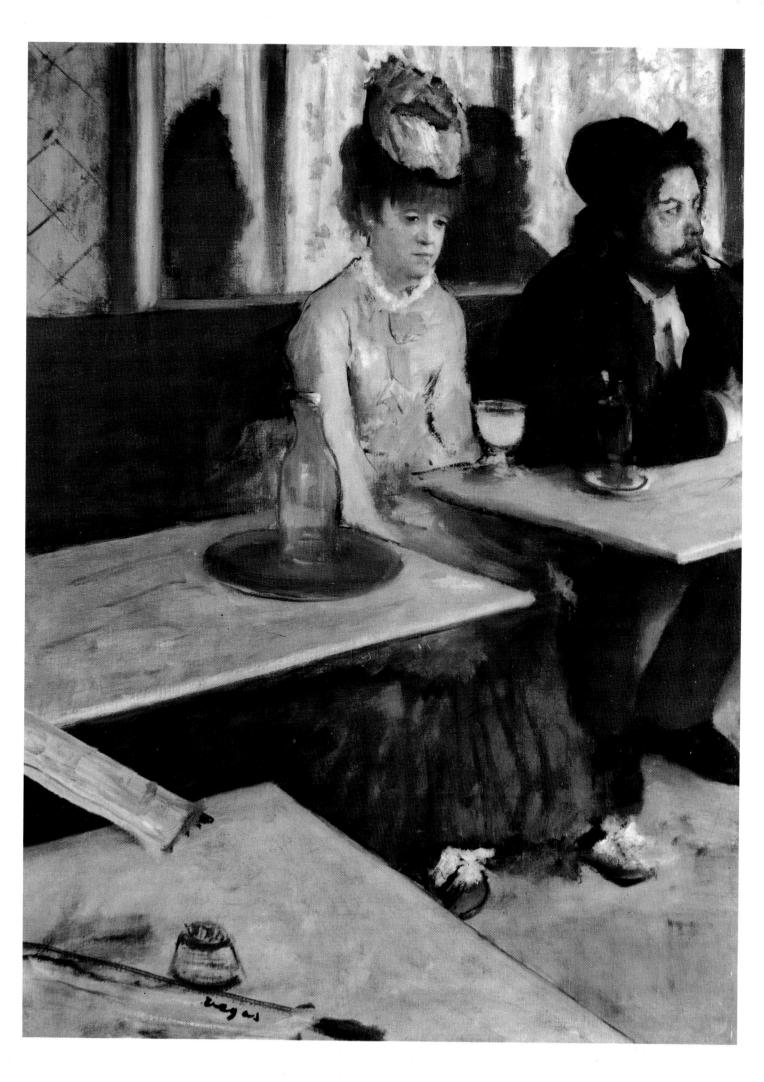

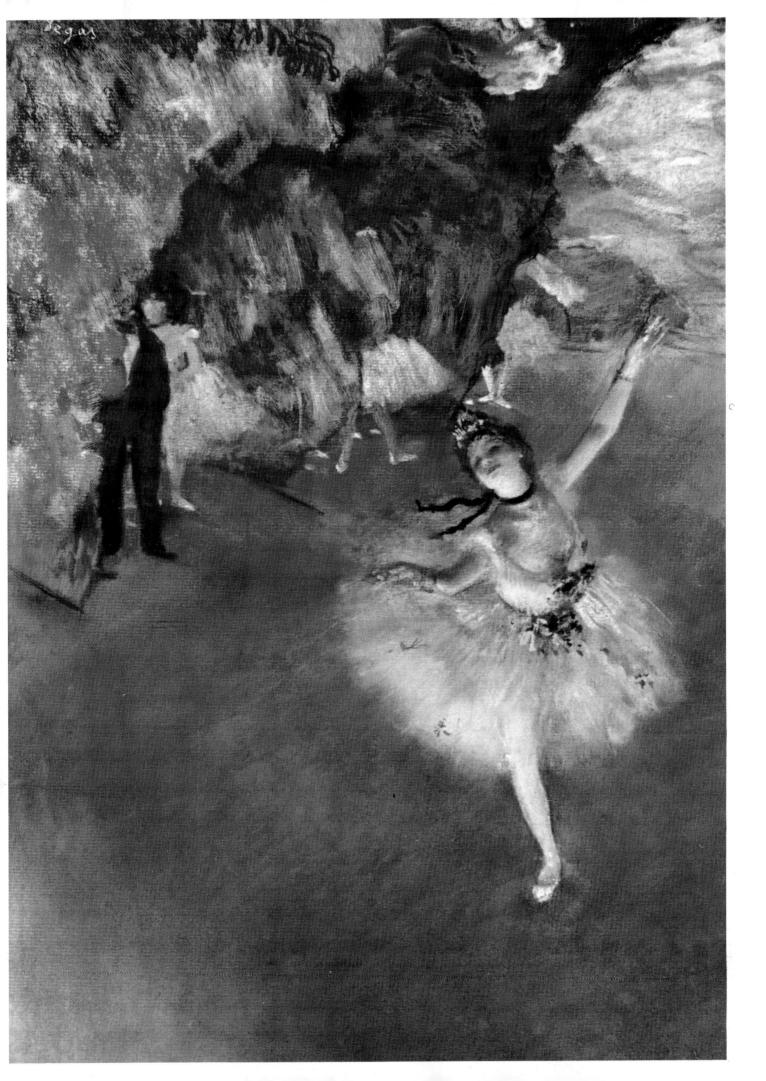

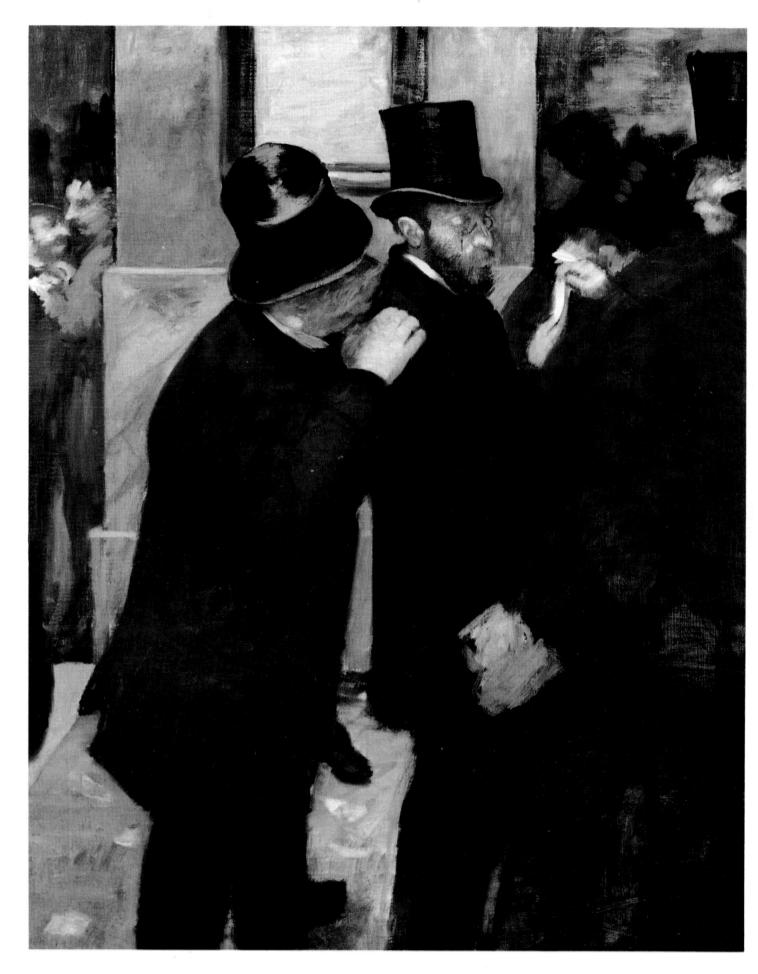

AT THE STOCK EXCHANGE, 1878–9

canvas, 100 × 82 cm $(39\frac{1}{4} \times 32\frac{1}{4} \text{ ins})$ *Jeu de Paume, Paris*

The Paris Bourse, or stock exchange, would have been familiar to a man of Degas' rank. His family fortune was founded on banking although, following the death of his father in 1874 and a general post-war depression, Degas had to sell his house and collection of Old Master paintings to settle the family's debts. In this painting of stockbrokers, as in other works of this period, he cleverly conveys the importance of his subjects by their stance, despite their faces being barely visible. In some pictures, including one of Mary Cassatt, he even showed people entirely from the back, following the critic Duranty's theory that the status of a person could easily be determined from his deportment.

PORTRAIT OF DIEGO MARTELLI, 1879

canvas, 110 × 100 cm $(43\frac{1}{2} \times 39\frac{1}{4} \text{ ins})$ National Gallery of Scotland, Edinburgh

Here in one of Degas' most successful portraits, as in *The Star* (page 76), he takes an unusually high angle of view, also placing the figure off-centre. Martelli was an Italian critic and the earliest writer to describe the importance of the Impressionist movement to his countrymen. In Degas' portrait we see him surrounded by the clutter of his profession, his slippers cast aside and his eyes averted from the viewer, apparently unaware of the artist's intrusion, caught with the spontaneity of a snapshot. However, despite the seeming randomness of the elements which comprise the picture, as always Degas produced a multitude of preliminary sketches to achieve his apparently instantaneous result.

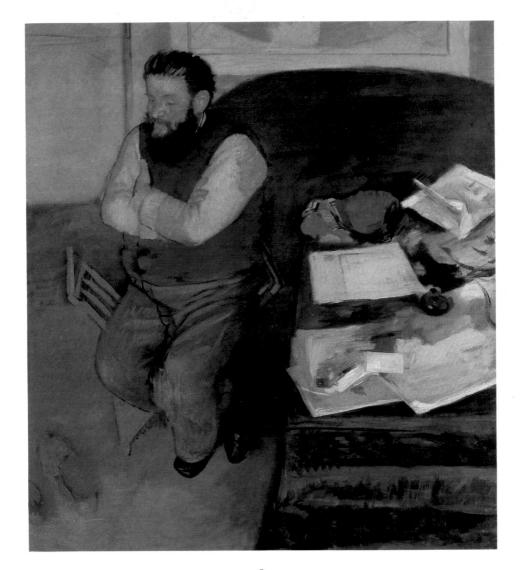

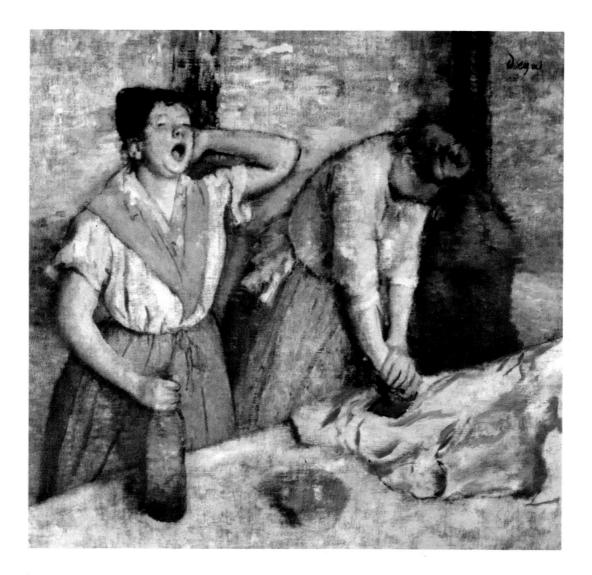

WOMEN IRONING, C. 1884

canvas, 76×81.5 cm (30×32 ins) Jeu de Paume, Paris

When the writer Edmond de Goncourt visited Degas' studio in 1874, he reported in some amazement: 'Degas places before our eyes laundresses while speaking their language and explaining to us technically the downward pressing and circular strokes of the iron, etc., etc.', although he entirely sympathized with Degas' belief that laundresses and dancers were 'two professions . . . that provide for a modern artist the most picturesque models of women in this time'. Paris was indeed famous for its laundries, but Degas in paint and Zola in print (in his novel, L'Assommoir, 1876) were the first to appreciate their artistic potential. In *Women Ironing* Degas deals with a theme which with modifications he returned to on numerous occasions. As in many of his ballet paintings he conveys the tedium of his subjects' repetitive tasks, while the physical exhaustion resulting from their labours is often graphically described in yawning and stretching gestures, creating out of an apparently mundane situation a vivid and precise record of a transient moment. The bottle, often incorrectly identified as containing wine, was actually an essential item of laundry equipment, used as a mould for the rounded starched shirt-cuffs that were then fashionable.

THE TUB, 1886

pastel, 60×83 cm $(23\frac{1}{2} \times 32\frac{3}{4} \text{ ins})$ *Jeu de Paume, Paris*

At the last Impressionist exhibition in 1886, at which Seurat's Grande Jatte stole the show, Degas presented a group of ten pastels collectively titled, 'Sequence of nudes, of women bathing, washing, drying, wiping themselves, combing their hair or having it combed'. The theme of women bathing was by no means original, having been treated before Degas by such painters as Rembrandt and Ingres, as well as in the Japanese prints which Degas and his associates collected. However, whereas Western artists had invariably placed their bathers in a classical context, Degas' were clearly contemporary scenes, which made them the subject of heated controversy. Many regarded them as obscene, especially in England where a few years later the Irish writer George Moore was to report Degas as explaining 'hitherto, the nude has always been represented in poses which presuppose an audience, but these women of mine are honest and simple folk, unconcerned by any other interests than those involved in their physical condition . . . It is as if you looked through a key-hole.' To the Victorian mind, this last remark suggested nothing less than voyeurism. In reality no artist could have been more detached from his subjects, as Degas commented: 'I show them deprived of their airs and affectations reduced to the level of animals cleaning themselves.' His concerns were rather to represent in an unidealized way the range of gestures and poses adopted by women going about their habitual activities, often viewed from unusual, sometimes unflattering

angles, as in this example where the woman is seen from above. The washstand - to Degas as important an element in the picture as the woman - cuts obliquely across the drawing, a device he applied from his knowledge of Japanese prints and photography. At the time of the exhibition of this series of pictures, Renoir marvelled at Degas' consummate ability with pastel, a medium which he found difficult to master but with which he declared Degas achieved 'the freshness of fresco'.

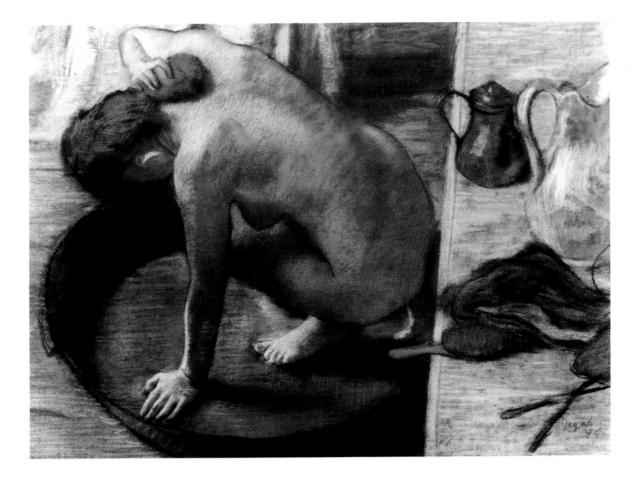

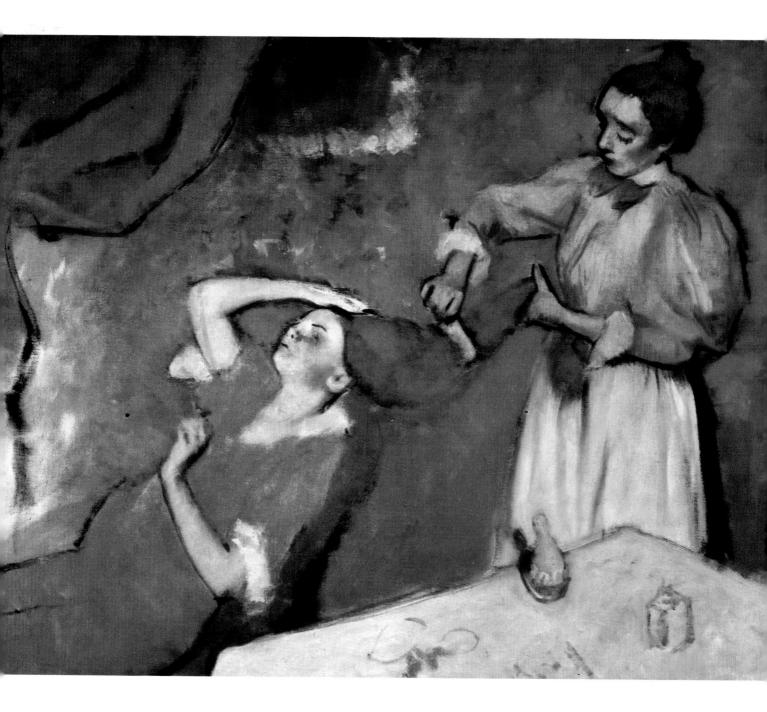

COMBING THE HAIR, 1892-5

canvas, 114 × 146 cm (45 × 5 7_2^1 ins) National Gallery, London

In this unfinished painting Degas pursued the theme of women grooming themselves which with ballet subjects was to be his principal motif in his last years. Combing the hair features in many works, and he observantly notes that the fashion for long hair often required the assistance of a maid and even so was something of a struggle, hence the woman clutches her hand to her hair as it is tugged. In later life, Degas' use of brilliant colour increased. There is little more than the suggestion of form and the hair, dress, wall and drapes are blended in a rich sea of red. By this time his eyesight had worsened to such an extent that he tackled fewer detailed subjects, turning his attention briefly to landscapes, a group of which were shown by Durand-Ruel in 1893, the only exhibition in his lifetime devoted to his work.

FOUR DANCERS, C. 1899

canvas, 151×180 cm $(59^{1}_{4} \times 70^{3}_{4} \text{ ins})$ National Gallery of Art, Washington Chester Dale Collection

As his eyesight failed, Degas' mastery of line was superseded by the increasingly lavish use of colour, which he handled with great verve on the large scale demanded by his dimness of vision. About the time this painting was executed, he wrote to a friend: 'My sight is getting decidedly worse and I am having some rather black thoughts about it', a sense of gloom that made him reclusive. Yet he succeeds with all the skill of his early years in capturing on canvas the unpremeditated gestures of the dancers as they prepare to go on stage, placing them to the left and cropping the figure on the extreme left to emphasize the space into which they are to proceed. In this and his last works painted after about 1900, by which time he could see so little that his figures are drawn without facial features and swim in swirling oceans of rich colour, he might be mistaken for a pioneer Abstract Expressionist.

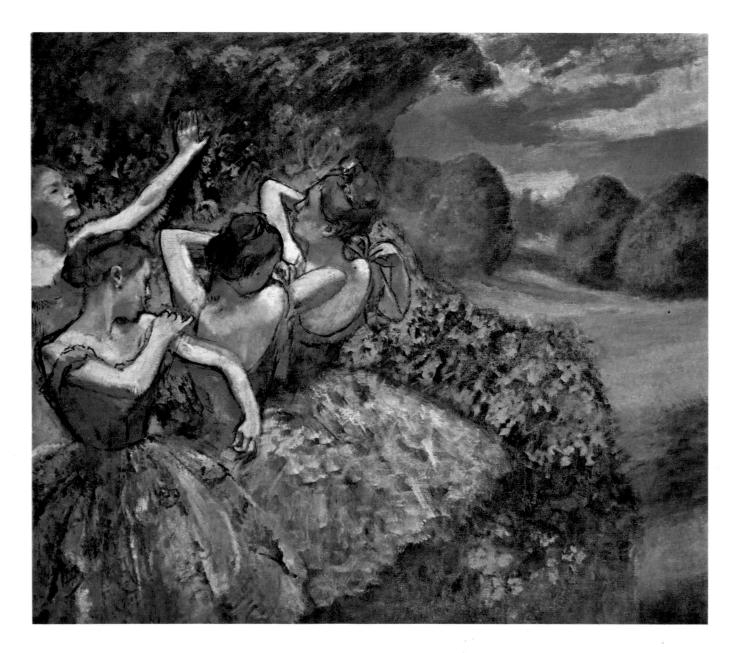

MARY CASSATT (1844–1926)

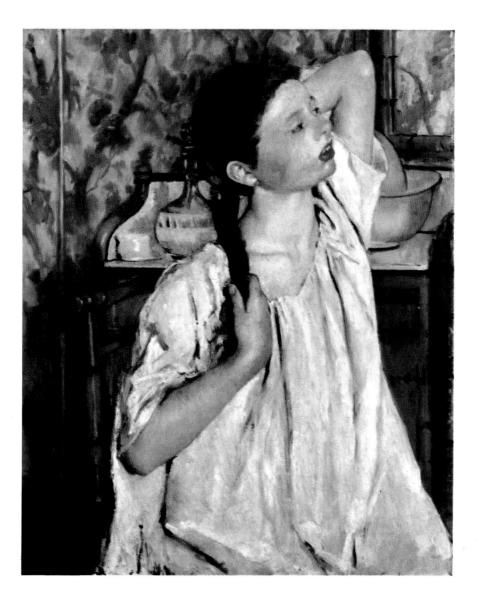

GIRL ARRANGING HER HAIR, 1886

canvas, 75 \times 62.5 cm (29 $_2^1 \times$ 24 $_2^1$ ins) National Gallery of Art, Washington Chester Dale Collection

"What drawing, what style!" was Degas' comment on seeing this painting by his pupil, Mary Cassatt, at the last Impressionist exhibition in 1886. Like Degas Mary Cassatt made no attempt to idealize her subject – an unattractive girl in an awkward pose – but she achieves the result that so impressed Degas through her subtle use of colour to contrast the figure dominating the foreground with the deeper tones of the background, and the sweeping curve of the hair and arm which provides unity to the composition.

CLAUDE MONET (1840–1926)

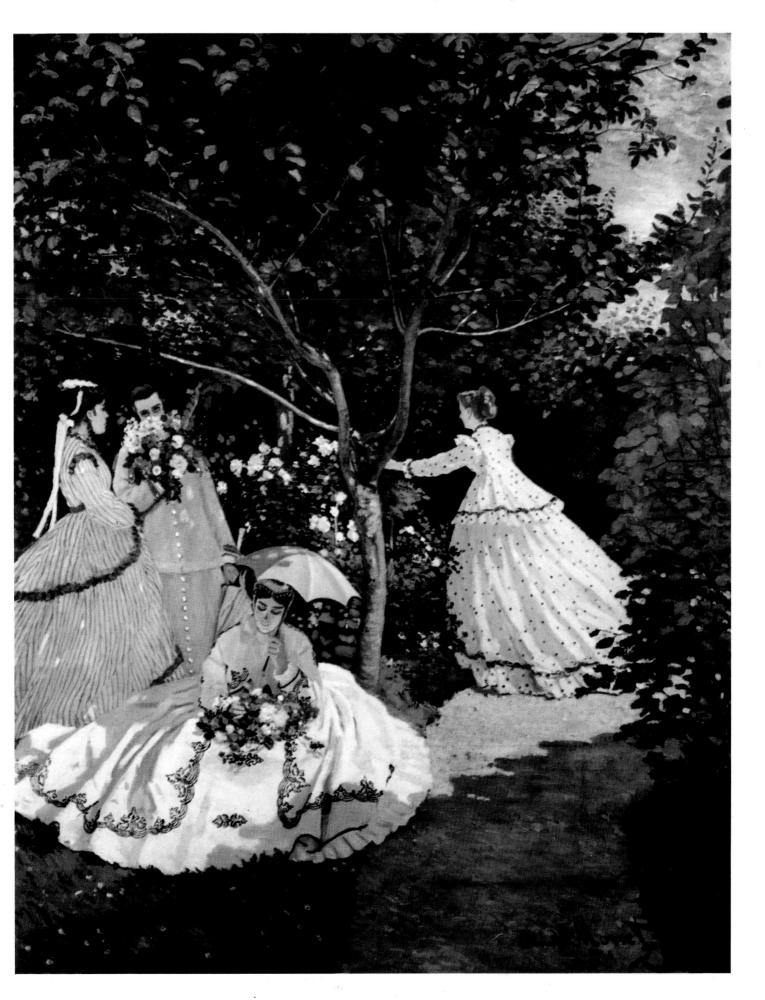

Previous page

WOMEN IN THE GARDEN, 1867

canvas, 255×205 cm $(100\frac{1}{2} \times 80\frac{3}{4}$ ins) Jeu de Paume, Paris

Monet spent the summer of 1866 in Ville d'Avray, 'experimenting with effects of light and colour', as well as evading his many creditors. This painting was the most important product of that period. Although painted on a large canvas, he was determined to execute it entirely out of doors. This meant digging a trench into which the canvas could be lowered so that he could reach the upper part, and painting under as near as possible identical lighting conditions.

HIGH TIDE AT ETRETAT, c. 1868

canvas, 66×131 cm $(26 \times 51\frac{1}{2} \text{ ins})$ *Jeu de Paume, Paris*

Monet's perpetual financial difficulties were temporarily relieved when he was commissioned to paint two portraits for the Gaudibert family at Etretat near Le Havre. There he remained with Camille Doncieux, whom he was to marry in 1870, and their son Jean through the winter of 1868-9, 'enjoying the most complete tranquillity', as he wrote to Bazille. The dramatic chalk cliffs at Etretat attracted numerous artists during the nineteenth century, including Courbet and Whistler, and it was a location to which Monet was to return in later years. On one of these occasions Hughes Le Roux was to describe how 'on November mornings, when the spray flew thicker than torrential rain, they would see Claude Monet down on the beach. With water streaming under his cape, he painted the storm amidst the swirl of the salt water.' Monet's later polychromatic studies of the same scene, which Le Roux saw him working on, represent a development that is scarcely suggested by this relatively subdued work, painted almost decoratively after the fashion of the Japanese prints which he studied. The silhouetted figures were described by the critic Gustave Geoffrov as a 'tiny group of spectators, so well observed, in their anxiety and powerlessness in the presence of a low sky, of black rocks, and an angry sea unfurling its strong waves against the puny figures, so small before the high billows and the furious gallops of the sea'.

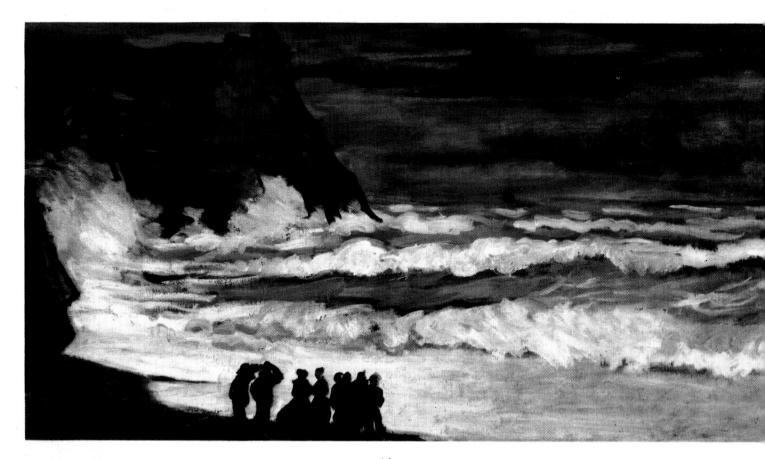

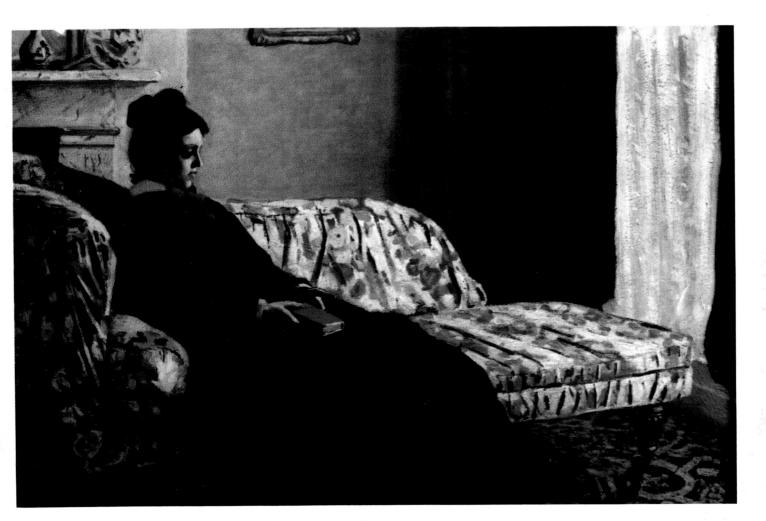

MADAME MONET ON THE COUCH, c. 1871 canvas, 48×75 cm $(19 \times 29^{1}_{2} \text{ ins})$ *Jeu de Paume, Paris*

Monet and Camille, with whom he had been living since 1866, were married on 28 June 1870, less than three weeks before the outbreak of the Franco-Prussian War. Both before and after this time, Camille was Monet's favourite model. She was also painted by Manet and Renoir.

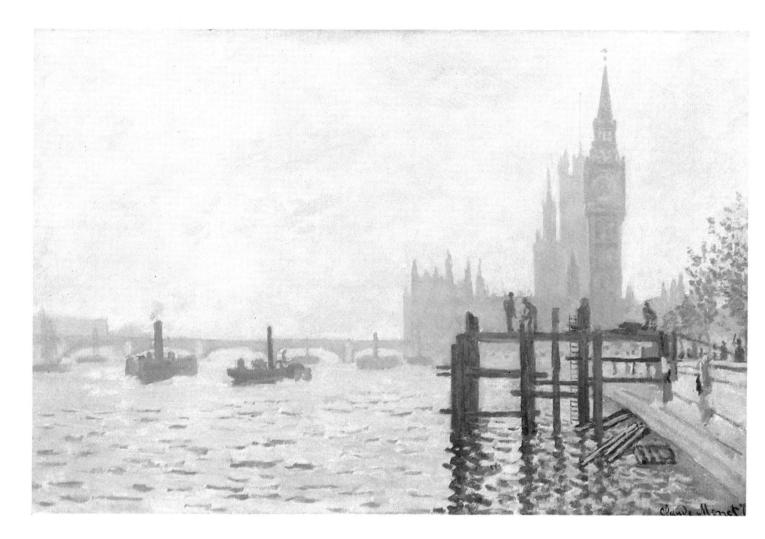

THE THAMES BELOW WESTMINSTER, 1871

canvas, 47×72.5 cm $(18\frac{1}{2} \times 28\frac{1}{2}$ ins) National Gallery, London

Monet spent the period of the Franco-Prussian War and the Commune (1870-1) in London where he met up again with Pissarro. Like James Whistler, who was working in London at the same time, he found the River Thames a continually fascinating subject. Although they did not work together, and there is no evidence that they made contact at this time, both Monet and Whistler were concerned with the decorative harmonies that could be achieved in their paintings, deriving much inspiration from their knowledge of Japanese prints. Monet's mastery of depicting water through the use of long brush-strokes is displayed as ably in this foggy river scene as in his brilliant summer subjects such as those painted at Argenteuil (page 91). The contrast with his later painting of a similar view (page 102) emphasizes his subsequent departure from this 'pure Impressionist' period.

REGATTA AT ARGENTEUIL, 1872

canvas, 48×75 cm $(19 \times 29\frac{1}{2} \text{ ins})$ Jeu de Paume, Paris

Returning to France after the War, Monet settled in Argenteuil where his friend and patron Gustave Caillebotte lived and where he stayed until 1876. It was there that the characteristics of his 'pure Impressionist' style were most fully developed. Renoir, Manet and other members of the group joined him at different times – Renoir's work in particular becoming almost indistinguishable from Monet's. His use of large dashes of pure, bright colour and his special ability to depict the changing effects of light on water are apparent in this painting. As Zola remarked of Monet a few years previously: 'With him water is lively, deep, true, everywhere. It chops around the barques with greenish islets broken up by white glimmers. It extends in glaucous pools suddenly swept by a gust of wind, it increases the size of the masts which it reflects by breaking up their image, it has pallid and dull shades which come to light quite distinctly.'

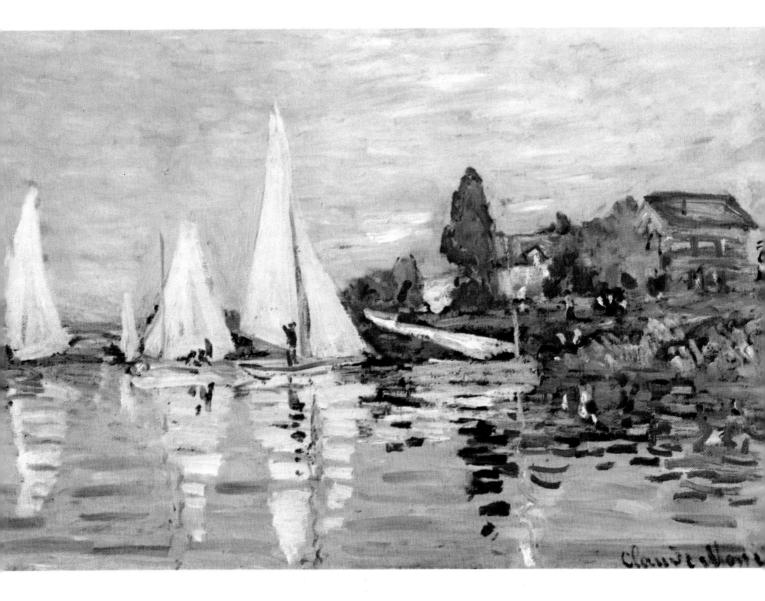

IMPRESSION, SUNRISE, 1872

canvas, 48×64 cm $(19\frac{1}{2} \times 25\frac{1}{2}$ ins) Musée Marmottan, Paris

Staying in Le Havre in 1872, Monet painted two views of the harbour, one showing sunrise, the other sunset. Although recent evidence has suggested that this painting has been mistitled and is in fact *Sunset*, while *Sunrise* (in a French private collection) is the one exhibited at the first Impressionist exhibition in 1874, it remains probable that this is the work which Louis Leroy saw at the exhibition and from which the title for the entire group was derived. It is by no means the most typical of Monet's paintings of this period, and its main interest stems from its historical significance in supplying the movement with a name: apparently the painting was titled at the time of its hanging and Monet was as surprised as his colleagues when the name was seized on by Leroy. The members of the group were never in universal agreement over the use of the term 'Impressionist', which was applied to the title of the third exhibition in 1877, but dropped from others. Several argued strongly against using it at all – most notably Degas – but so widely did it become adopted that it proved impossible to shake off the title by which the movement has since been internationally called.

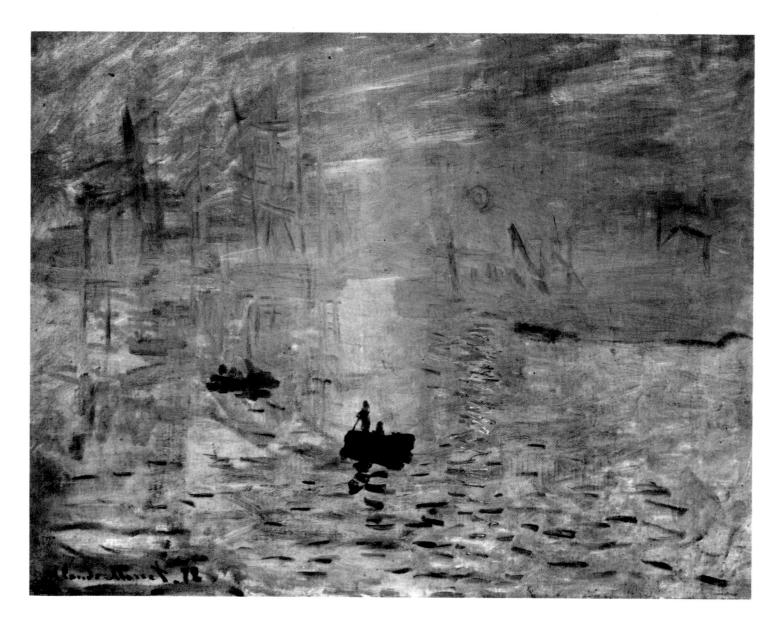

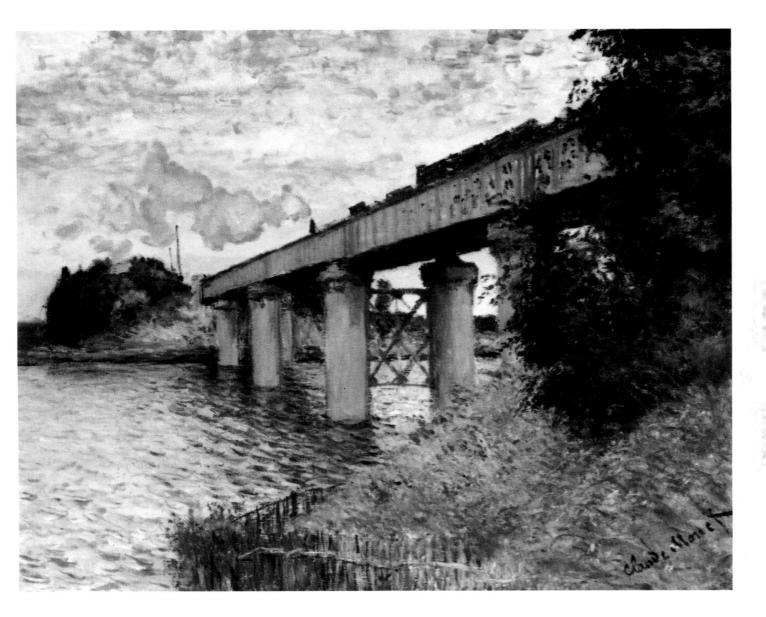

RAILWAY BRIDGE AT ARGENTEUIL, C. 1873

canvas, 54×71 cm $(21\frac{1}{4} \times 28$ ins) Jeu de Paume, Paris

During his period of residence at Argenteuil, Monet painted the road and rail bridges on many occasions. The railway was a relatively new phenomenon to artists of Monet's generation and provided a symbol of the modern age. In this painting Monet portrays the solid iron and stone structure of the bridge and the steam of the partly obscured locomotive as elements in a decorative composition based on triangular masses, confirming also his consummate ability to depict sky and water.

THE LUNCHEON, C. 1873

canvas, 160×201 cm $(63 \times 79^{1}_{4}$ ins) Jeu de Paume, Paris

Monet's domestic life during his settled period at Argenteuil, after the tribulations of his early years and the upheavals of the Franco-Prussian War, provided him with the subject for a number of paintings. This is one of eight of figures in his garden painted in 1873. As in the others his son Jean, then six years old, appears, but it has been pointed out that he is frequently isolated from the other people in the painting. One of the figures in the background is presumably Camille, emphasizing the psychological separation that is known to have existed between her and her son.

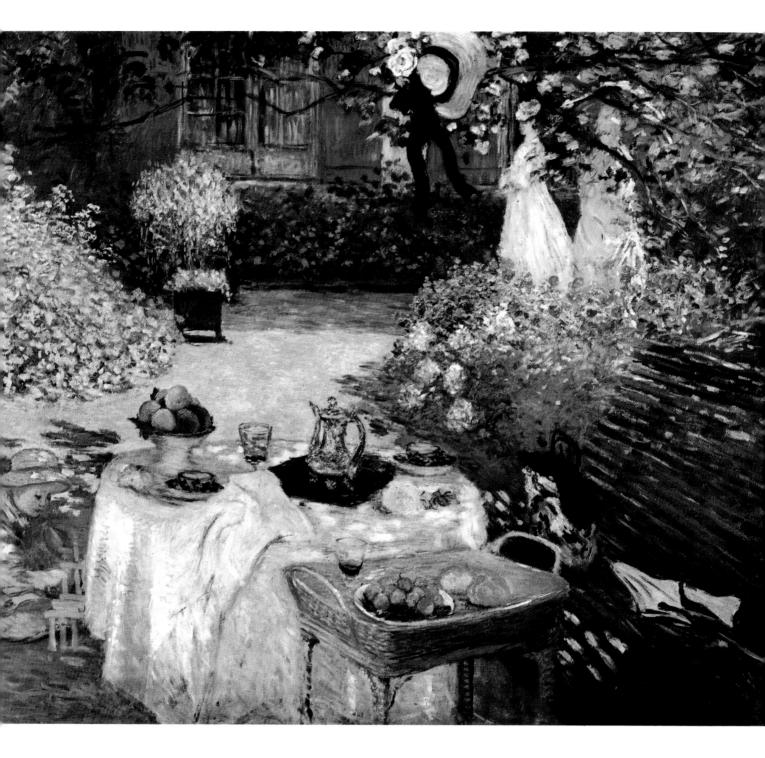

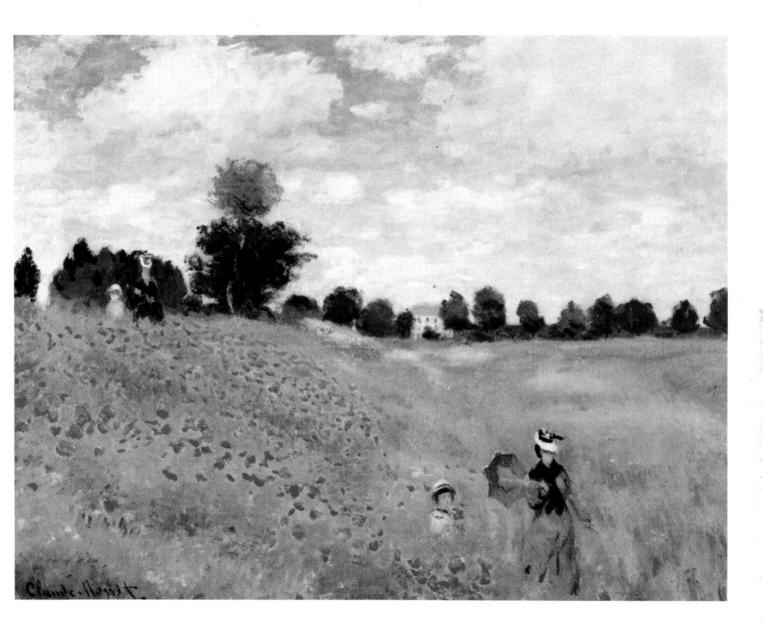

A FIELD OF POPPIES, 1873

canvas, 50×65 cm $(19^3_4 \times 25^1_2 \text{ ins})$ Jeu de Paume, Paris

'Here human beings pass as glimmers and a glimpse of everything is had through the transparent atmosphere . . . everything is illuminated and quivers under waves of light propagated in space', wrote Gustave Geoffroy of Monet's painting of his wife and son. Their faces are not rendered in detail, emphasizing the fleeting nature of Monet's 'impression' of the scene. It was painted in his tranquil period at Argenteuil from 1872 to 1875 and bears close comparison with works by Renoir from the same period. The enhanced colour of the red poppies against a green background derives from the fact that they are complementary colours, but it is more likely that Monet painted this instinctively rather than as a result of his study of colour laws.

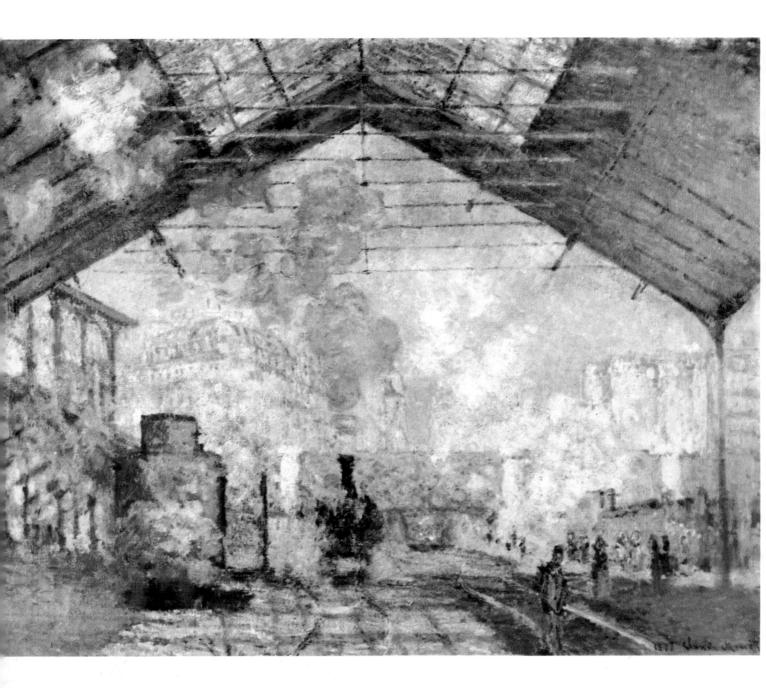

GARE SAINT-LAZARE, 1877 canvas, 75.5 \times 104 cm (29³/₄ \times 41 ins)

Jeu de Paume, Paris

Manet and Monet's patron, Gustave Caillebotte, among other artists, had found the St-Lazare railway station a rewarding subject. Monet turned to the same scene in 1877, renting an apartment in the rue Moncey so that he would be near the station. In this, as in his other paintings in the same series, Monet's move toward abstraction is evident: his evocative use

of colour to depict light and shade and atmospheric effects takes precedence over his representation of the subject itself – although the modernity of the railway was in keeping with the anti-Salon contemporaneity promulgated by Manet and his followers. Monet did not place any emphasis on the social implications of the railway, its significance as a feat of engineering or its grimy splendour, but used it to develop his experiments with colour. Writing later of Monet's series of paintings of the Gare St-Lazare, which were shown at the

third Impressionist exhibition in 1877, the critic Lionello Venturi commented: 'Monet wanted to reveal that even a black machine and a mass of black panes could be depicted by blue, that the dirty grey of the ground could be seen as green, and that the smoke itself could become light.'

LAVACOURT, WINTER, 1881

canvas, 59 × 80 cm $(23\frac{1}{2} \times 31\frac{3}{4} \text{ ins})$ National Gallery, London

Monet moved to Vétheuil, near Paris, in August 1878. There his wife Camille was taken ill and was attended to by the wife of his former patron, Ernest Hoschedé, now bankrupt and compelled to sell his collection of Impressionist paintings for disastrously low prices. Camille died the following year, and Monet remained in Vétheuil where he devoted himself to landscapes painted in the summer from his houseboat on the Seine, and in the winter with his easel imbedded in the ice on the river. This wintry view of Lavacourt, on the other side of the river from his home, is one of many paintings of snow and ice painted at this time. Monet remained absorbed throughout his life with the changes brought about by nature, particularly at Vétheuil where he painted under the most adverse weather conditions to achieve the desired result.

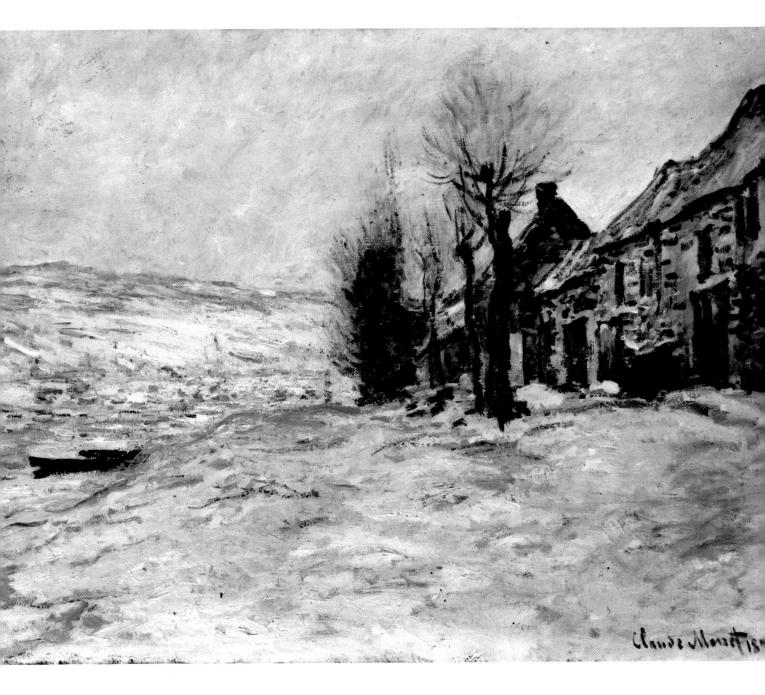

THE BOAT AT GIVERNY, c.1887canvas, 98×131 cm $(38\frac{1}{2} \times 51\frac{1}{2}$ ins) *Jeu de Paume, Paris*

In April 1883 Monet moved to Giverny, to the west of Vétheuil, with Mme Hoschedé, whom he later married and whose large combined family grew up there. This was to be Monet's principal home for the rest of his life; his gardens, water-lily pool and its bridge provided him with a range of motifs to which he continually returned – boats on his private pool featuring on several occasions. Paintings of this period show Monet adopting more intense colour after his period of paler, washed-out tones. He now wanted to turn his naturally deft hand to more difficult feats and found at Giverny the challenge of new conditions offered by river life and reflections in water. He talked of painting that which it is 'impossible to do', like the grass which grows on the river bed and can be seen, through the reflections, flowing in the current.

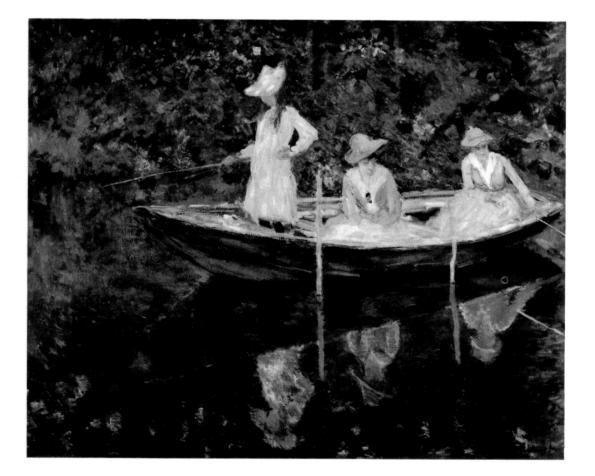

HAYSTACKS AT SUNSET, 1891

canvas, 63.5×99 cm $(25 \times 39^{1}_{4} \text{ ins})$ Art Institute of Chicago

Near his home in Giverny Monet began painting a series of works depicting haystacks under different lighting conditions, 15 of which were exhibited at Durand-Ruel's gallery in 1891. When he started, he thought that two canvases would suffice – one to express the effect of

dull light, the other in full sunshine – but as he progressed he recognized the infinite diversity of effects resulting from slight changes in the light, often so subtle that those who observed him at work were unable to appreciate them. Monet's haystacks series marks the beginning of his preoccupation with painting extensive groups of works featuring the same subject at various times of the day or different seasons, designed to be viewed as a group rather than individually. To him each painting was 'a true impression of a certain aspect of nature and not a composite picture'. It is recorded that the abstract artist Vasily Kandinsky first became aware of the potential of colour on seeing one of the haystacks series on display in Moscow. The series was also financially rewarding, all the paintings being sold quickly.

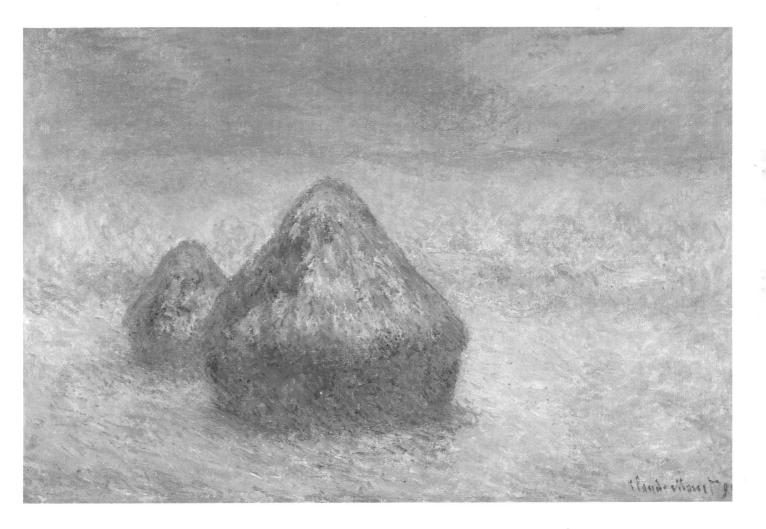

Overleaf

THE CATHEDRAL OF ROUEN, HARMONY IN BROWN, 1894

canvas, 107×73 cm $(39^{1}_{4} \times 25^{1}_{2}$ ins) Jeu de Paume, Paris

As with his *Haystacks*, Monet used the façade of Rouen Cathedral as a motif that he could paint under a range of different atmospheric conditions from dawn to dusk. Twenty of these were exhibited at Durand-Ruel's in 1895. Seeing them, Pissarro wrote: 'I am quite carried away by this unusual mastery . . . it is a deliberate work, long considered, pursuing the fleeting nuance of effects which I see achieved by no other artist.'

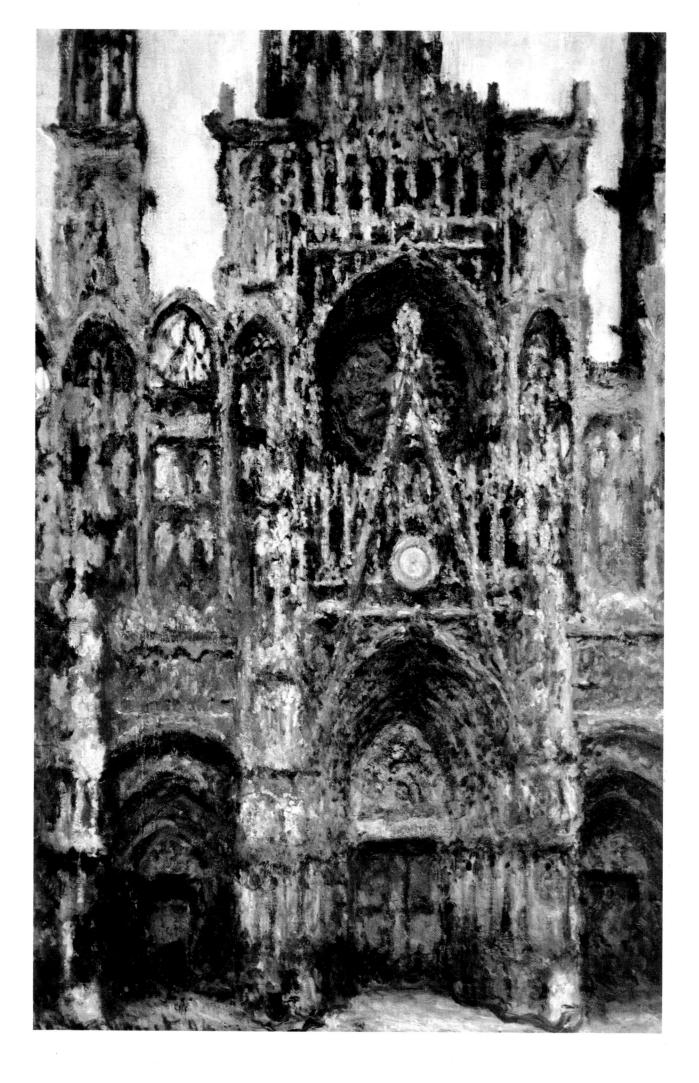

THE LILY POND, HARMONY IN PINK, 1900

canvas, 89.5 × 100 cm $(3.5 \times 3.9^{1}_{4} \text{ ins})$ Jeu de Paume, Paris

In 1900 Monet exhibited 13 paintings of the lily pond in his garden at Giverny, six of which, including this version, featured the Japanese bridge. It was largely through his more monumental canvases of the pond, exhibited in his later years, that Monet became internationally famous, but Charles Péguy believed these earlier studies revealed more: "When did he paint them best? Which versions were most successful? One's logical impulse would be to say the *last*, because he knew more . . . But I, on the contrary, say the *first*, because he knew *less*." Many writers and fellow artists believed that in his final years Monet degenerated into technical slickness, losing much of his early intuitive brilliance.

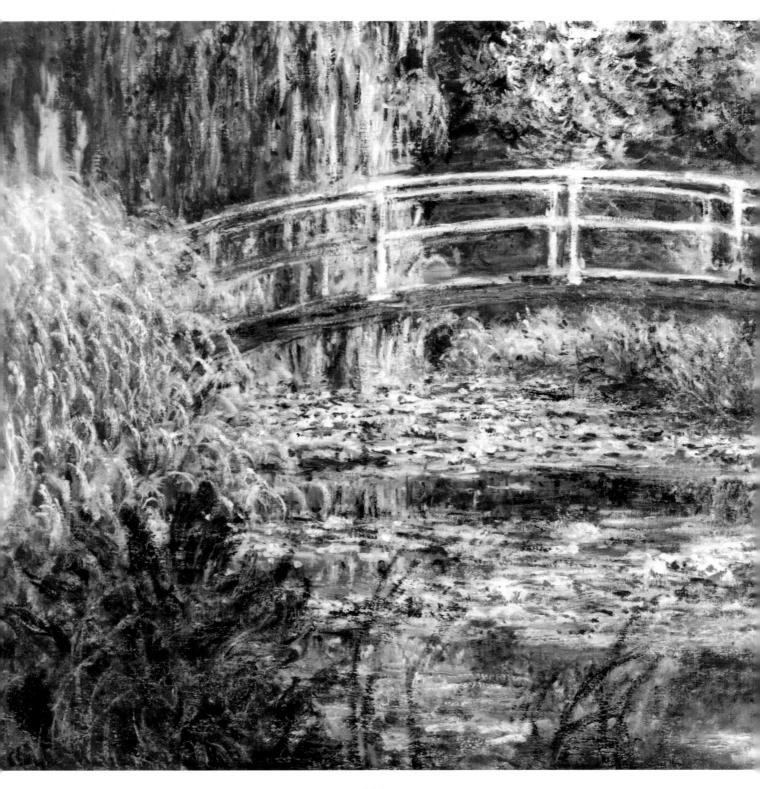

THE HOUSES OF PARLIAMENT, LONDON, 1904

canvas, 81×92 cm $(31_4^3 \times 36_2^1 \text{ ins})$ Jeu de Paume, Paris

In 1899 Monet revisited London. On this and on subsequent visits in 1900 and 1901, he painted the Thames from his room in the Savoy Hotel, and the Houses of Parliament from a room in St Thomas's Hospital on the South Bank of the river. As with the other series of paintings which occupied his later years, Monet executed innumerable examples at different seasons and different times of day, but, starting with the haystacks series, he began to complete his works in the studio. In his Thames views he had as many as 100 canvases in progress at the same time, returning to each perhaps 20 or 30 times as the lighting conditions most closely corresponded: 'Feverishly searching among these starts, I would choose one that did not differ too much from what I saw.' This erratic process exhausted him both physically and mentally, and led to his return to the formerly repudiated method of studio finishing, where he could work at leisure and contemplate the effects he was striving to achieve.

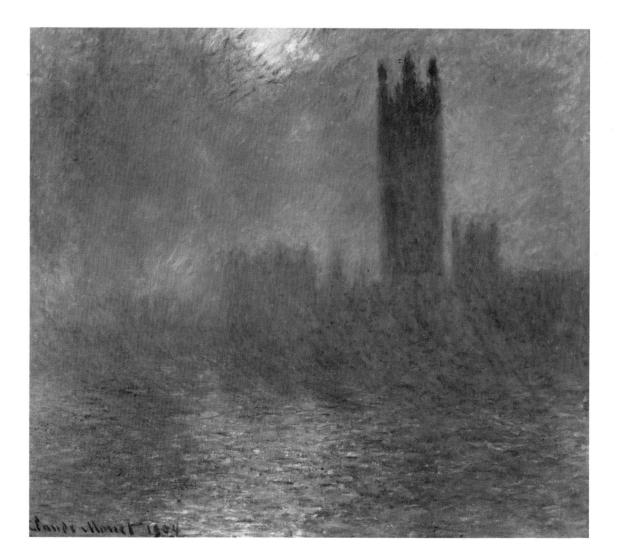

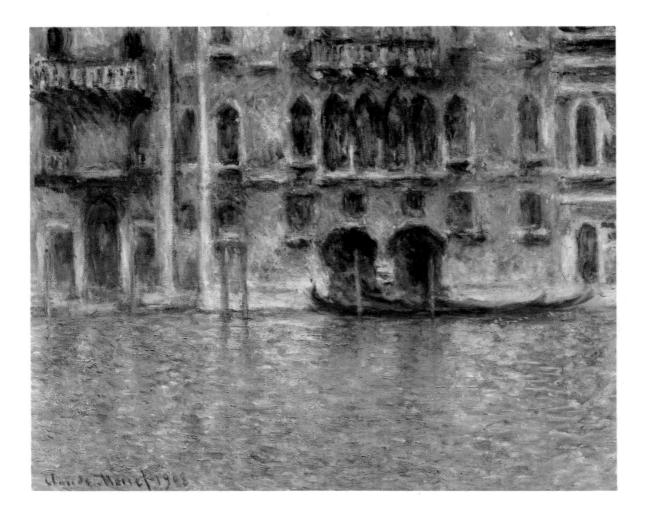

PALAZZO DA MULA, VENICE, 1908

canvas, 62×81 cm $(24_2^1 \times 31_4^3 \text{ ins})$ National Gallery of Art, Washington Chester Dale Collection

Monet visited Venice in 1908 while recuperating from illness and problems with his eyesight. An exhibition of his work held in 1912 included 29 views of the city, two of them of the Palazzo da Mula, this one showing it at dusk. By now he was revered as the 'father of Impressionism', and his influence on the Neo- and Post-Impressionists was generally acknowledged. Paul Signac, the Neo-Impressionist, wrote to him: 'On seeing your paintings entitled "Venice", the splendid interpretations of these subjects so familiar to me, my feeling was as complete and as strong as the one which I had, about 1879, on seeing your *Modern Life*, your Railway Station, your Streets decked with flags, and which decided my career.'

PIERRE AUGUSTE RENOIR (1841–1919)

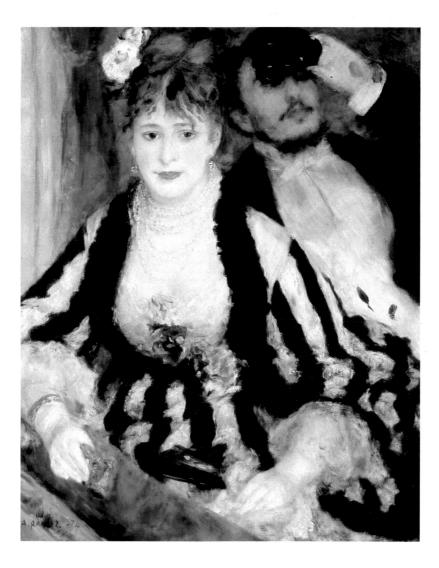

LA LOGE (THE THEATRE BOX), 1874 canvas, 80×64 cm $(31\frac{1}{2} \times 25$ ins) Courtauld Institute Galleries, University of London

One of six paintings by Renoir in the first Impressionist exhibition in 1874, La Loge is both a portrait (of the model Nini Lopez and Renoir's brother Edmond) and a scene of contemporary life. After the exhibition, Renoir tried to sell the painting for 500 francs, but was forced to accept 425 from the dealer, 'Père' Martin - the precise sum he needed to cover his rent and typical of the hand-to-mouth existence of the Impressionists at this time. Although Renoir had learned much from working alongside Monet, this picture was executed in his studio in the traditional manner. His use of black was contrary to the evolving Impressionist ideal. However, the result is a painting of considerable delicacy and charm and one of many similarly successful portraits for which Renoir was to achieve the greatest acclaim.

PORTRAIT OF CLAUDE MONET, 1875

canvas, 85×60.5 cm $(33\frac{1}{2} \times 23\frac{1}{2}$ ins) Jeu de Paume, Paris

Renoir visited Monet at Argenteuil after the 1874 exhibition and painted several portraits of him and his family. This was a particularly bleak period in Renoir's life: at the disastrous sale at the Hôtel Drouot his paintings gained the lowest prices of all and his attempt to have paintings exhibited at the Salon was unsuccessful. However, he met the collectors Victor Chocquet and Gustave Caillebotte at this time and they were to provide him with the financial support he desperately needed.

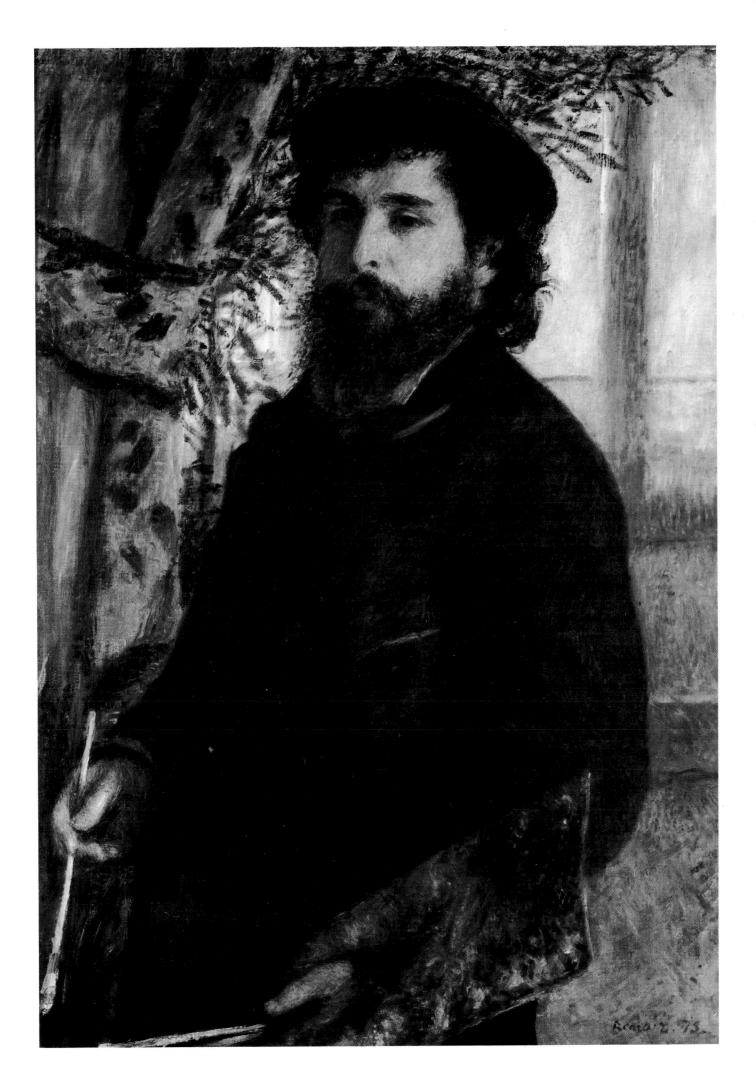

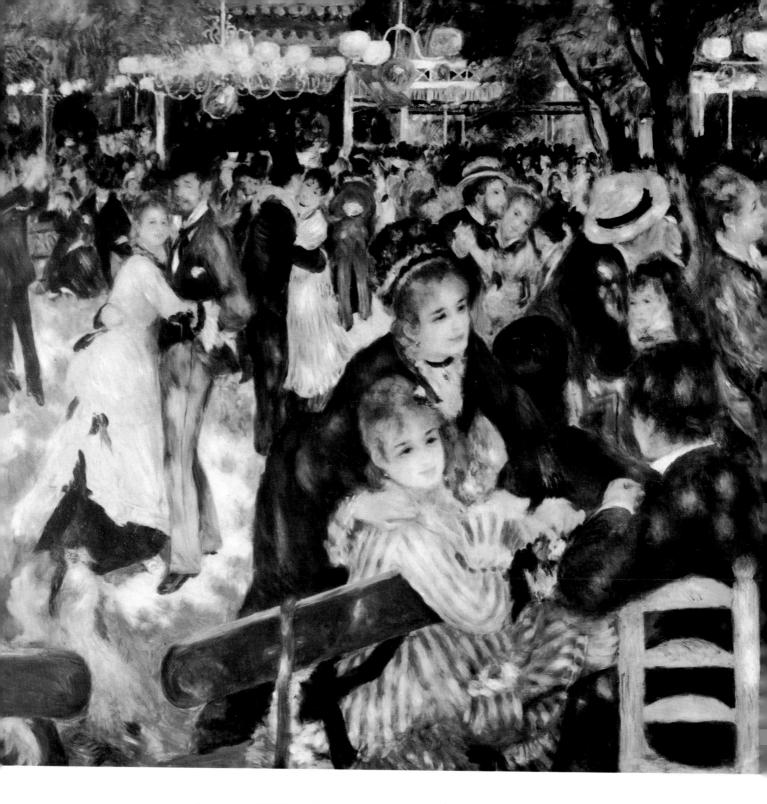

THE MOULIN DE LA GALETTE, 1876

canvas, 131×175 cm $(51\frac{1}{2} \times 68$ ins) Jeu de Paume, Paris

The windmill in Montmartre, Paris, converted into an open-air dance hall and known as 'la Galette' after a kind of cake served there, was a popular weekend venue for working-class people, students and artists. It offered 'a pleasurable suggestion of low life', as one writer described it. Renoir took this canvas there every Sunday for a number of weeks, painting entirely on the spot. As in Manet's *Tuileries* (page 51), the subjects were mostly the artist's friends, one of whom, Georges Rivière (seated at the table on the right), described the painting in his journal *L'Impressionisme* as 'a page of history, a precious monument of Parisian life depicted with rigorous exactness; nobody before him had thought of capturing some aspects of daily life in a canvas of such large dimensions'.

WOMAN READING, 1874

canvas, 46.5 × 38.5 cm (18 × 15 ins) Jeu de Paume, Paris

Renoir's debt to such French masters as Fragonard is exemplified by this portrait, one of many of women engaged in such simple pursuits as reading and sewing. It was through his particular ability to create charming paintings of women and children in relaxed and natural attitudes that Renoir became one of the first of the Impressionists to receive portrait commissions – an important contributing factor in the general acceptance of the Impressionist style among collectors and the public at large. The model here was Margot, a favourite of Renoir's for several years. She appears in his *Moulin de la Galette* (page 106) and many other compositions between this period and her death from typhoid in 1881.

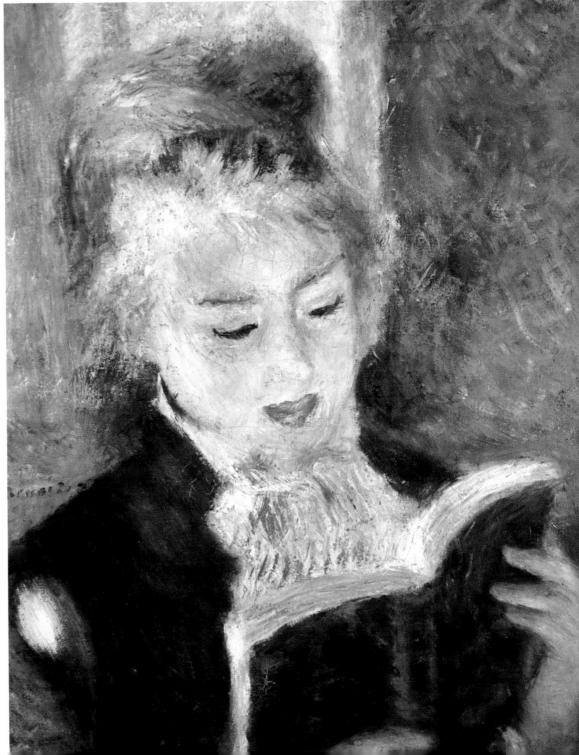

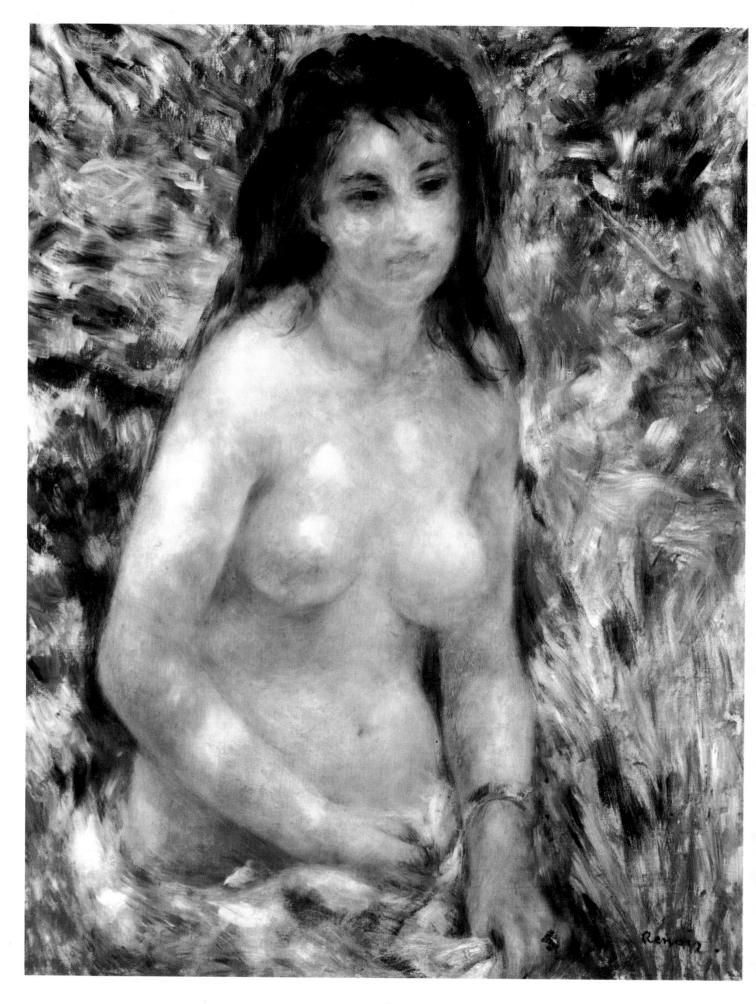

NUDE IN THE SUNLIGHT, C. 1876

canvas, 81×64.8 cm $(31\frac{3}{4} \times 25$ ins) Jeu de Paume, Paris

'Try to explain to M. Renoir that a woman's torso is not a mass of flesh in the process of decomposition with green and violet spots which denote the state of complete putrefaction of a corpse!' wrote Albert Wolff about this painting. Typical of the derision that greeted Impressionism, Wolff's criticism disregarded Renoir's ability to introduce innovations like the effect of sunlight passing through leaves, causing human flesh to take on a mottled appearance.

BANKS OF THE SEINE AT CHAMPROSAY, 1876

canvas, 55 × 66 cm $(21\frac{1}{2} \times 26 \text{ ins})$ *Jeu de Paume*, *Paris*

It was at the home of his friend the writer Alphonse Daudet at Champrosay that Renoir met Georges Charpentier, the publisher of Daudet, Zola and Maupassant. Charpentier became one of Renoir's most important patrons. This landscape, painted at the time of their meeting, is less characteristic than Renoir's portraits: when his colleagues acclaimed the virtues of landscape, he remarked, 'Alas, I am a painter of figures.'

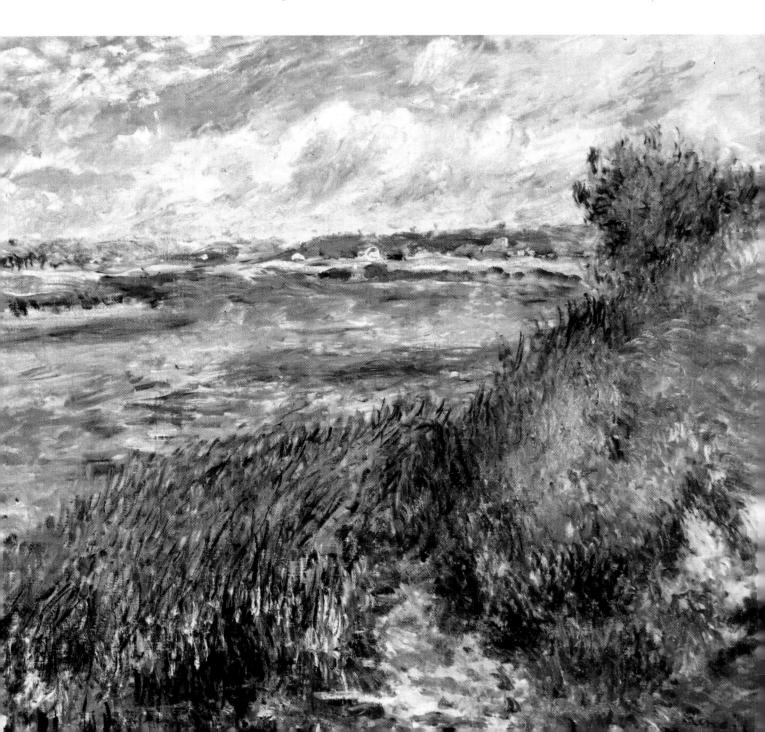

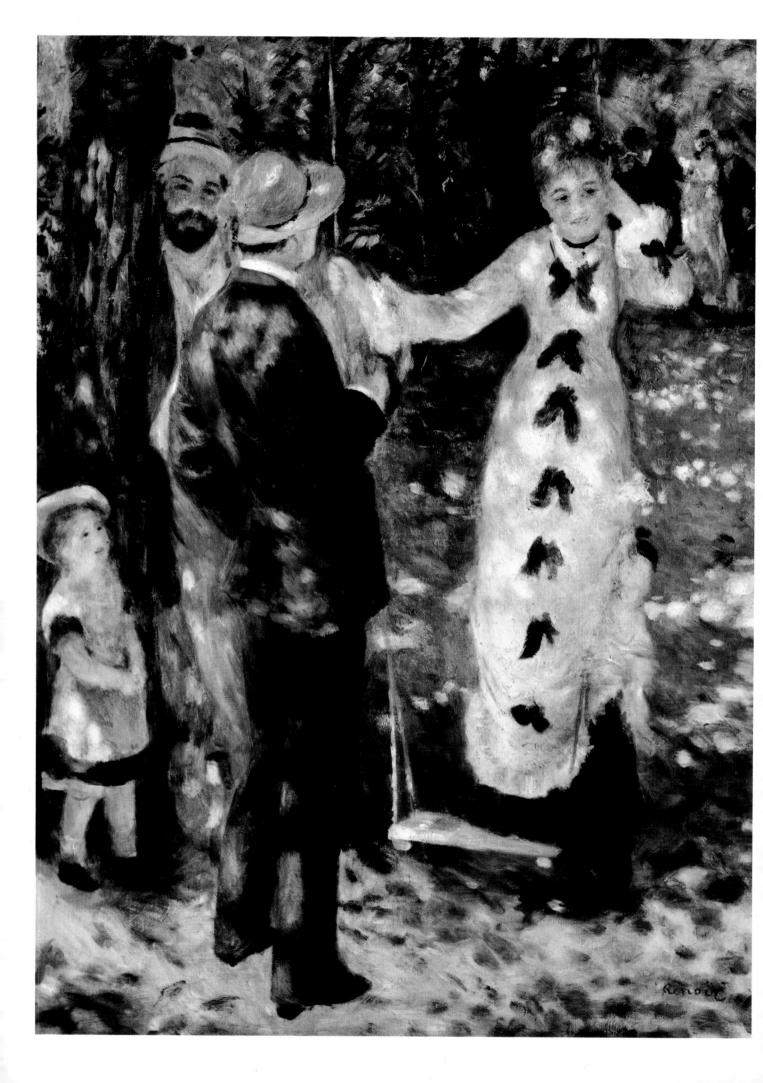

THE SWING, 1876

canvas, 92×73 cm $(36 \times 28\frac{3}{4} \text{ ins})$ Jeu de Paume, Paris

Painted in the garden of his house in the rue Cortot, this painting, shown at the third Impressionist exhibition in 1877, features his current favourite model, Jeanne, who also appears seated in the centre foreground of his *Moulin de la Galette* which was painted at the same time. Renoir excelled in painting happy people in sunny settings, here using a motif to which he frequently returned – the dappling effect of light rays passing through the leaves and branches of a tree.

PATH CLIMBING THROUGH THE LONG GRASS, c. 1876-7

canvas, 60×74 cm $(23\frac{1}{2} \times 29$ ins) Jeu de Paume, Paris

Renoir made no attempt to delineate the people or landscape in detail, offering instead in the Impressionist style a fleeting glimpse, remarking, 'some things in a canvas gain by being sketched and left to the imagination. It is a matter of feeling.' Some critics held that Renoir failed to convey nature as effectively as some of his colleagues, Philippe Burty going so far as to state: 'Renoir is generally no good at landscapes. It seems as if he were somehow bewildered by daylight, and he sees bright patches, splashes and rays of light, jets falling from the clouds or arrows flying through leaves and branches.' But to the art historian Maurice Sérullaz, this painting is a major 'summary of Impressionism', although the subject is almost banal.

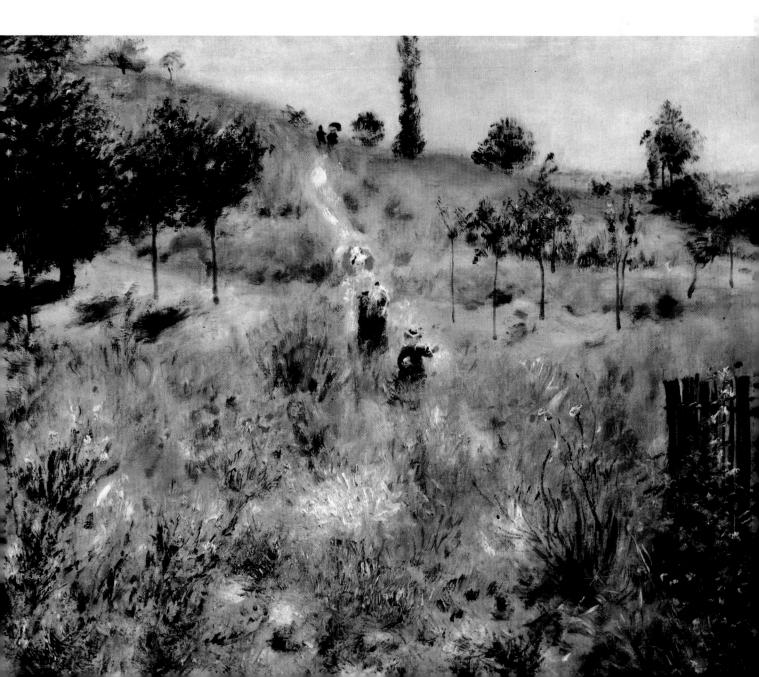

THE ROWER'S LUNCH, C. 1880

canvas, 54.7×65.5 cm $(21\frac{1}{2} \times 25\frac{3}{4}$ ins) Art Institute of Chicago

This painting, executed in the period immediately before Renoir was to change his style to one with fit.ner outlines and a greater element of construction, contains all of the most obvious attributes of Impressionism – an outdoor scene by a river, with the sun flickering through trellis-work, small dabs of paint, feathery brush-strokes and coloured shadows. But it also contains a happiness, a *joie de vivre*, which of all the Impressionists is mainly found in the work of Renoir; his paintings of ordinary working people exude an aura of urban relaxation and of contentment with the simple pleasures of life. The miseries caused by his financial worries were seldom reflected in his outlook on life, or in his work.

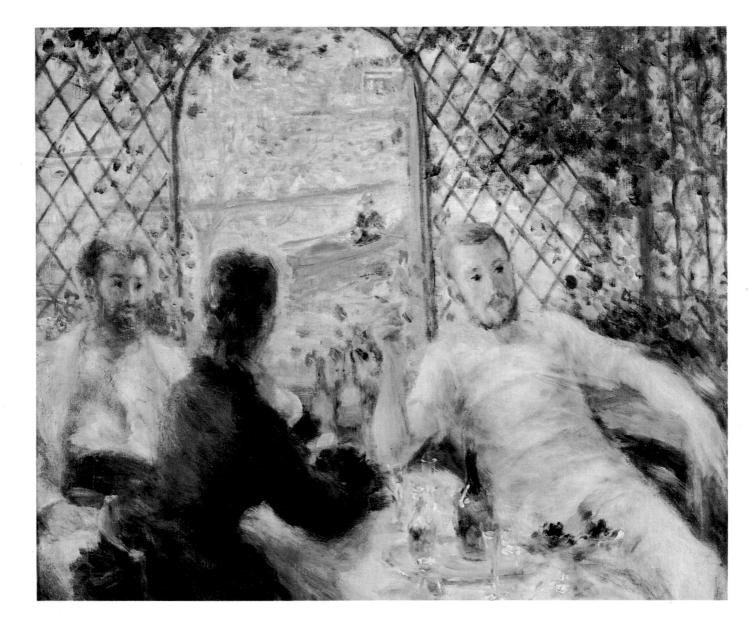

Opposite page

RAILWAY BRIDGE AT CHATOU, 1881

canvas, 54×65.7 cm (21 × 25³/₄ ins) *Jeu de Paume, Paris*

Painted in the same period as his *Luncheon of the Boating Party*, Renoir's excursion into landscape in which the figure is subordinated to a minor role is clearly less successful than his more characteristic works in which he depicts women and children, holidaymakers and nudes.

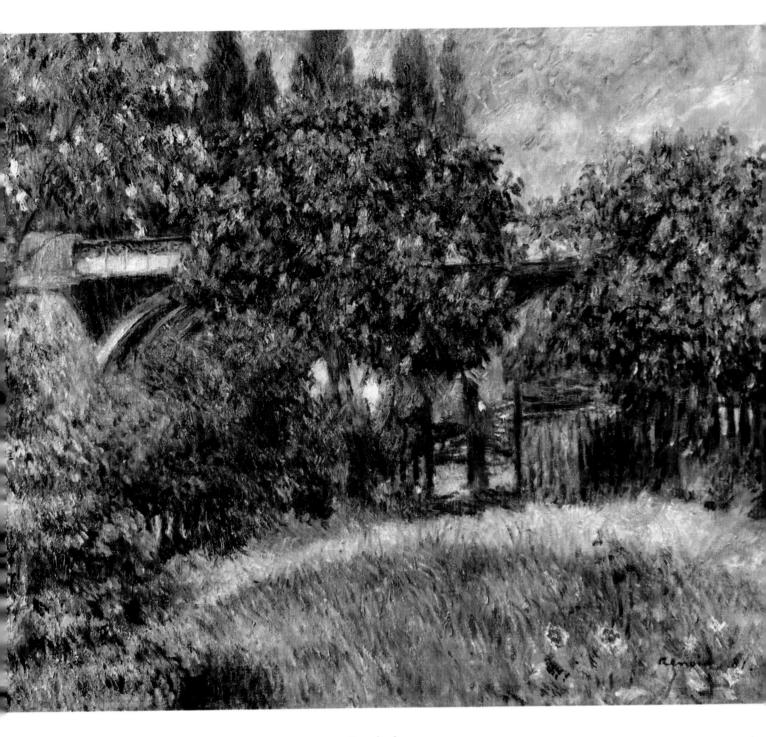

Overleaf

LUNCHEON OF THE BOATING PARTY, 1881

canvas, 129 × 173 cm (51 × 68 ins) Phillips Memorial Gallery, Washington

In 1881 Renoir travelled to Algiers and then returned to France where he painted at Chatou and Bougival. At the Restaurant Fournaise on the island of Chatou he painted this scene of holidaymakers, featuring a number of friends, including, on the left, Aline Charigot, whom he was later to marry. In the right foreground, wearing a straw hat, is Gustave Caillebotte, one of Renoir's wealthy patrons who owned among other works his *Swing* (page 111) and

Moulin de la Galette (page 106). Caillebotte helped organize the seventh Impressionist exhibition in 1882, at which this painting was shown and admired by many, including

Eugène Manet who wrote to his wife Berthe Morisot that 'the picture of rowers by Renoir looks very well'. The theme was one to which the Impressionists often returned. As the critic René Gimpel commented: 'The Impressionists show their particular talent and attain the summit of their art when they paint our French Sundays . . . kisses in the sun, picnics, complete rest, not a thought about work, unashamed relaxation.' The painting was largely executed in the studio; already Renoir was moving towards the conclusion that pure

Impressionism carried out in the open imposed too many restrictions.

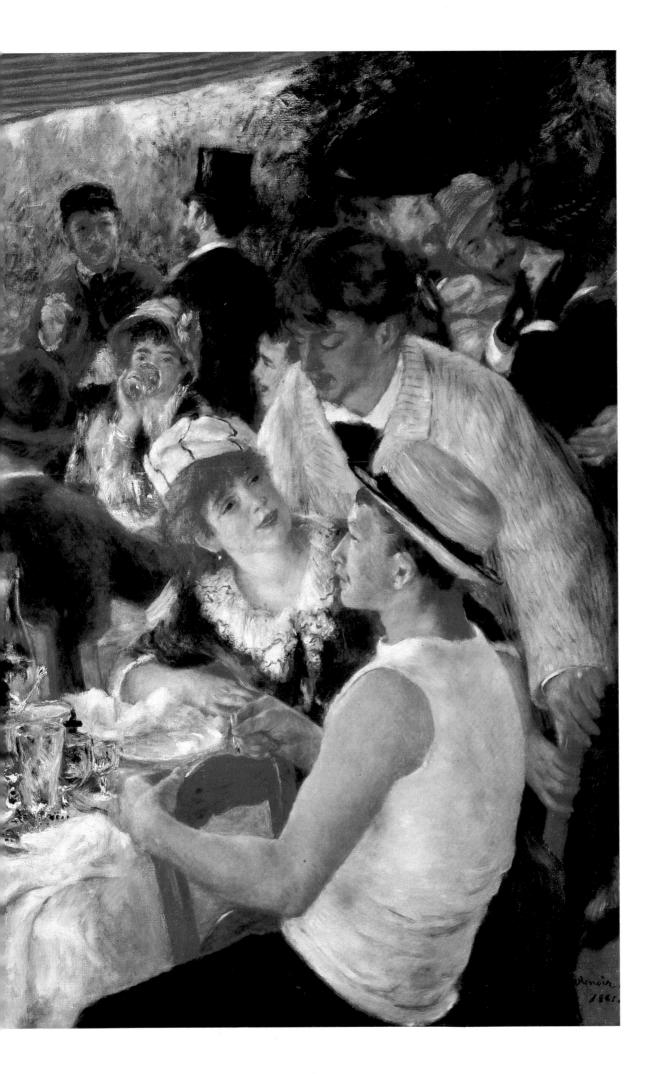

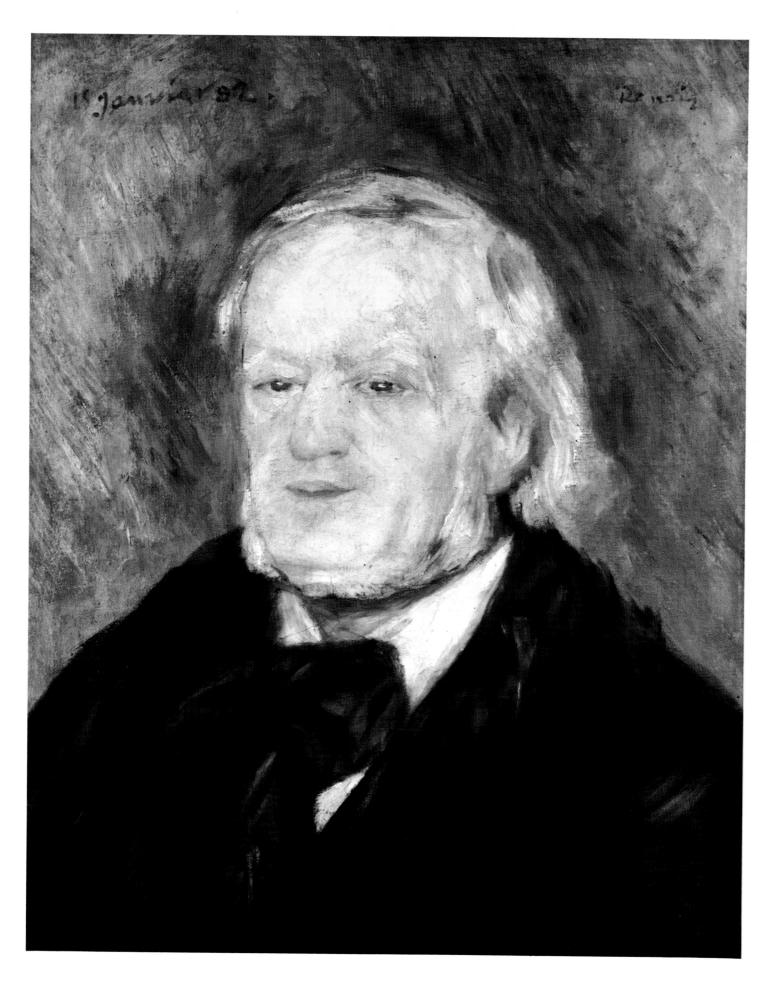

RICHARD WAGNER (1813–83), 1882

canvas, 53 × 46 cm $(20\frac{3}{4} \times 18 \text{ ins})$ Jeu de Paume, Paris

Many of the Impressionists and their circle were admirers of the composer Richard Wagner, whom Renoir met and painted in Italy. After working in Capri, Renoir travelled from there to Palermo where on 15 January 1882 he visited Wagner on the introduction of their mutual friend, Judge Lascaux. Wagner agreed to sit for his portrait but, as Renoir described,

although he was 'in a jolly mood', he allowed him only 35 minutes and was unappreciative of the result. He also reputedly spent the entire sitting delivering an anti-Semitic tirade.

DANCING AT BOUGIVAL, 1883

canvas, 180×98 cm $(70^3_4 \times 38^1_2 \text{ ins})$ Museum of Fine Arts, Boston

Renoir's brother Edmond and his model Suzanne Valadon posed for this work, which contains elements of the gaiety of his previous *Moulin de la Galette* (page 106) and *Luncheon of the Boating Party* (page 114). However, despite the obvious Impressionist methods, Renoir was by now seeking a more classically linear and modelled style and a concern for detail that has resulted in his including such minutiae as used matches and cigarette butts on the ground. This near life-size work was exhibited soon after completion by Durand-Ruel in London where Renoir had a small but growing following.

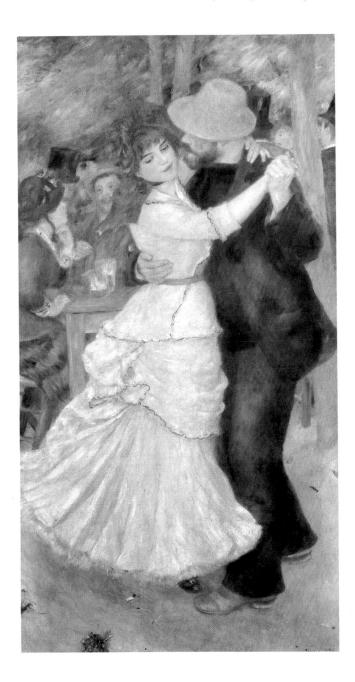

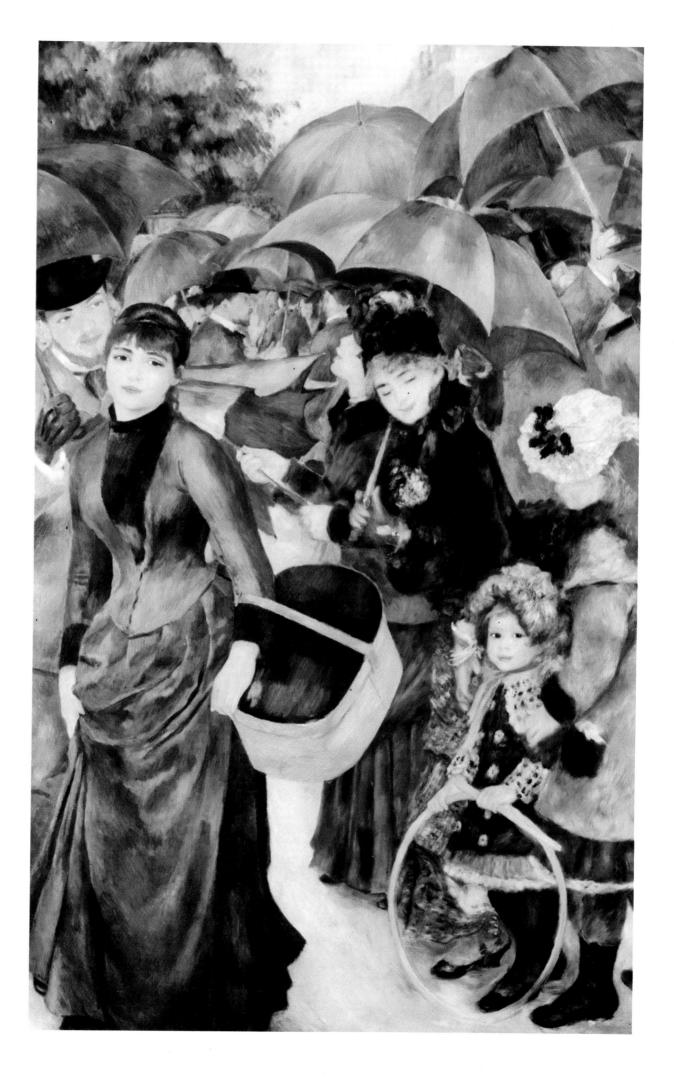

THE UMBRELLAS, 1881–4

canvas, 180×114.9 cm $(70\frac{3}{4} \times 45\frac{1}{4} \text{ ins})$ National Gallery, London

After his trips to Italy where he saw Raphael's frescoes and Pompeiian wall paintings and concluded that he had followed the Impressionist route as far as it could take him, Renoir underwent a period of reappraisal of his work and arrived at a more formal and decorative style, of which *The Umbrellas* is a good example. In fact, painted during the period when his work was in transition, it shows clearly both his earlier Impressionist style, particularly in the figures on the right, and his more refined techniques of the mid-80s in the painting of the girl with a hatbox as well as in the complex decorative arrangement of the formally contoured figures and umbrellas.

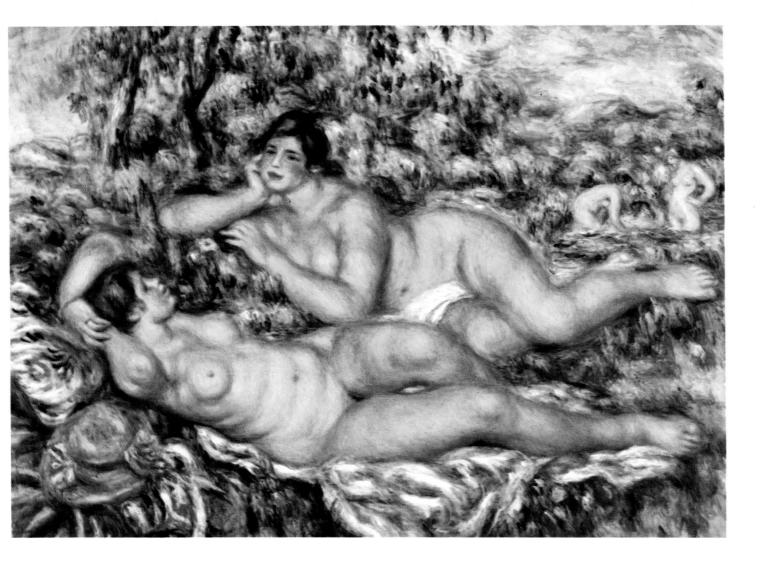

THE BATHERS, c. 1918–19 canvas, 110 × 160 cm $(43\frac{1}{4}\times63 \text{ ins})$ *Jeu de Paume, Paris*

Also known as Nymphs, The Bathers is one of Renoir's last paintings and depicts Andrée Hessling, later the wife of his son Jean. It was executed on a specially constructed easel which carried the canvas on rollers, so that he could wind down the upper part for access from a seated position, since by now he was crippled with rheumatism. By this time he had left Impressionism far behind, following such Old Masters as Rubens.

CAMILLE PISSARRO (1830–1903)

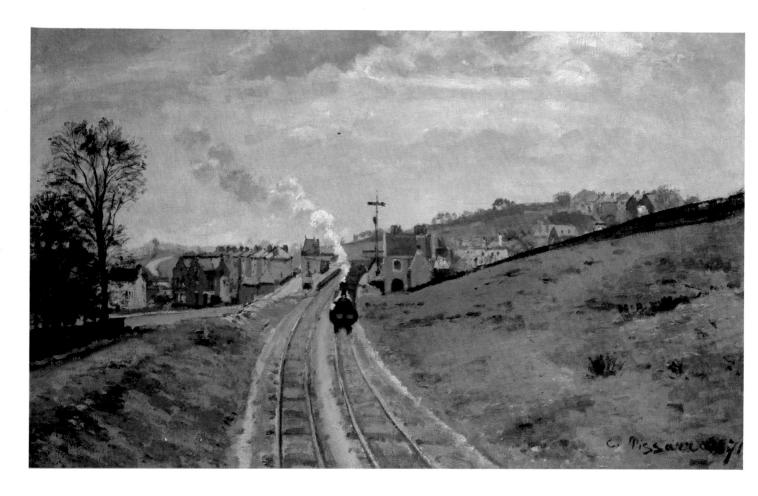

LORDSHIP LANE STATION, LOWER NORWOOD, LONDON, 1871 canvas, 44×73 cm $(17^1_4 \times 28^3_4 \text{ ins})$ Courtauld Institute Galleries, University of London

For many years called *Penge Station*, this painting is now believed to depict Lordship Lane Station, now closed, on the London, Chatham and Dover line. At the time he painted it Pissarro was living in nearby Upper Norwood, having fled from France during the Franco-Prussian War. Pissarro follows the developing Impressionist method of painting the simple, unidealized scene before his eyes, this landscape closely paralleling a large number of works by him showing roads on the outskirts of French and English villages. As he himself remarked, the influence of Turner, whose famous railway painting *Rain, Steam and Speed* he may have seen in London, was limited. The unaffected simplicity of Pissarro's landscapes lacked both the romanticism of Turner and the drama of those epic painters then popular. This meant that his work found little favour among critics or the picture-buying public. Deciding to return to France, he wrote to his friend Théodore Duret: 'My painting doesn't catch on, not at all, a fate that pursues me almost everywhere.'

THE RED ROOFS, 1877

canvas, 54.5 × 65.6 cm $(2I_2^1 \times 25_4^3 ins)$ Jeu de Paume, Paris

After a year back at his home in Louveciennes, which had been ransacked by Prussians during the War and where his paintings had been either destroyed or stolen, Pissarro moved to Pontoise where he remained for ten years until 1882 when he went to nearby Osny. In the area around Pontoise he found a wide range of rural scenes, painting alongside Cézanne at the time this work was executed. It was also at about this time that he first met and influenced Gauguin. One of Pissarro's most truly Impressionist masterpieces, it features his use of vibrant brilliant colour applied with a stippled technique. Pissarro was essentially a painter of rustic landscapes such as this, and readily acknowledged Duret's advice to follow the 'path of rural nature' at which he excelled.

THE CÔTE DES BOEUFS AT L'HERMITAGE, NEAR PONTOISE, 1877 canvas, 114.9 × 87.6 cm $(45\frac{1}{4} \times 34\frac{1}{2} \text{ ins})$ *National Gallery, London*

As in his *Red Roofs*, Pissarro here offers a view of houses seen through an intricate tracery of trees, the two figures almost lost in the undergrowth and subordinated to a minor role in the composition.

GARDEN AND TREES IN BLOSSOM, SPRINGTIME AT PONTOISE, 1877 canvas $6_{5.5} \times 8_1$ cm $(2_{54}^3 \times 3_2 \text{ ins})$ *Jeu de Paume, Paris*

Shown at the fourth Impressionist exhibition in 1879, Pissarro's view of the Quai de Pothuis, on which his house was situated, was acquired by Gustave Caillebotte, while a similar painting of the same subject by Cézanne was owned by Pissarro. Cézanne's typically emphasizes the form of the trees; Pissarro's version captures the essential charm of the total view. At the same time Pissarro began to attempt to preserve the accuracy of his colours by painting the frames of his pictures white so that there would be no alien colour reflections.

WOMAN IN A FIELD, 1887

canvas, 54.5×65 cm $(21\frac{1}{2} \times 25\frac{1}{2}$ ins) Jeu de Paume, Paris

Pissarro was introduced to Seurat by Gauguin in October 1885. He was immediately responsive to Seurat's scientific theories (later known as Neo-Impressionism) which he soon put into practice in landscapes executed around Eragny. In 1886 he caused conflict within the Impressionist group by demanding that Seurat and Signac be included in the eighth and last Impressionist exhibition. His sudden transition to Seurat's 'divisionist' style astonished his colleagues, whose work was also undergoing re-evaluation at this time, but in a less dramatic fashion. This painting is neither as Impressionistic as Pissarro's earlier works, nor as rigorously divisionist as Seurat's of the same period; after working in this modified mode for a while, he returned to his former methods with certain changes to his palette and technique.

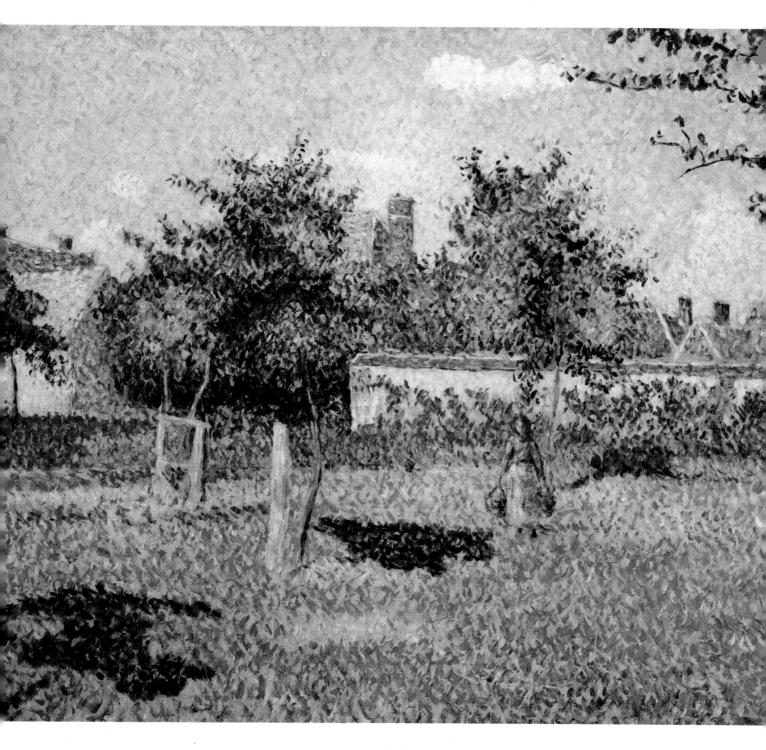

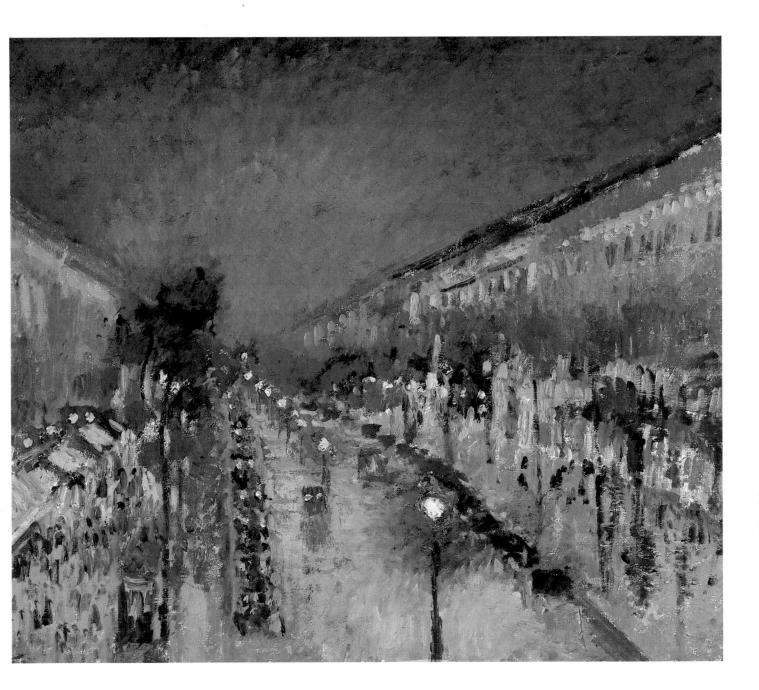

PARIS, THE BOULEVARD MONTMARTRE AT NIGHT, 1897 canvas, 53.3 × 64.8 cm (21×25¹/₂ ins) *National Gallery, London*

Painted six years before his death, this painting, along with others from the same period, was executed from behind the windows of a room overlooking the street. Pissarro's eyesight had deteriorated and he was compelled to work indoors, returning to his former Impressionist style, after his experiments with divisionism, with a palette of increased brilliance. In this night scene of the Boulevard Montmartre, he equals Monet in the skilful evocation of the reflected lights on the wet surfaces and the barely suggested outlines of the passers-by. Pissarro moved increasingly to depictions of cityscapes in his last years, in contrast with his characteristically rural earlier works. A major retrospective exhibition conferred on him the acclaim he had struggled for during the major part of his working life.

THE CHURCH OF SAINT-JACQUES AT DIEPPE, 1901

canvas, 54.5 × 65.6 cm $(21\frac{1}{2} \times 25\frac{3}{4} \text{ ins})$ Jeu de Paume, Paris

Following Monet in his fascination for capturing the varying light affecting a single scene, Pissarro returned to this subject on numerous occasions. Unlike Monet, however, whose late 'series' paintings of Rouen Cathedral demonstrate his belief in the supremacy of colour, Pissarro never departed from his dedication to the ideals evolved in the formative years of Impressionism and presents his personal view of the unidealized nature of the landscape.

More than any other Impressionist, he was the most willing to learn and the most willing to teach. Gauguin, who died in the same year as Pissarro (1903), honestly acknowledged

Pissarro's pre-eminence among the Impressionist masters: 'If we observe the tonality of Pissarro's work, we find there, despite fluctuations, not only an extreme artistic will, never belied, but also an essentially intuitive, pure-bred art . . . He looked at everybody, you say! Why not? Everyone looked at him too, but denied him. He was one of my masters and I do not deny him.'

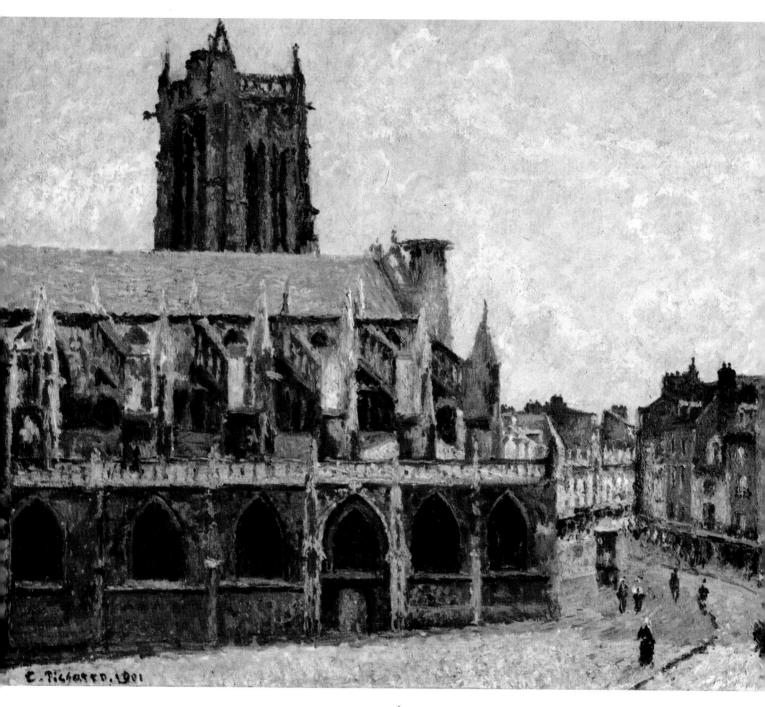

ALFRED SISLEY (1839–99)

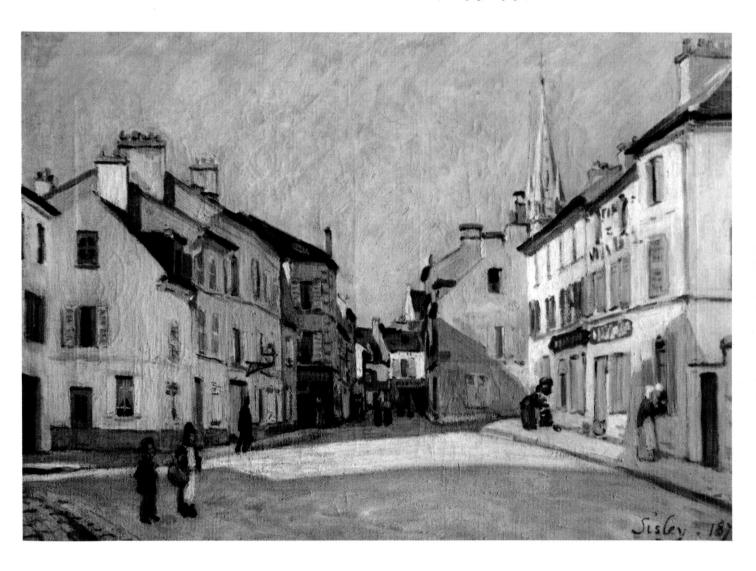

SQUARE AT ARGENTEUIL, 1872

canvas, 46.5 × 66 cm ($18\frac{1}{4}$ × 26 ins) *Jeu de Paume, Paris*

The landscape around Argenteuil provided Sisley, Monet and other Impressionists with a range of subjects – the river particularly appears in innumerable works – but few artists tackled the subject of the village itself. Monet and Sisley worked together in Argenteuil in

1872, and through paintings produced here and elsewhere have become known as the principal landscapists of the Impressionist movement. Sisley's greater subtlety in the use of colour in rendering the textures of the buildings in this painting exemplifies his particular influences, most notably those of Corot, Courbet and Boudin in whose works soft colours predominate. His inclusion of figures is an untypical feature.

THE VILLAGE OF VOISINS, 1874

canvas, 38×46.5 cm ($15 \times 18\frac{1}{4}$ ins) Jeu de Paume, Paris

Sisley's work is often taken as an example of Impressionism at its purest. He delighted in depicting landscapes and especially waterscapes, with the opportunities they offered for

reflected light, and his feeling for tonal relationships and movement enabled him to enliven the vast expanses of water and sky. Sisley's paintings continue the inheritance of the Renaissance in the careful way space and perspective are rendered by the use of lines, be it a row of trees, a road, or roof tops, which converge at a vanishing point on the horizon. The accusation of formlessness could not be levelled against works such as these, as it has been against Monet, and they remain very much in the traditional mould of naturalism. Sisley was one of the few Impressionist artists not to attempt to go beyond the mere imitation of visual appearances.

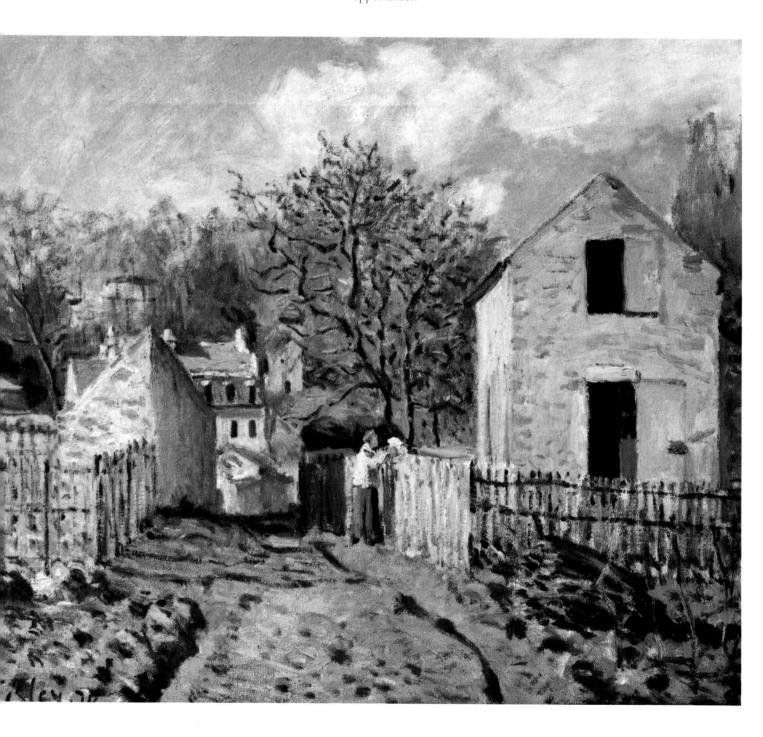

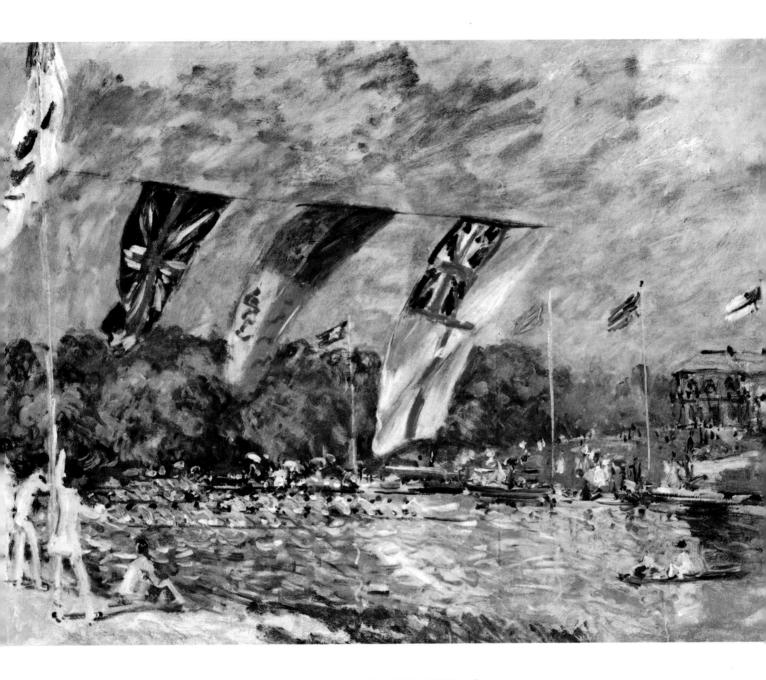

THE REGATTA AT MOLESEY, 1874 canvas, 66 × 91.5 cm (26 × 36 ins) *Jeu de Paume, Paris*

Although Sisley was a British subject, he spent most of his life working in France. He passed some time in England in his youth, and may perhaps have returned during the Franco-Prussian War, although this is by no means certain. However, shortly after the first Impressionist exhibition, he travelled to England in the company of Jean-Baptiste Faure, an opera singer and admirer of the Impressionists whose works – especially those of Manet – he collected. Staying in the Hampton Court area, Sisley painted several Thames scenes, including this one of the regatta at Molesey in which he applies all the hallmarks of pure

Impressionist technique, such as the use of dashes of bright colour and the snapshot-like 'freezing' of the movement of the oarsmen in their oblique posture. Regattas which offered movement, colour and reflection provided the Impressionists with an ideal motif to which many of them frequently returned.

THE FLOOD AT PORT-MARLY, 1876

canvas, 60×81 cm $(23\frac{1}{2} \times 32$ ins) Jeu de Paume, Paris

One of several versions of the same subject painted by Sisley in 1872 and again in 1876. Like Monet he delighted in depicting the storm-laden sky and the effects of reflected light on the water. In his lifetime Sisley never achieved great success; ironically it came soon after his death when a similar canvas to this made 45,150 francs and prices began to rise steadily.

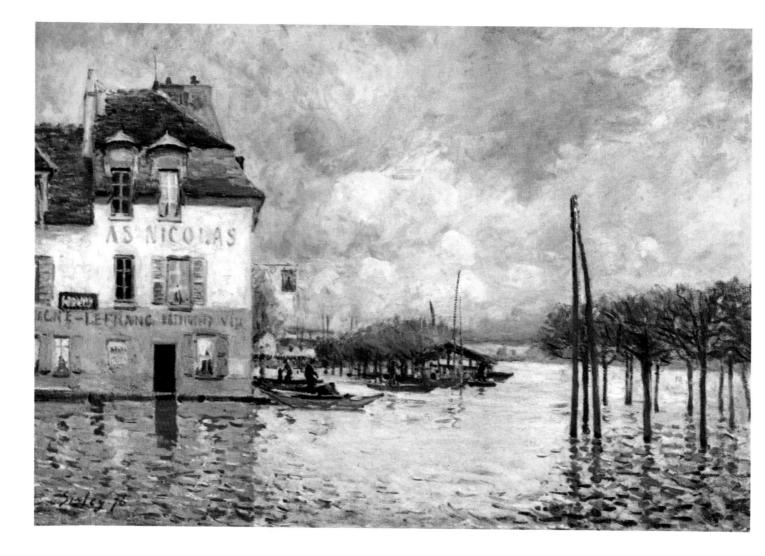

SNOW AT LOUVECIENNES, 1878

canvas, 61×50.5 cm $(24 \times 19^{1}_{2} \text{ ins})$ Jeu de Paume, Paris

Sisley followed Courbet in his fascination with winter landscapes, but unlike his predecessor who built up his paintings by means of the palette knife, Sisley's work delicately captures the subtle nuances of reflected light and its effect on local colour through the use of the characteristic Impressionist brush-stroke.

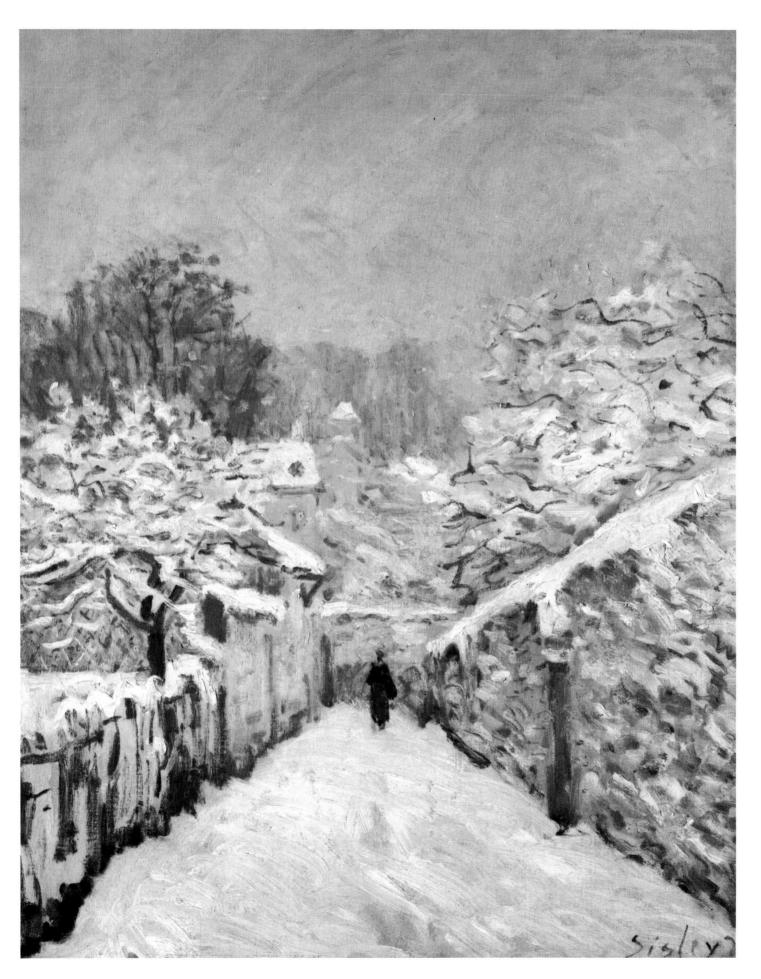

THE SEINE AT SURESNES, 1877

canvas, 60.7 × 73.7 cm (24 × 29 ins) Jen de Panme, Paris

This landscape was painted at the time of Sisley's direst poverty: the following year he was to offer Duret 30 paintings in return for 500 francs a month for six months – 100 francs a painting. Two years later he was still only able to get 300 francs for the canvas which in 1969 was sold for £60,000 (then US\$144,000). This painting displays the Impressionist concern with the effects of wind in rippling the surface of water, causing the grass to quiver and the clouds to streak by – transient motion that they attempted with varying success to depict in paint.

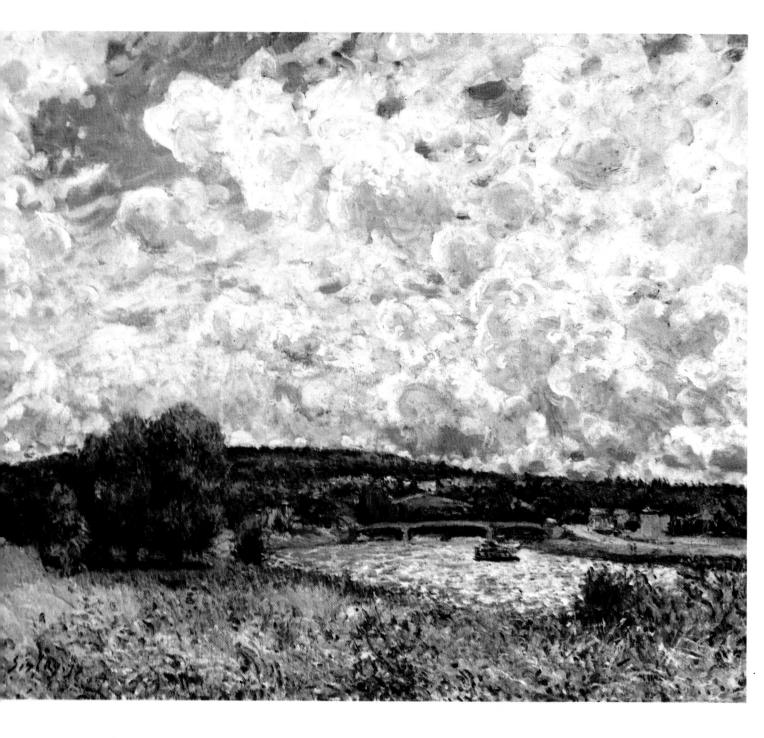

ARMAND GUILLAUMIN (1841–1927)

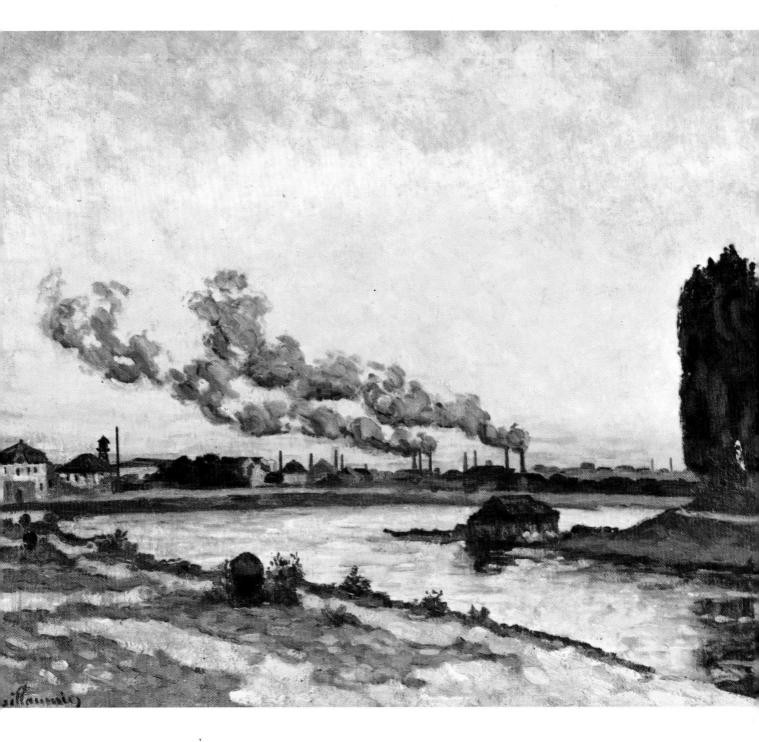

SUNSET AT IVRY, 1873 canvas, 65×81 cm $(25\frac{1}{2} \times 31\frac{3}{4} \text{ ins})$ *Jeu de Paume, Paris*

Guillaumin was a former railway employee who gave up his work in favour of painting in 1868. He was closely allied with the Impressionists but never achieved the success of his colleagues. He won 100,000 francs which relieved him of the financial struggle that dogged the others in their early years. This painting, exhibited in 1874, demonstrates his striking use of colour which developed to a pitch that almost anticipates the Fauves. His painting of factory chimneys is an uncharacteristic theme for the Impressionists, although Van Gogh adopted the industrial landscape in his early years. Guillaumin's work was described by a contemporary critic as displaying 'the confidence of a genuine emotion confronting nature'.

PAUL CÉZANNE (1839-1906)

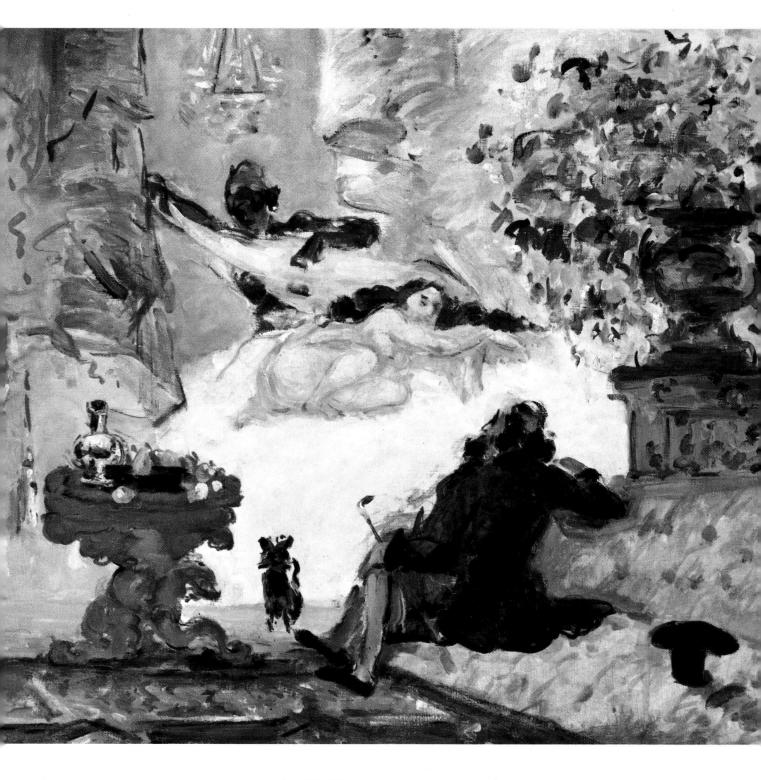

A MODERN OLYMPIA, c. 1873-4

canvas, 46×55.5 cm $(18 \times 21_4^3 \text{ ins})$ Jen de Panme, Paris

Acquired by Dr Gachet, at whose home Cézanne discussed Manet's *Olympia* (page 52), this work from Cézanne's 'romantic' period was painted as a parody of Manet, and features a man who one can assume was meant to represent Cézanne himself confronted by a dreamlike erotic scene. Although exhibited in 1874, along with two landscapes, it was radically different from anything produced by the other members of the group – and was one of the factors that determined Degas to remain outside the exhibition. It marks the end of Cézanne's bizarre romantic-erotic phase.

L'ESTAQUE, c. 1878–9 canvas, 59.5 \times 73 cm (23 $\frac{1}{4} \times$ 28 $\frac{3}{4}$ ins) *Jeu de Paume, Paris*

Cézanne spent the period of the Franco-Prussian War at the house owned by his mother at L'Estaque, near Marseilles, returning there for extended stays between 1876 and 1889. Having followed Pissarro's advice, to 'replace tonal modelling by the study of colours', he began in the brilliant southern sunlight to put the theory into practice – to attempt, like Monct, to depict light through the use of colour alone. He has here, as in so many of his landscapes, divided the painting into horizontal bands; the foreground, the sea, the distant mountains and the sky. Distance is created not through lines meeting at the horizon and making a tunnel into the picture, but by one horizontal plane being placed on top of another. In this he is working in a similar way to Poussin – one of the Old Masters he most admired. But these horizontal bands have another effect: as well as creating a sense of distance, they also emphasize the surface of the canvas itself. Cézanne was always very aware of the need to organize what he saw into a work of art, and the success of this painting is a result of the relationship he created between the surface design and the illusion of depth. In the foreground the closely woven, interlocking horizontals and verticals of trees and houses also work as a two-dimensional design.

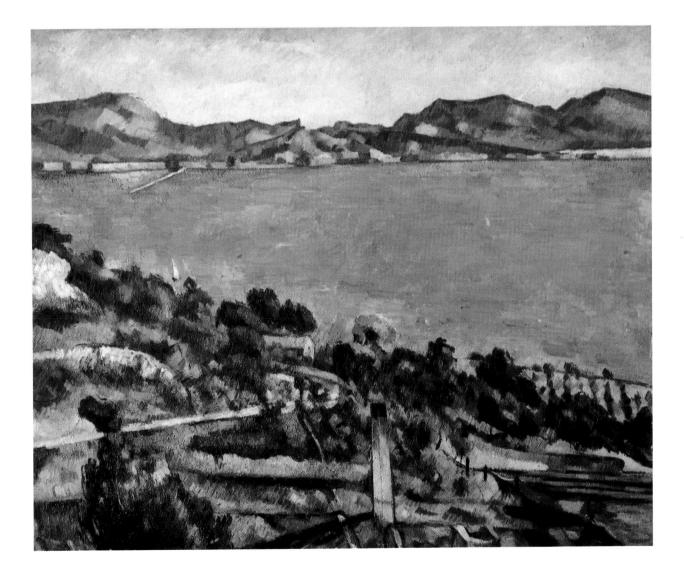

MONT SAINTE-VICTOIRE, C. 1886-8

canvas, 66×90 cm $(25\frac{3}{4} \times 35\frac{1}{2}$ ins) Courtauld Institute Galleries, University of London

Unlike his colleagues, Cézanne was more concerned with the structure of his subjects than with the passing effects of light and atmosphere, so that although, like Monet, he returned repeatedly to the same theme, he attempted not to represent changing effects of light but the solidity of the landscape by gradations of colour. He continually emphasized the emotional content of his work: he was determined to be more than a simple copier of nature. He painted this mountain and the surrounding landscape about 60 times from every possible angle. Again the horizontal and vertical lines are drawn clearly with the trees and the viaduct in the distance.

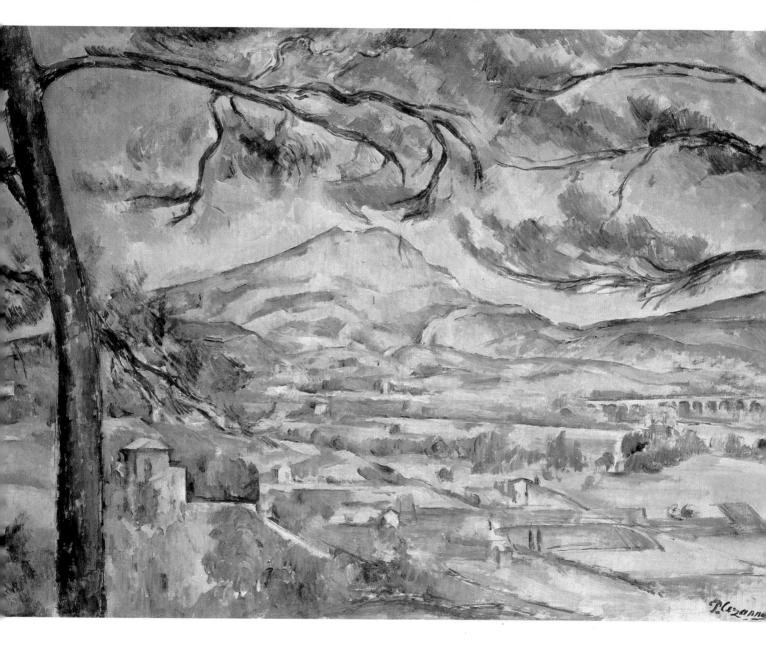

MADAME CÉZANNE IN A YELLOW ARMCHAIR, 1890–4 canvas, 81×64.8 cm $(31\frac{3}{4} \times 25\frac{1}{2}$ ins) *Art Institute of Chicago*

Cézanne painted 27 portraits of his wife Hortense, and in none of them did he portray her as young and attractive. He paid as much attention to the chair she sat in and the background as he did to the facial features and personality of his sitter. This is his last painting of her and she was only 40 years old at the time. He possessed, however, a cloth-bound notebook in which he sketched more intimate portraits of her.

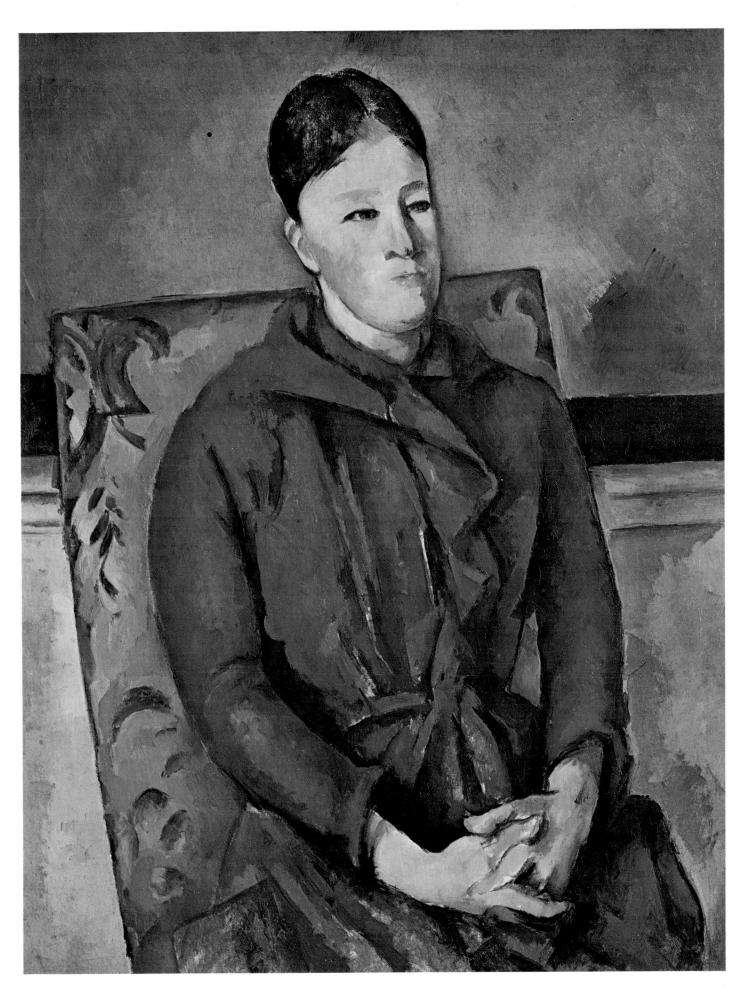

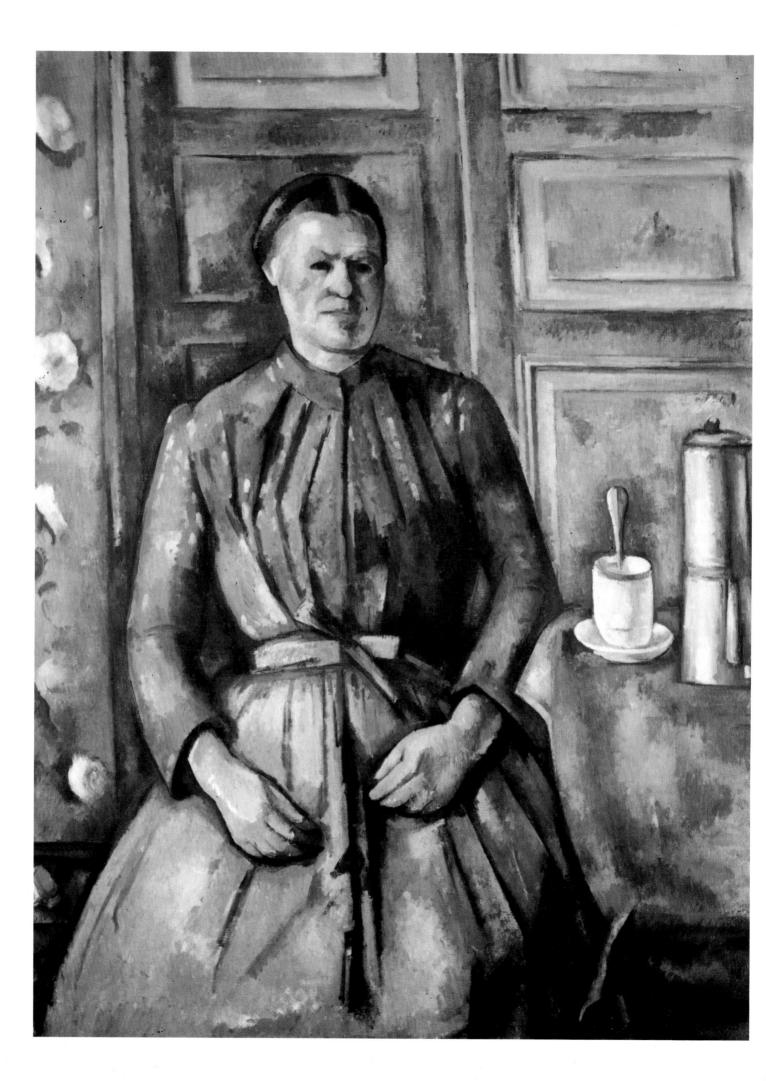

THE WOMAN WITH A COFFEE POT, c. 1890-5

canvas, 130.5 \times 96.5 cm (51 $\frac{1}{4}$ \times 37 $\frac{3}{4}$ ins) Jeu de Paume, Paris

The vagueness of the dating of this work is typical, since Cézanne never dated his paintings. It has been placed, however, in his so-called 'classical' period, described by one of his biographers as his 'Age of Style', which evolved after his romantic and Impressionist phases. Like other paintings of this period, it is richly coloured and solid; the stern-faced woman 'is planted like a strong tower', as art historian Lionello Venturi described her.

THE CARD PLAYERS, C. 1890-5

canvas, 47.5×57 cm $(18\frac{1}{2} \times 22\frac{1}{2}$ ins) Jeu de Paume, Paris

Cézanne demanded that his sitters remain motionless, so, as in *Woman with a coffee pot*, it was imperative for them to be placed in a sustainable relaxed pose. One of five known paintings on the same theme, all with different numbers of players and accessories, his *Card Players* presents a carefully balanced symmetrical composition, the bottle serving as the central axis. Cézanne was generally less interested in the human elements in his paintings in which the structure is the dominant feature, but in this and other portraits he also achieves a skilful portrayal of the personality of his sitters through their posture – the relaxed, experienced player on the left, the more tense, nervous man on the right.

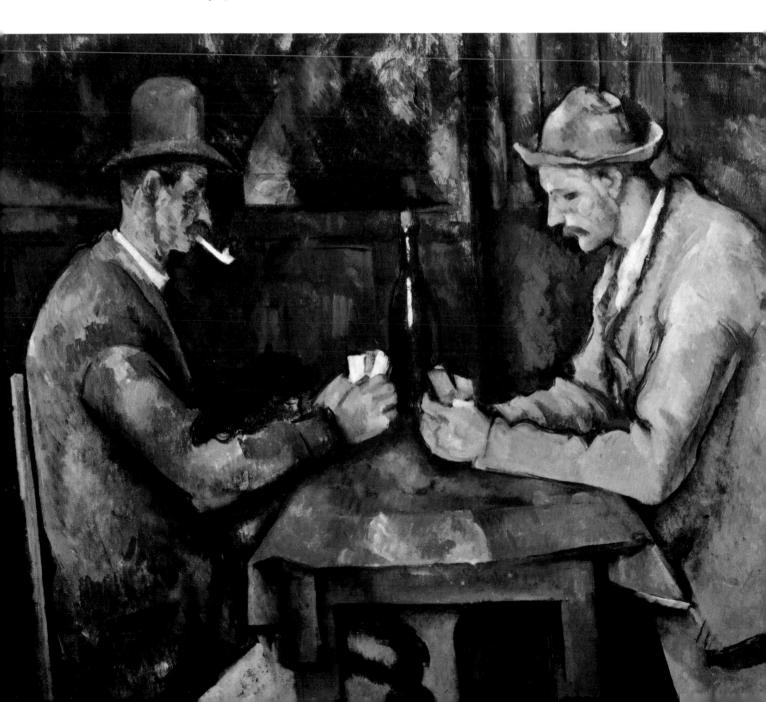

APPLES AND ORANGES, C. 1895-1900

canvas, 74×93 cm $(29 \times 36\frac{1}{2} \text{ ins})$ Jeu de Paume, Paris

While human subjects frequently irritated Cézanne by slight movements, his still-lifes provided him with motifs to which he could devote countless hours of patient work – not least in the careful arrangement of the various elements to achieve a perfect harmony of different coloured forms. Watching him set up a similar still-life, a young painter, Louis le Bail, described how the cloth 'was very slightly draped upon the table, with innate taste. Then Cézanne arranged the fruits, contrasting the tones one against the other, making the complementaries vibrate, the greens against the reds, the yellows against the blues, tipping, turning, balancing the fruits as he wanted them to be, using coins of one or two sous for the purpose. He brought to this task the greatest care and many precautions; one guessed that it was a feast for the eve to him.'

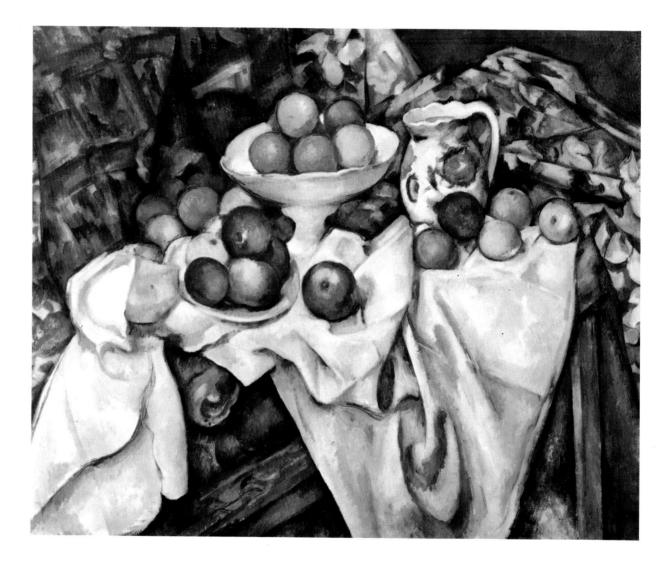

STILL-LIFE WITH A PLASTER-CAST, C. 1895

paper on panel, 70×57 cm $(27\frac{1}{2} \times 22\frac{1}{2}$ ins) Courtauld Institute Galleries, University of London

As in *Apples and Oranges*, Cézanne is not concerned to achieve a still-life that might be replicated in everyday life; he creates his own harmony of forms and colour by juxtaposing a seemingly strange mixture of elements. Visual appearance and perspective have been subordinated to the demands of the overall design. The floor and items in the background have been tilted forwards to that they come into contact with the foreground. The plaster-cast becomes the pivotal point of the composition with all the other components linked to each other around it; the onions on the table make contact with the floor which leads up to the paintings and down to the drapes of the table-cloth. The relationship of a subject to its background was an issue the Cubists would take much further.

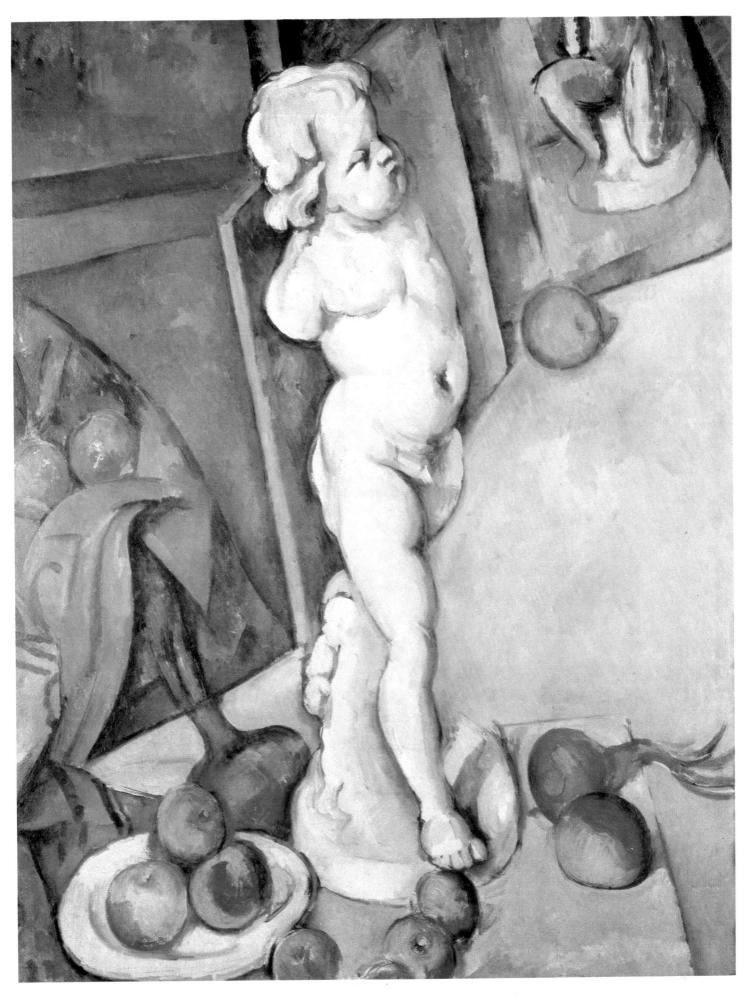

BATHERS, 1890–1900 canvas, 22 \times 33.5 cm (8 $_2^1 \times$ 13 ins) *Jeu de Paume, Paris*

Cézanne long considered painting the theme of naked figures in a landscape, a classical motif and one which attracted him first in his early romantic period; at that time he aspired to paint after the style of Delacroix, but lacked the technical ability to do so. He did not use a model, as he explained to Emile Bernard, because he was too diffident at his age to ask a young woman to pose naked for him – which would anyway have offended his bourgeois neighbours in Aix. Instead, he used studies from his earlier years, and it is possible that he sketched an older nude woman whose figure he then idealized. He painted several versions on the same theme; these and other late works by Cézanne were decisive in their influence on the development of Cubism.

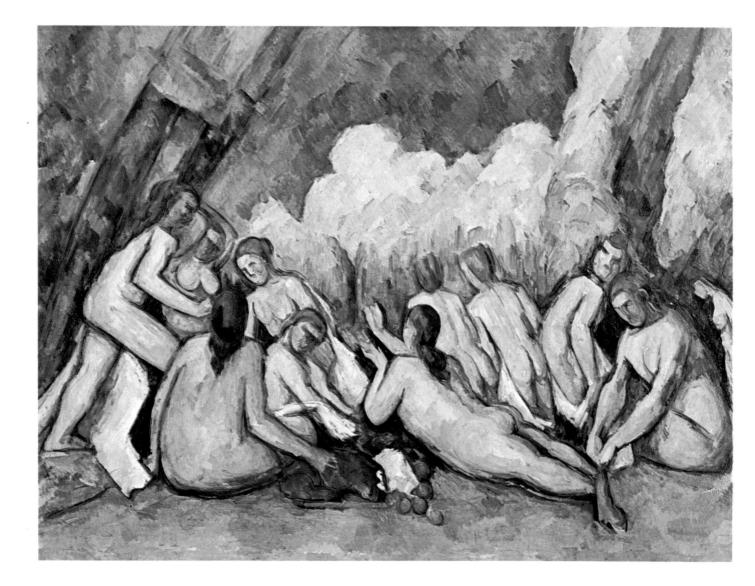

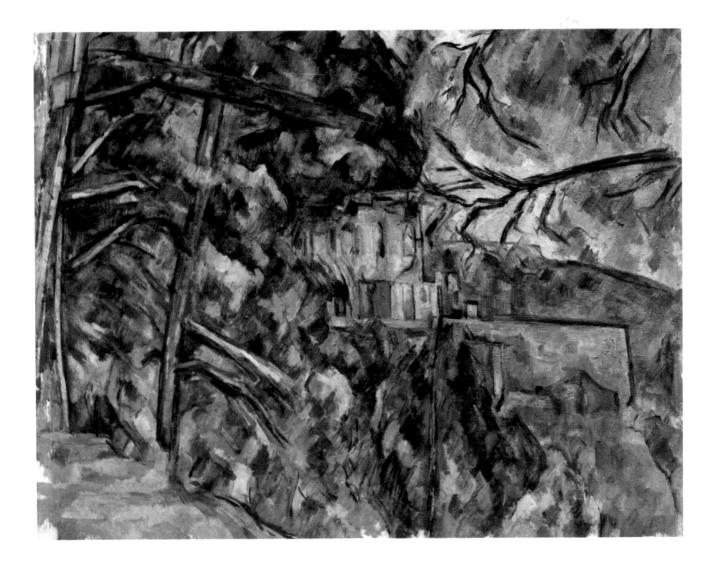

THE CHÂTEAU NOIR, 1900–1904

canvas, 73.7×96.6 cm $(28_4^3 \times 37_4^3 \text{ ins})$ National Gallery of Art, Washington Gift of Engene and Agnes Meyer

Cézanne painted certain landscapes time and time again. This farmhouse near his home in Aix-en-Provence was used by him as a studio and in fact appears in a number of his paintings, including his landscapes of Mont Sainte-Victoire. Dissatisfied with his composition, Cézanne had a one-inch strip of canvas added to each side of the original painting while he was still working on it. He then placed trees to frame the picture on the left side, whereas on the right he created a greater (and in consequence more dramatic) distance between the square block of the house's terrace and the edge of the painting. The composition seems to revolve around the central pivot of the house, and Cézanne's horizontal lines, used in earlier works to create depth, are now abandoned in favour of emphasizing diagonals and distorting spatial relationships. The enigmatically placed branches in the top right hand corner assume a decorative rather than a constructive function and stress the flat nature of the canvas.

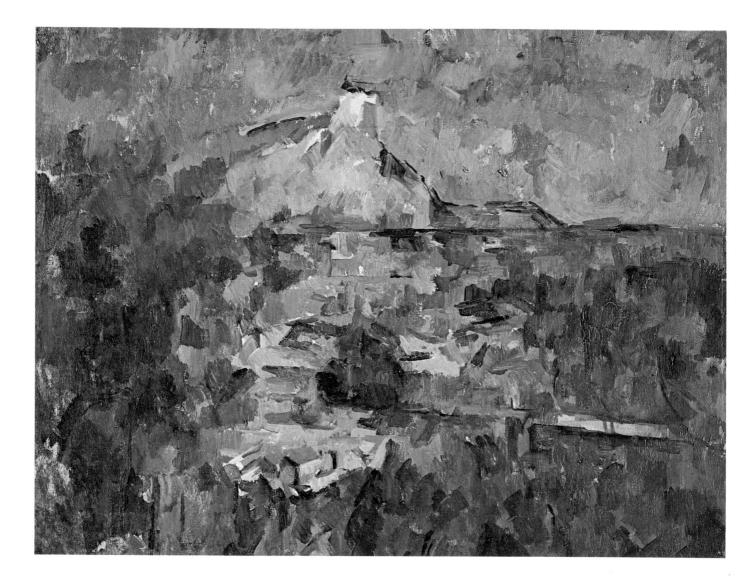

ROAD ON THE PLAIN, WITH HOUSES AND TREES, 1904–6

canvas, 60×72 cm $(23\frac{1}{2} \times 28\frac{1}{4} \text{ ins})$ Kunstmuseum, Basle

In his old age Cézanne was able to distinguish variations of colour and tone more and more acutely, and would sit for hours before his landscapes or still-lifes pondering his next brushstroke. One painting could take so long that sometimes the fruit would rot and he would have to resort to artificial fruit. The earlier formal structure of horizontals and verticals and the cool tones have given way to a flickering surface mosaic of intense colour. Cézanne's late paintings, like those of Monet and Renoir, show a greater subjective and emotional content than his earlier work.

VINCENT VAN GOGH (1853–90)

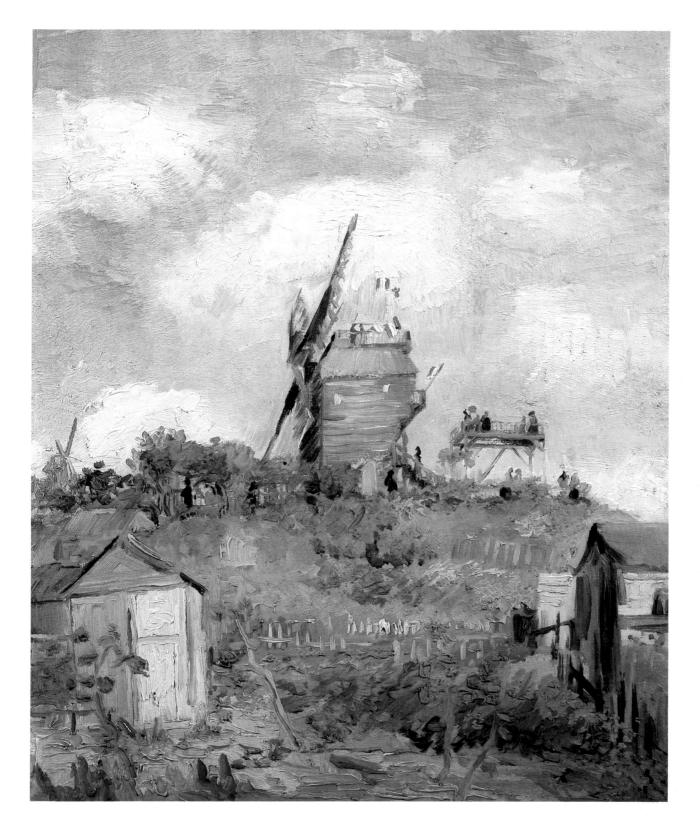

THE MOULIN DE LA GALETTE, MONTMARTRE, 1886

canvas, 46×48 cm $(18 \times 18\frac{3}{4} \text{ ins})$ Glasgow Art Gallery and Museum

In 1860 Montmartre was just a village. This dance hall was so named after a windmill that had stood on the site in those days. Van Gogh here showed it in a pleasantly rural setting, unlike his friend Toulouse-Lautree who concentrated on people rather than landscapes.

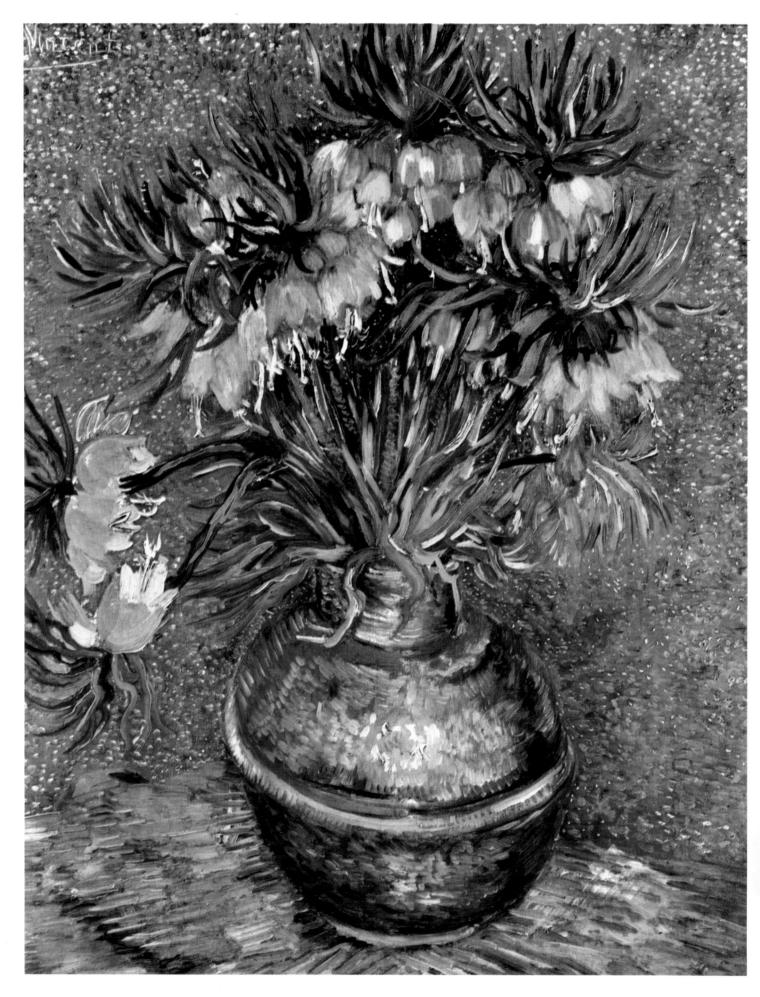

LILIES IN A COPPER VASE, 1886

canvas, 73 × 60.5 cm $(28\frac{3}{4} \times 23\frac{3}{4} \text{ ins})$ Jeu de Paume, Paris

Vincent Van Gogh travelled from Antwerp to Paris where he settled with his brother Theo in 1886 – the year of the eighth and final Impressionist exhibition. His first contact with their paintings was made among those works sold by Theo at the dealers Boussod & Valadon. Vincent enrolled in the studio of Fernand Cormon, but also spent a good deal of his time working alone and studying in the Louvre. While Theo visited their family in Holland, a friend who stayed with Vincent reported to Theo: 'He has painted a few very beautiful things . . . his series of flower still-lifes strike one as gay and colourful on the whole.' He also remarked on Van Gogh's surprising tendency to emphasize contrasting complementary colours (as in this painting).

THE TEA GARDEN, 1886

canvas, 49.5 \times 64.5 cm (19 $\frac{1}{2}$ \times 25 $\frac{1}{2}$ ins) *Jeu de Paume, Paris*

After his arrival in Paris, Van Gogh's style lightened in contrast with the earthy colours of his Dutch period. The Impressionists and the colour theories of Chevreul helped to alter his style which was to become still freer.

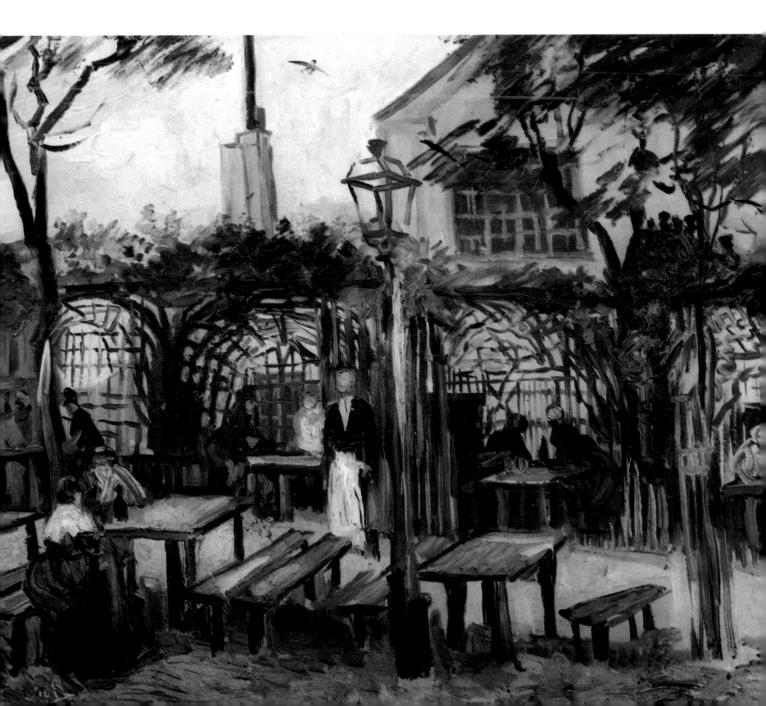

CARAVANS, 1888

canvas, 45×51 cm $(17\frac{3}{4} \times 20$ ins) Jen de Panme, Paris

Although gipsy carts and caravans like this do not normally occur in Van Gogh's paintings, they are nevertheless typical, in their unpretentiousness, of all his subjects. Whether it be a pair of shoes, a still-life, a portrait, a pot of flowers, his own room at Arles, the corner of a garden, or a landscape, each painting and each subject is treated with a humility and a reverence characteristic of this man who wished, through his art, to lighten the burden of the downtrodden. While in England from 1873 to 1875, Van Gogh had been influenced by Victorian graphic artists, whose often over-sentimentalized work appealed to his social consciousness. The other great influence was the Barbizon artist Jean François Millet, who depicted farmworkers with a quiet and noble dignity. Working from black and white reproductions of paintings by Millet, and also by Delacroix, Van Gogh in his last year was to make his own colourful versions of the work of both of them.

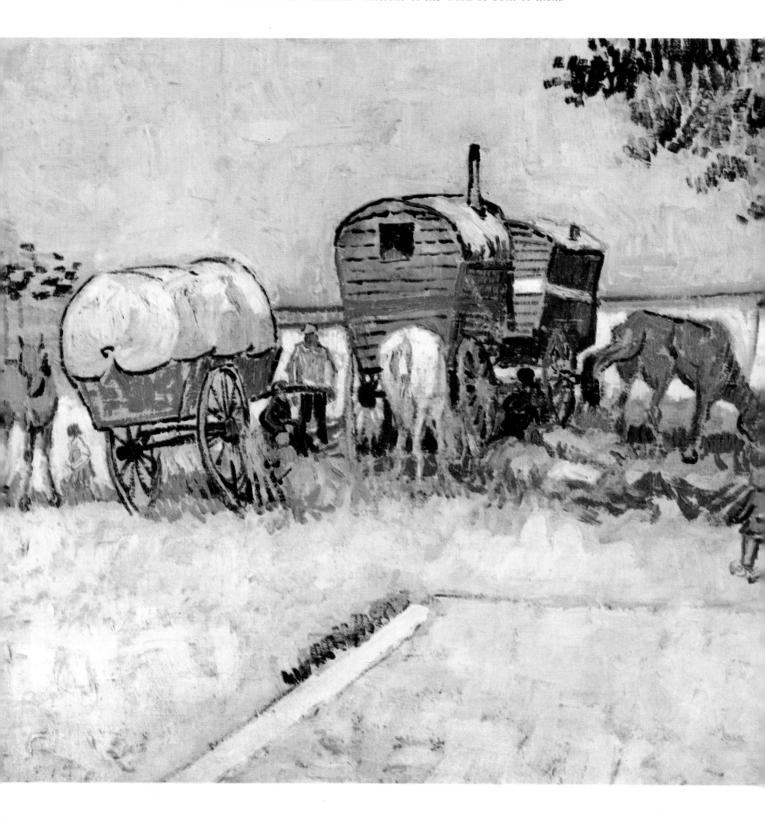

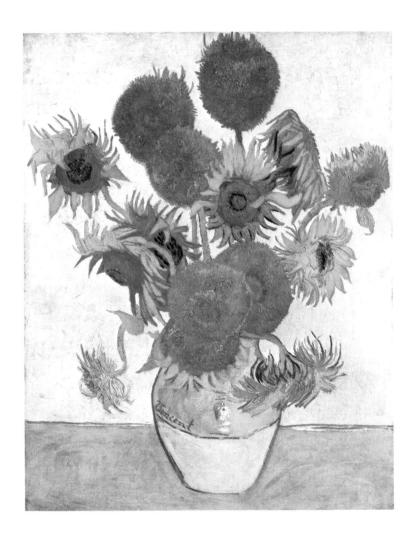

SUNFLOWERS, 1888

canvas, 92×73 cm $(36^1_4 \times 28^3_4 \text{ ins})$ National Gallery, London

Perhaps Van Gogh's best-known painting, this is one of a series of works on the same theme executed during his stay in Arles. He originally planned to produce twelve such paintings to decorate the studio he intended to share with Gauguin, or possibly the guest room of his 'Yellow House'. Gauguin's stay was short-lived, however. Gauguin is known to have admired these paintings, most of which were completed before his arrival in Arles, but later arrogantly claimed to have exerted an influence on his painting of these subjects: 'From that day Van Gogh made astonishing progress; he seemed to become aware of everything that was in him, and thence came all the series of sunflowers after sunflowers in brilliant sunshine.' The *Sunflowers* shows two of the most obvious characteristics of Van Gogh's

technique. One is the way he draws with his brush producing angular and brittle brushstrokes, which convey so readily his nervous and excited personality and create the tension within the painting; he was by nature perhaps always more a draftsman than a painter. The other is the manner in which he used thick 'impasto' paint to give the painting a sculptural

and tactile presence. Writing about an earlier painting, he had said: 'It struck me how sturdily those little stems were rooted in the ground. I began painting them with a brush, but because the surface [of the canvas] was already so heavily covered, a brush-stroke was lost in it – then I squeezed the roots and trunks in from the tube, and modelled it a little with the brush. Yes – now they stand there rising from the ground, strongly rooted in it.'

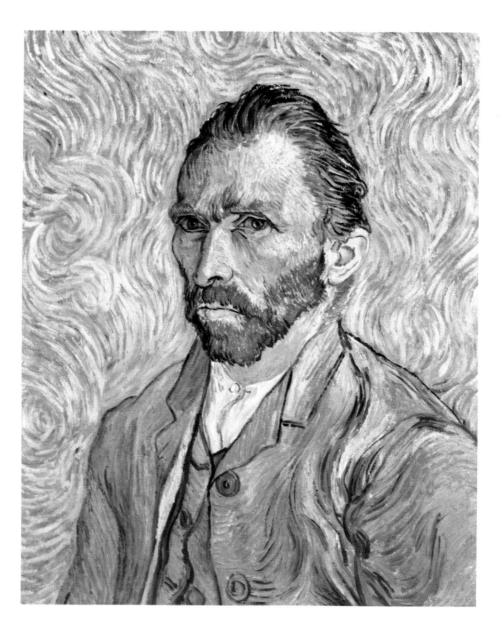

SELF-PORTRAIT, 1889 canvas, 65×54.5 cm ($26 \times 21_4^3$ ins) *Jeu de Paume, Paris*

This is Van Gogh's last self-portrait when he was near to despair at St Rémy, near Arles. The background is more ambiguous than his previous portraits, and seems to suggest a swirling confusion, though the lips are set as if he were holding himself in check.

PORTRAIT OF DR GACHET, 1890

canvas, 68×57 cm $(26_4^3 \times 22_2^1 \text{ ins})$ Jeu de Paume, Paris

In 1890 Van Gogh was sent by his brother to the home of Dr Paul Gachet at Auvers-sur-Oise. Gachet was both an admirer and friend of the Impressionists and a medical doctor interested in mental illness, and he offered Van Gogh considerable encouragement about his state of health and his art. Soon after his arrival, Vincent wrote to Theo describing the portrait he was painting of Gachet 'with a white cap – very blond hair, very bright'. He described his soulful visage as 'the distressed expression typical of our times' and explained the validity of 'our modern taste for colour as a means of expression and of exaltation of character'.

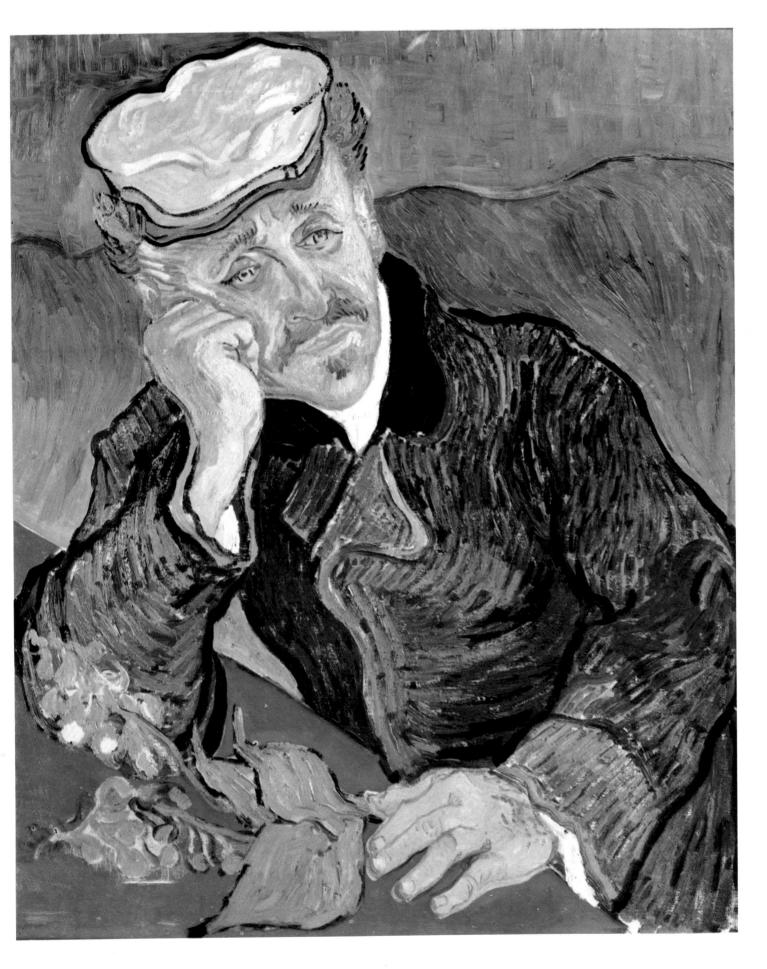

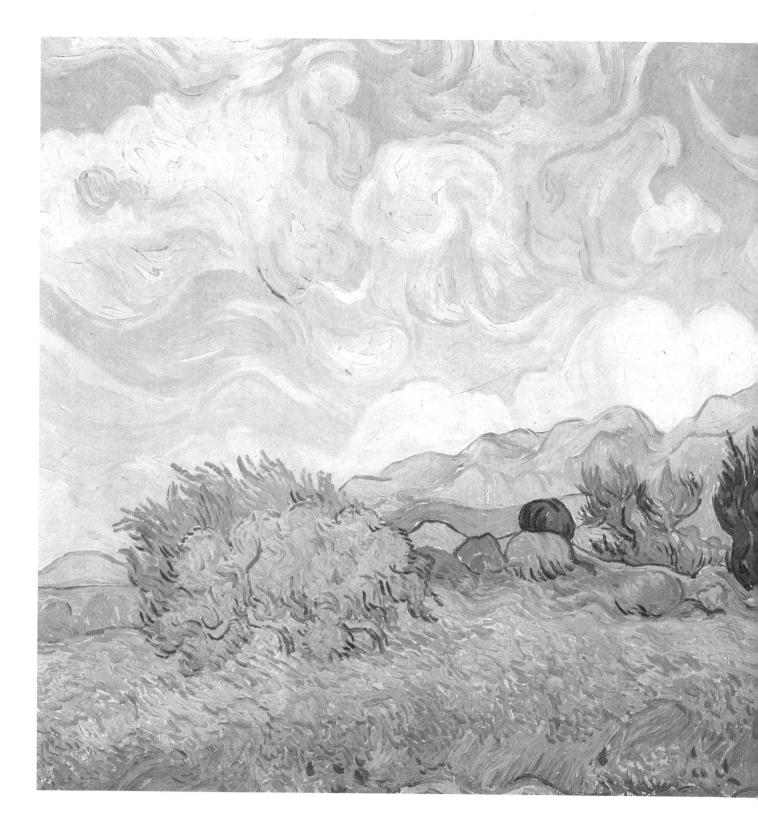

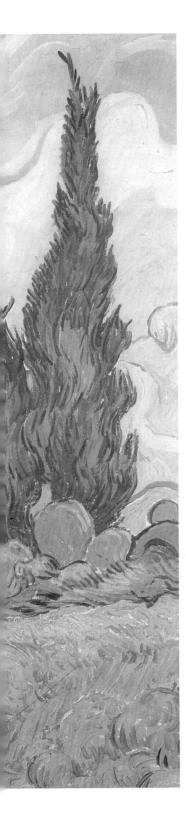

A CORNFIELD, WITH CYPRESSES, 1889

canvas, 72×90.9 cm $(28^1_4 \times 35^1_2 \text{ ins})$ National Gallery, London

This extraordinary painting, the first of three versions of the same subject, was painted between May and June 1889, while Van Gogh was in the asylum at St Rémy. He wrote to his brother Theo: 'Cypresses still preoccupy me. I should like to do something with them like my canvases of sunflowers, because it is surprising to me that they haven't been done yet the way I see them. They are beautiful in line and proportion like an Egyptian obelisk. And the green is of such a distinguished quality. It is the black spot in a sunlit landscape, but it is one of the most interesting black notes, one of the most difficult to hit right that I can imagine.' Progressively, as his mental derangement worsened, his world became as turbulent as his emotions - plants, the sky and even the earth seemed to writhe and flow like waves or flames. Yet within this continually changing landscape we can still see the Impressionist bases of his art - the divided brush-strokes of brilliant colour freely applied which he united to his own emotive style to create the exaggerations and distortions implicit in Expressionism. Throughout the brief five years of his artistic maturity Van Gogh was at his happiest working directly from a subject in front of him. For a brief period in 1888, while Gauguin was with him in Arles and exercising pressure on the younger artist, Van Gogh tried painting from memory but was always unhappy with the resulting 'abstractions'. as he called them. It was through nature - her colours, sunlight, shapes, and even individual blades of grass - that he expressed his joy and despair. Van Gogh's earlier religious zeal, together with his fervent desire to assist the underprivileged and to be of use in the world, is manifested in his communion with God through nature via the medium of art; he had written in 1880 of trying 'to understand the real significance of what the great artists, the serious masters, tell us in their masterpieces, that leads to God'. This developed into a pantheistic approach, influenced by the many Japanese woodcuts which were being imported into France at that time (mostly as packing material for commercial goods). Van Gogh writes of the Japanese artist who is interested not in examining such issues as politics or cosmology, but in depicting a single blade of grass, 'but this blade of grass leads him to draw every plant and then the seasons, the wide aspects of the countryside, then animals, then the human figure. So he passes his life, and life is too short to do the whole . . . Isn't it almost a true religion which these simple Japanese teach us, who live in nature as though they themselves were flowers? And you cannot study Japanese art, it seems to me, without becoming much gayer and happier, and we must return to nature in spite of our education and our work in a world of convention.' In practical terms the influence of the Japanese print is seen in the use of strong outlines, areas or bands of single colours (also found in the work of Gauguin) and often marked diagonal lines of composition which lead the eye into the picture.

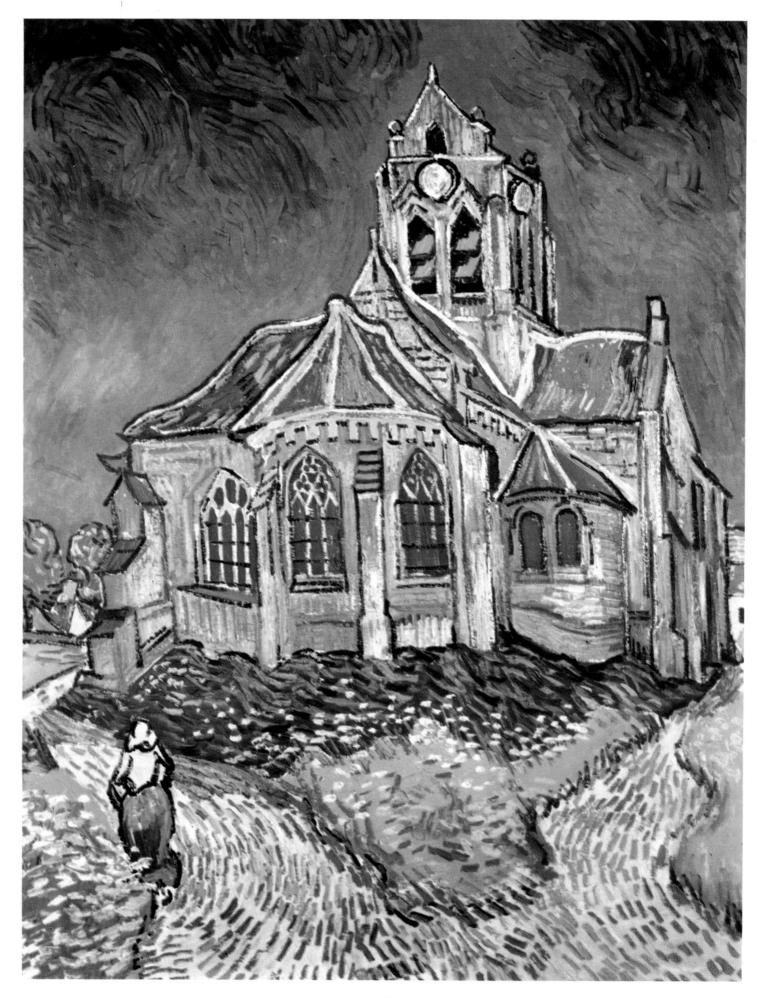

THE CHURCH AT AUVERS-SUR-OISE, 1890

canvas, 94×74.5 cm $(37 \times 29^{1}_{4} \text{ ins})$ Jen de Paume, Paris

At Auvers, Van Gogh worked hard to take his mind off his torments. He described this painting in a letter to his sister: 'I have done a bigger picture of the village church, an effect showing the building purple against a simple, deep blue sky of pure cobalt. The stained-glass windows appear as patches of ultramarine blue, the roof is violet and partly orange. In the foreground there is some grass with flowers and some sand, rose coloured with the sun on it. It is almost the same thing that I did at Nuenen of the old tower and the cemetery, but in the present picture the colour is more expressive, more rich.'

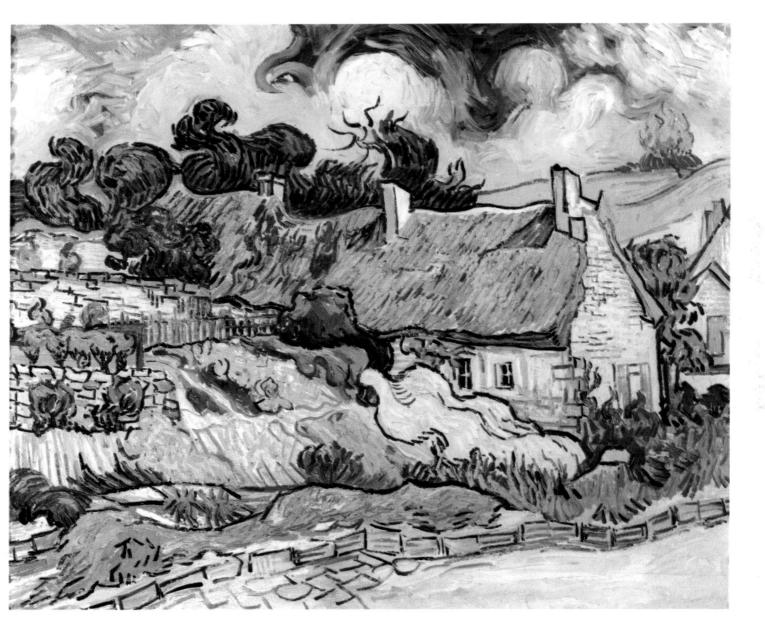

COTTAGES AT CORDEVILLE, 1890 canvas, 73 × 92 cm $(28^3_4 \times 36^1_4 \text{ ins})$ *Jeu de Paume, Paris*

Van Gogh stayed with Dr Gachet in Auvers from May to July 1890. He painted numerous views of the buildings and the surrounding landscape. He was attracted by the town, but as he poured his emotion into his canvases, his mental state worsened. In a letter to Theo he wrote: 'in my work I am risking my life and half my reason has been lost in it'. He never finished this letter. Within hours he had shot himself, and two days later he died. Pissarro is reported to have remarked that on his first encounter he could see that Van Gogh would either go mad or surpass the Impressionists 'but I didn't realize he would do both'.

PAUL GAUGUIN (1848–1903)

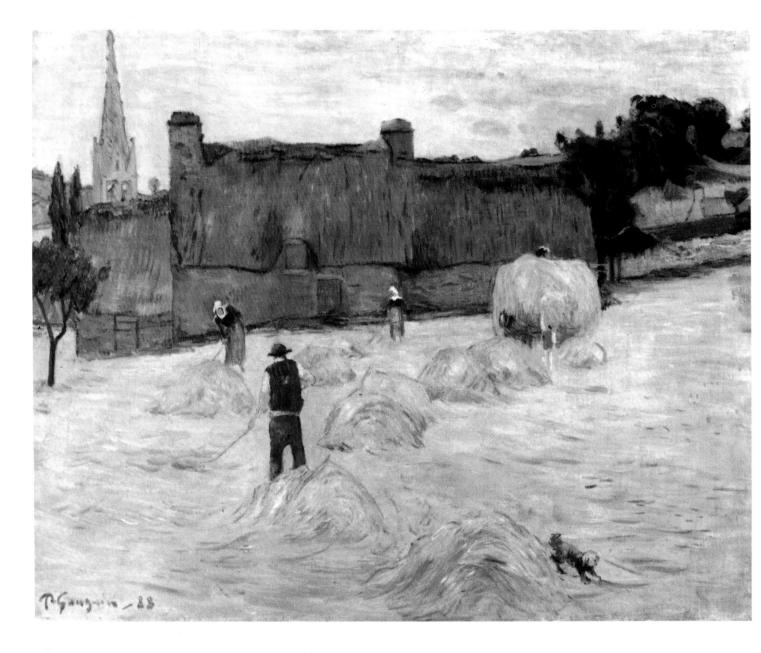

HARVEST IN BRITTANY, 1888

canvas, 73 × 92 cm $(28_4^3 \times 36_4^1 \text{ ins})$ Jen de Paume, Paris

In Brittany in 1888 Gauguin became the undisputed leader of the 'Pont-Aven School' of artists. With Emile Bernard, a brilliant and well-read artist half Gauguin's age, he evolved a new style which departed from the teachings of his Impressionist masters. This painting marks the end of Gauguin's Impressionist phase; already the bold, flat colours and strong outlines that characterize his 'pictorial symbolism' are appearing.

THE ALYSCAMPS AT ARLES, 1888

canvas, 91.5 \times 72.5 cm (36 \times 28¹/₂ ins) Jeu de Paume, Paris

This painting, one of several of the same subject executed by Gauguin during his brief stay with Van Gogh in Arles, marks the beginning of his move toward the simplification of form and colour to achieve a powerful emotive effect, even in the absence of the mystical content of such paintings as *Vision after the Sermon* (page 162).

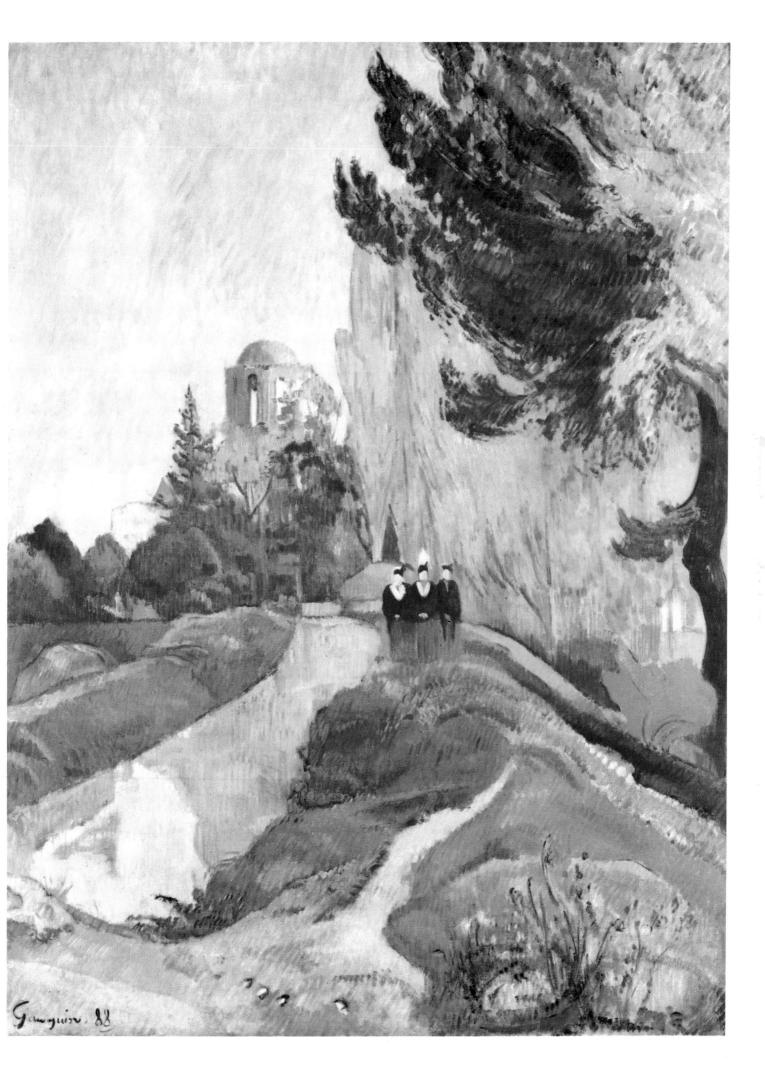

VISION AFTER THE SERMON, 1888

canvas, 73×92 cm $(28_4^3 \times 36_2^1 \text{ ins})$ National Gallery of Scotland, Edinburgh

Also known as Jacob Wrestling with the Angel, this, one of Gauguin's best-known works, was painted in Pont-Aven after his break with Impressionism. The result was revolutionary in its containment of forms within distinct outlines, its use of pure, flat colours and the elimination of shadows – features derived from Japanese prints which had affected the art of the Impressionists, but never in such an extreme manner. Gauguin tried to present his symbolic masterpiece to a local church, but the curate could not be convinced that he was serious and declined the gift.

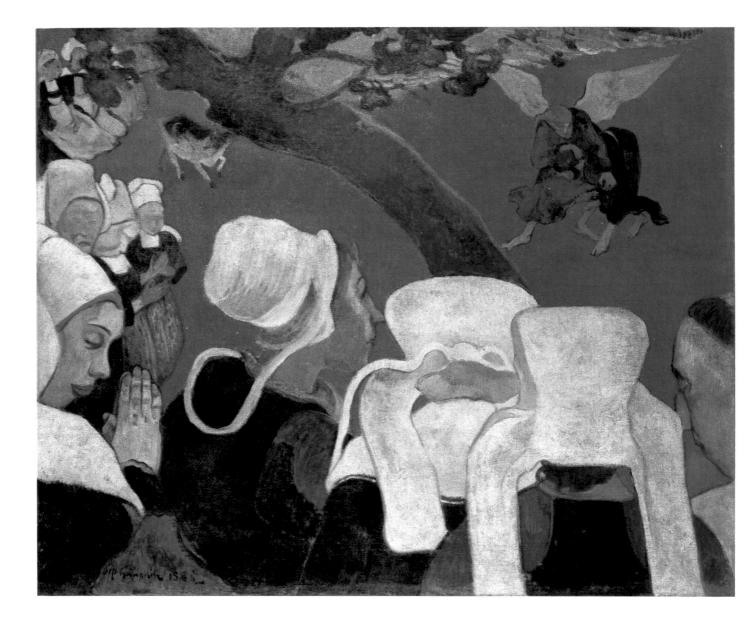

LA BELLE ANGÈLE, 1889 canvas, 92×73 cm $(36^1_4 \times 28^3_4 \text{ ins})$ *Jeu de Paume, Paris*

As with his *Vision after the Sermon*, Gauguin attempted to give this painting away, this time to his sitter, Angèle Satre, wife of a future mayor of Pont-Aven, but she was horrified and refused to accept it. Later, when Gauguin was raising money for a journey to Tahiti, the painting was sold at auction to Degas. It displays a wide range of motifs and influences: the use of bright colour and divided brush-strokes recalls Gauguin's Impressionist period. The background is Japanese, while the inclusion of the primitive figurine has been variously interpreted and may derive from Gauguin's studies of ethnography during his travels and at

the Paris Universal Exposition held in 1889.

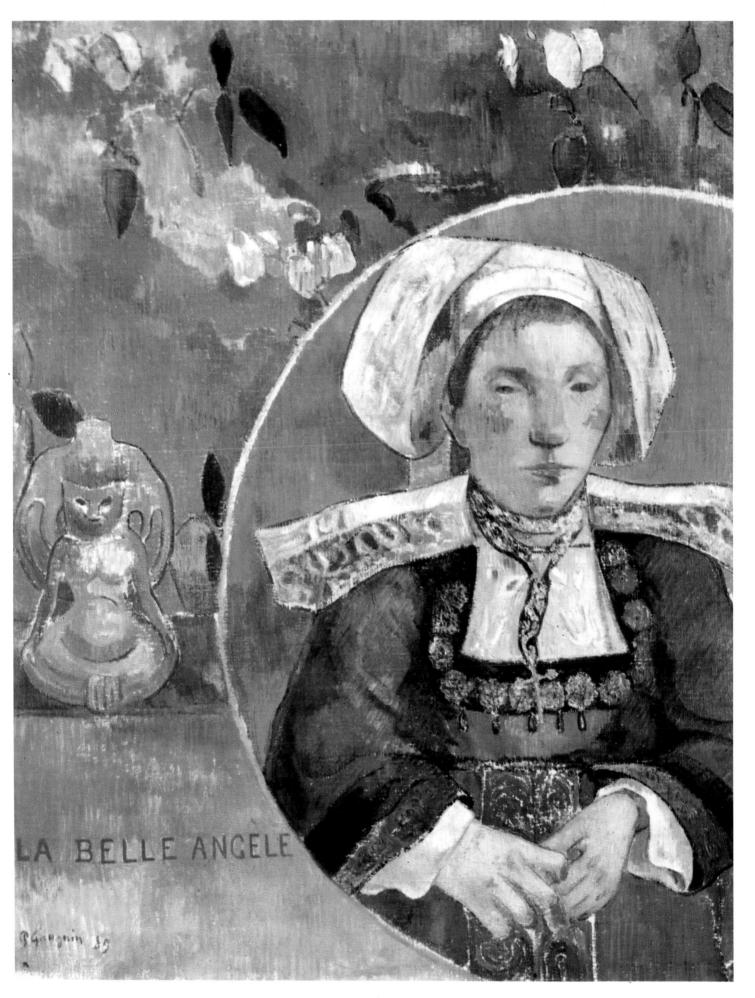

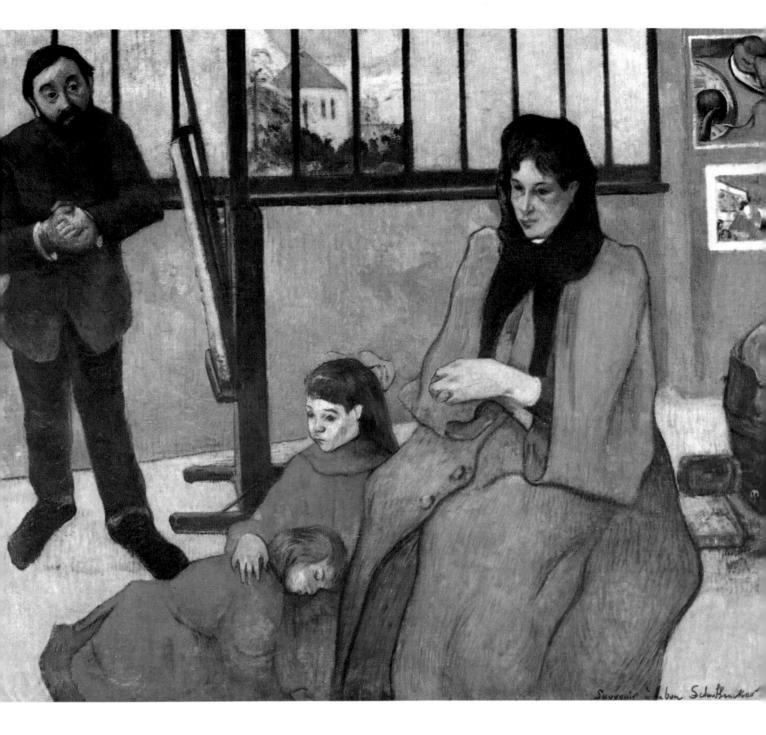

THE SCHUFFENECKER FAMILY, 1889 canvas, 73×92 cm $(28^3_4 \times 36^1_4 \text{ ins})$

Jeu de Paume, Paris

Gauguin met Emile Schuffenecker, an amateur artist, when they were both working for a firm of stockbrokers, and it was Schuffenecker who introduced him to Bernard in Pont-Aven. At the end of 1888, on Gauguin's return to Paris after his disastrous stay with Van Gogh in Arles, he stayed with Schuffenecker who frequently gave him financial support. Gauguin exhibited with the 'XX' (the *vingt*, or twenty – a group of artists) in Brussels, but the response to his work was generally unfavourable and he decided to return to Brittany.

Before leaving, he painted this portrait of his host and his wife and daughters in Schuffenecker's studio in the Rue Boulard. By now, Gauguin was fully committed to following his 'synthesis of form and colour', which is evident in this painting. At the same time, he incorporates such psychological features as the shy, modest attitude of his friend,

and the depiction of one of his sitters asleep. This would have been unthinkable to his Impressionist predecessors from whom he had now radically departed. His continuing interest in Japanese art, from which the flat, solid colours of his paintings largely derive, is reiterated by the presence of a print on the wall behind the figures – a recurring motif.

AREAREA, 1892

canvas, 75 × 94 cm $(29^{1}_{2} \times 37 \text{ ins})$ Jeu de Paume, Paris

In 1891 Symbolism in Painting: Paul Gauguin, an article by Georges-Albert Aurier, was published in which he attempted to summarize the painter's art under five headings: '(1) ideist, as its one aim will be the expression of an idea; (2) symbolist, as it will express this idea with forms; (3) synthetic, as it will put down these signs and forms in a generally understandable manner; (4) subjective, because the object will never be considered merely as an object, but as the expression of an idea perceived by the subject; (5) decorative, because decorative painting, such as the Egyptians and also probably the Greeks and Primitives conceived it, is no other than a manifestation of art which is at one and the same time subjective, synthetic, symbolist and ideist.' The primitive aspect was of particular importance to Gauguin; he had found it to some extent in Brittany, but in an attempt to shake off what he saw as the evil effects of 'civilization' he sailed for Tahiti. Gauguin's trip was subsidized by the French Minister of Fine Arts as a vague 'artistic mission'. There, he believed, he gradually turned into a 'savage'. While he was there a second article by Aurier appeared in which Gauguin was hailed as a leading Symbolist - 'the uncontested initiator of this artistic movement'. Arearea (Joyousness), a highly decorative work painted in Tahiti at the end of 1892, contains the elements that characterize his work from this time: the absence of relief, simplification of volume and design, and a supposedly primitive intensity of colour combining to evoke an atmosphere of the unknown.

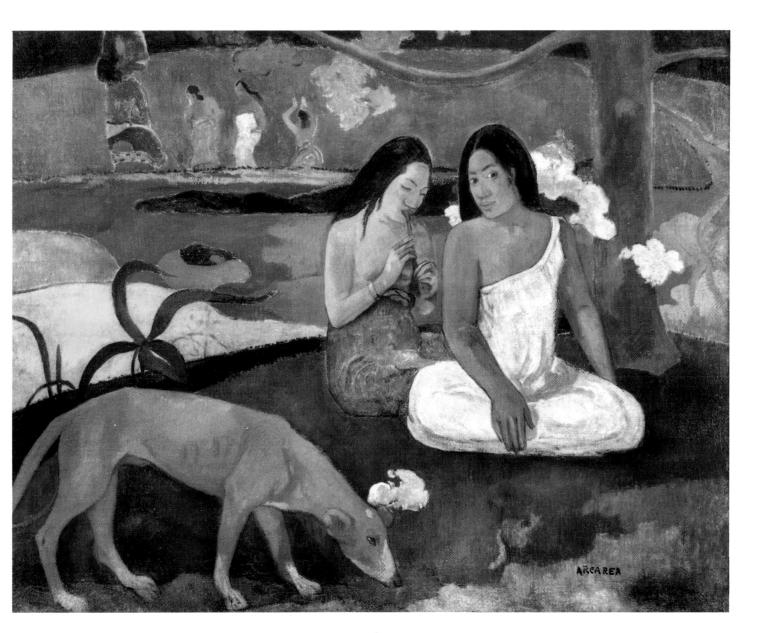

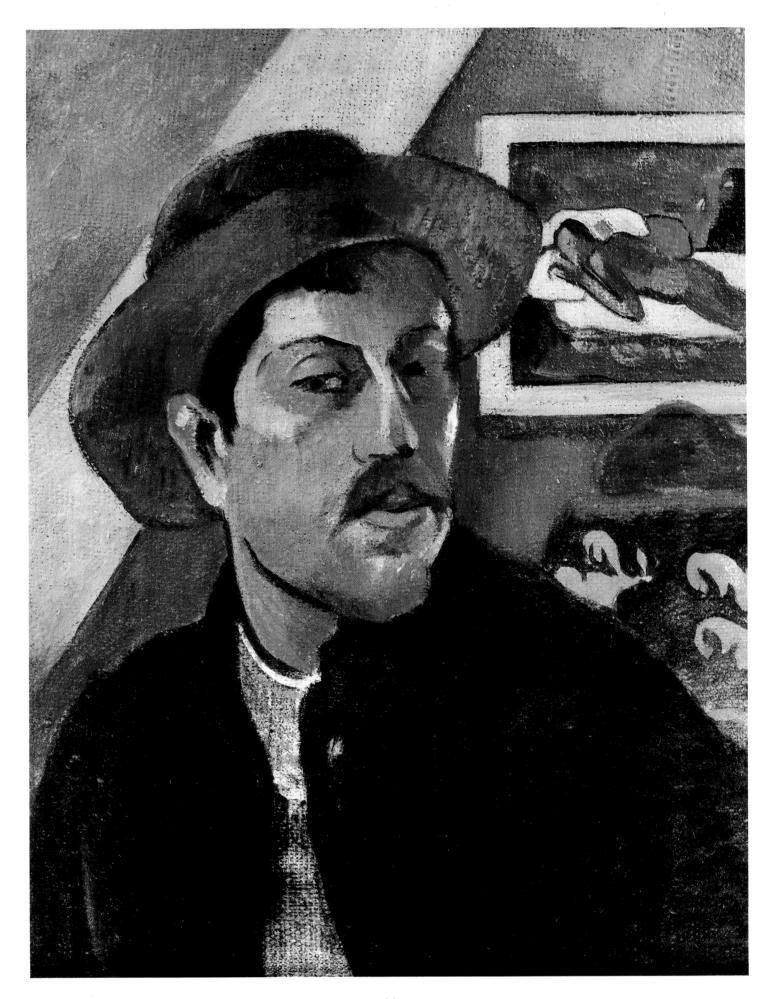

SELF-PORTRAIT, C. 1893-4

canvas, 46 × 38 cm (18 × 15 ins) Jeu de Paume, Paris

Gauguin returned to France at the end of 1893, but this self-portrait reveals his yearning to return to Tahiti: on the wall behind him is a copy, in reverse, of his painting *Manao Tupapau* (The Spirit of the Dead Watching), a nude painting of Teha'amana, his young Tahitian mistress whom he had left on the island.

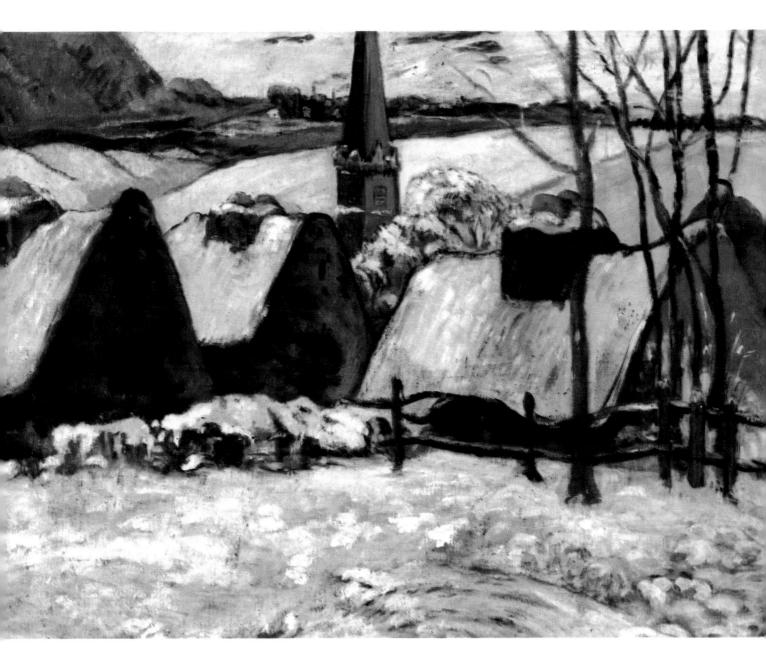

BRETON VILLAGE IN THE SNOW, 1894 canvas, 62×87 cm $(24_2^1 \times 34_4^1 \text{ ins})$ *Jeu de Paume, Paris*

Back in France, Gauguin divided his time between Brittany and Paris. It was once believed that this painting had been painted from memory in Tahiti at the end of his life as a remembrance of his earlier days. It is now thought that he painted it on the spot, but retouched it in Tahiti, where it was discovered after his death. At a sale of his effects in 1903, together with four carved panels, it fetched seven francs; it is a measure of the increase in the regard in which Gauguin's work is now held that when it was sold to the Louvre in 1952, it made nine million francs.

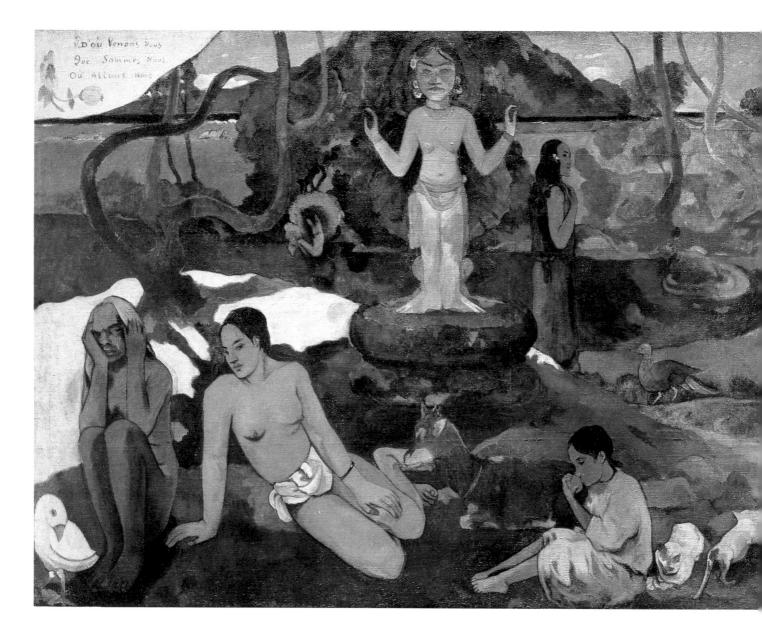

WHERE DO WE COME FROM? WHO ARE WE? WHERE ARE WE GOING?, 1897

canvas, 139×375 cm $(54_4^3 \times 147_2^1 \text{ ins})$ Museum of Fine Arts, Boston

Back in Tahiti, at the end of 1897, Gauguin was ill, penniless and thoroughly dispirited. His daughter Aline had died of pneumonia earlier in the year, and he had been evicted from his home. In utter despair he attempted to commit suicide by swallowing arsenic, but he vomited so much that it did not take effect. Immediately before this, he painted this masterpiece, a huge work in which he attempted to draw together the results of his artistic

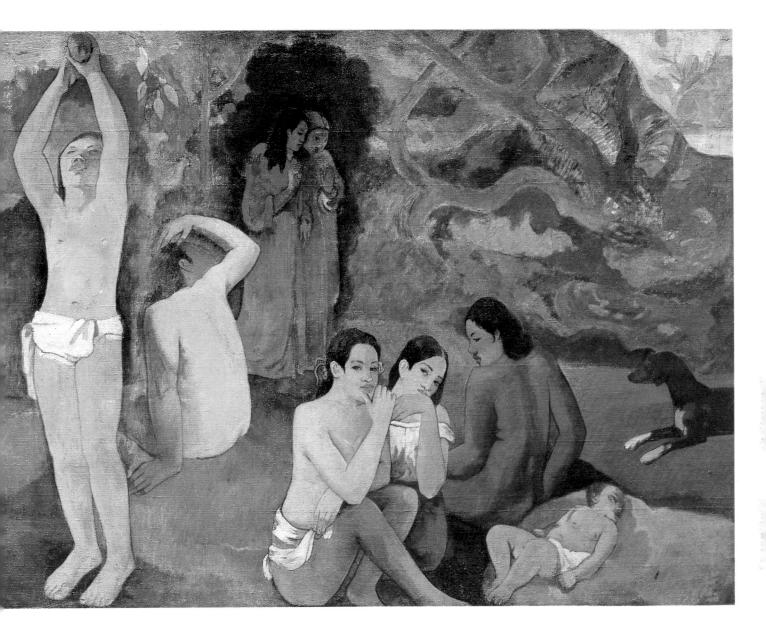

endeavours and psychological and philosophical beliefs. In the event, he considered it as his last testament. Gauguin described how 'I worked on it day and night at a feverish pace . . . I put into it, before dying, all my energy, so much painful passion in terrible circumstances and so sharp a vision without any alterations that the motif disappears and life wells up

from it.' In the spring of 1898 the painting was sent to Paris where it was shown at the Vollard Gallery. In answer to criticism of it Gauguin wrote: 'I have tried to put my dream into a suggestive setting, and to interpret it without recourse to literary means, and with all the simplicity the medium allows: a difficult task. Criticize me if you wish for having failed, but not for having tried.' To his friend, Daniel de Monfreid, he declared 'I think that not only does this picture surpass all my previous ones, but that I shall never do a better, or even one like it'.

169

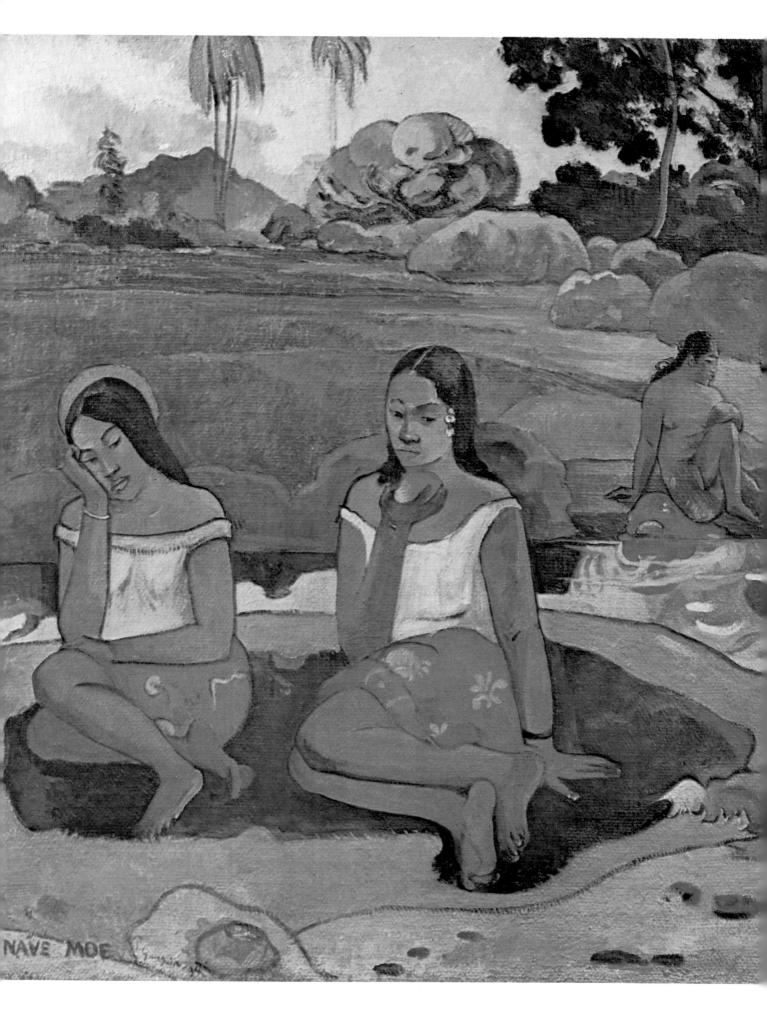

NAVE, NAVE, MOE, 1894

canvas, 73×98 cm $(28\frac{3}{4} \times 38\frac{1}{2}$ ins) The Hermitage, Leningrad

It must be remembered that the idvllic world of the South Seas depicted in the paintings of Gauguin resembles more his hoped-for paradise than what he actually found upon his arrival in Tahiti in 1891. Gauguin, in his desire to escape the materialistic and corrupt civilization of Europe, had been seduced by the full scale replica of a Javanese village exhibited at the Paris Exhibition of 1889, and by the propaganda distributed by the French Government to encourage emigration to the colonies, both of which presented a romanticized view of a life of plenty, with little need to work, abundant food, song and love. In reality Gauguin found that European civilization and Christian missionaries had all but eradicated Polynesian culture. The women did not go around naked; they only occasionally wore the bright cloth with large floral designs so often seen in Gauguin's paintings, and which by that time was being manufactured in Europe and exported to the colonies. Instead, a Christian sense of propriety had forced the women into voluminous white gowns which covered their nakedness from neck to wrist to ankle. The woodcarvings of gods and spirits so often

seen in Gauguin's South Sea paintings, and the descriptions in his letters of native religion and superstition, belonged to a previous age; his knowledge of them came mostly from items seen in Europe or from books which he took with him on his self-imposed exile.

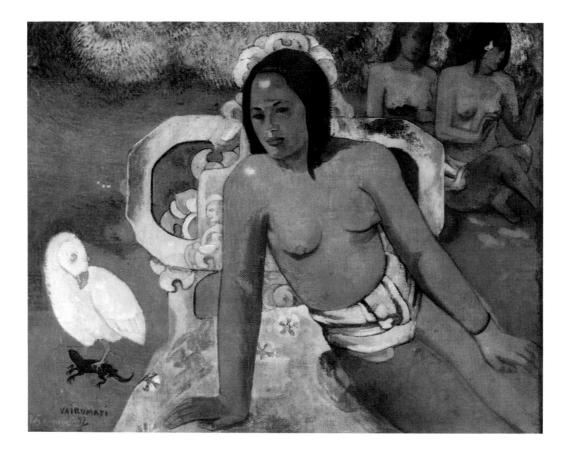

VAIRUMATI, 1897 canvas, 73 × 94 cm $(28_4^3 \times 37 \text{ ins})$ *Jeu de Paume, Paris*

In the same year that Gauguin painted *Where do we come from?* he produced *Vairumati*, based on the character in a Tahitian legend related to him by his mistress: 'She was tall and the sun's fire burnt in the gold of her flesh, while all the mysteries of love slept in the night of her hair.' She appears again in the left foreground of *Where do we come from?* with the same 'strange white bird' beside her. Gauguin described the legend in his extraordinary journal *Noa Noa*, the text and pictures of which were published in France in the *Revne Blanche* in 1897. Among his last writings was his *Before and After* (1903) in which he described the appeal of the Tahitian women who feature in so many of his later paintings: 'What

distinguishes the Tahitian woman from all other women, and often causes her to be mistaken for a man, is the proportions of her body. Nude, she is Diana the huntress with

wide shoulders and narrow pelvis . . . the skin is a golden yellow.' Here, as elsewhere, Gauguin uses colours not in a descriptive, but in an emotive way: his colours express the way he feels rather than what he actually sees. However, unlike Seurat, he does not use any fixed scientific system for the application of pigment. 'Colour,' he writes in a letter, 'being enigmatic in the sensations which it gives us, can logically be employed only enigmatically. One does not use colour to draw but always to give the musical sensations which flow from itself, from its own nature, from its mysterious and enigmatic interior force. We can see in

this painting how the colours are used harmoniously rather than naturalistically. In his 'abstract' treatment of colours and in his idea of the relationship of harmonious colours to harmonious sounds, he is the forerunner of early abstract painters such as Kandinsky.

Looked at in this way it is difficult to explain exactly what Gauguin's paintings really mean, but the artist would have considered a work successful if it had provoked in the spectator the same kind of intense sensation which he himself had experienced while producing the painting.

'NEVERMORE', 1897

canvas, 59.5 × 116 cm $(23\frac{1}{4} \times 45\frac{3}{4} \text{ ins})$ Courtauld Institute Galleries, University of London

In his second sojourn in Tahiti Gauguin became increasingly fascinated with the islanders' religion and folklore, and in his paintings he frequently expresses their superstitious fears. '*Nevermore*' contains such images as 'the bird of the devil that is keeping watch', as he described it. The painting harks back to Manet's *Olympia* (page 52) and is similarly defined by a hard-edged outline; the curves of the subject's body are repeated in the bedhead and the background decoration. The painting expresses his intention, as he described it 'to suggest by means of a simple nude a certain long-lost barbarian luxury. The whole is drowned in colours which are deliberately sombre and sad; it is neither silk nor velvet, nor *batiste*, nor gold that creates luxury here, but simply matter that has been enriched by the hand of an artist.' In attempting to depict a dream-like scene, he follows his aspiration to provoke thought in the viewer 'by the mysterious relationship existing between our brains and such arrangements of colours and lines'.

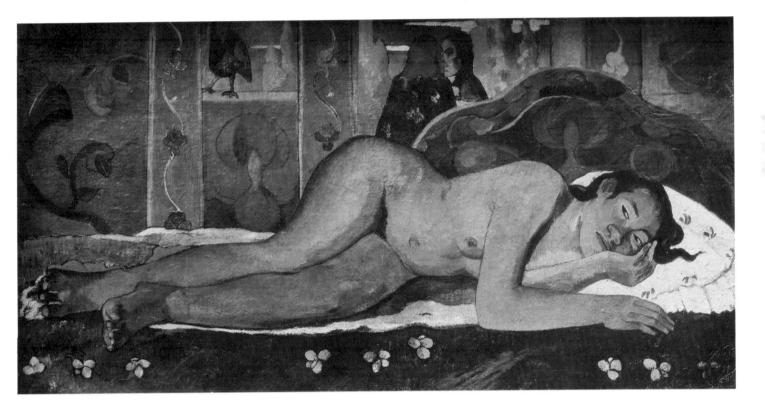

Overleaf

THE WHITE HORSE, 1898

canvas, 140×91.5 cm (55×36 ins) *Jeu de Paume, Paris*

This painting displays Gauguin's use of colour, which was derived from Impressionism but which he developed to achieve different ends: 'Colour, which is vibration, like music, has the power to achieve the most general and yet the most indeterminate element in nature: its inner force.' Gradually, de Monfreid and other friends and dealers began to find collectors for Gauguin's work, on one occasion describing in a letter to him how a couple of his canvases would suit a buyer since they would 'fit into his collection admirably between a magnificent Cézanne and a Degas'. But just as his long-sought appreciation was materializing, Gauguin's health was deteriorating and his output declined; not a single painting appears to have been produced in 1900.

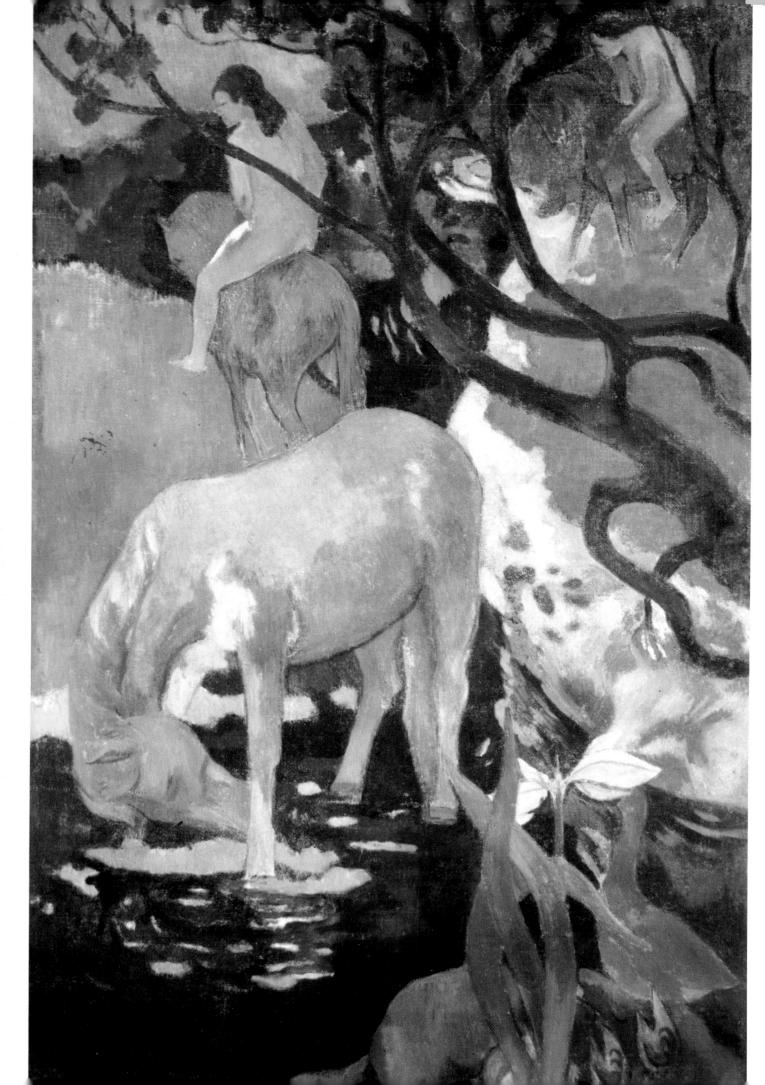

'AND THE GOLD OF THEIR BODIES', 1901

canvas, 67×76 cm $(26\frac{1}{2} \times 30$ ins) Jeu de Paume, Paris

In August 1901, Gauguin left Tahiti for the Marquesas Islands. This painting dates from his stay in Dominica in 1901. From there he wrote to de Monfreid: 'I am more and more pleased with my choice . . . What models!!! A wonder, and I have already begun to work . . . In the isolation of a place like this, a man's mind is reinvigorated. Here poetry arises all by itself, and to suggest that poetry you have only to surrender to your dreams as you paint . . . I feel that in art I am right, but will I have the strength to give it positive expression?' His health worsened, the island was devastated by a cyclone and he fell foul of the civil and religious establishment when he tried to encourage the inhabitants to relinquish Christianity and to return to their own religion. He was tried and sentenced to three months imprisonment, but died before the sentence could be carried out.

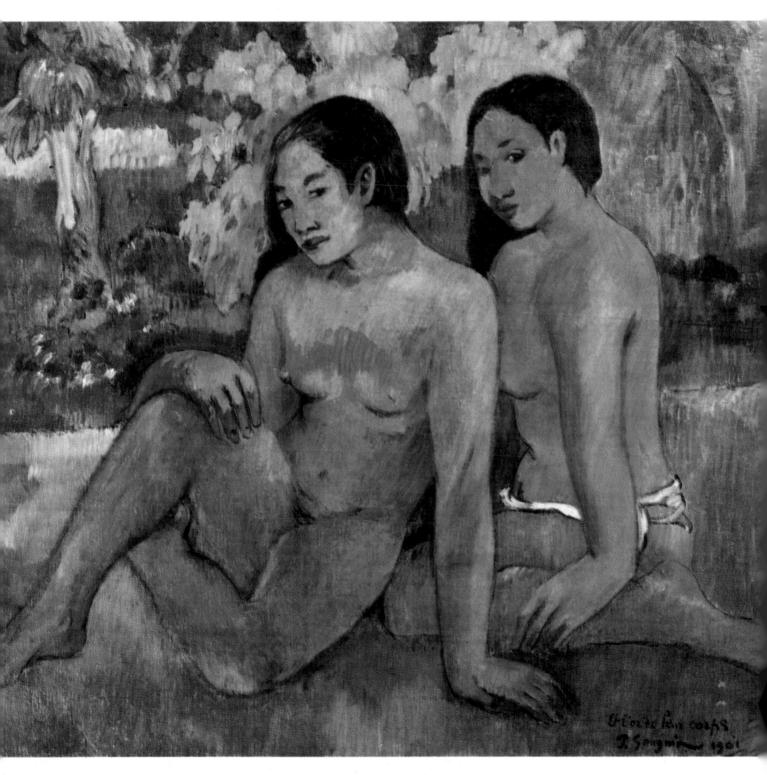

HENRI DE TOULOUSE-LAUTREC (1864–1901)

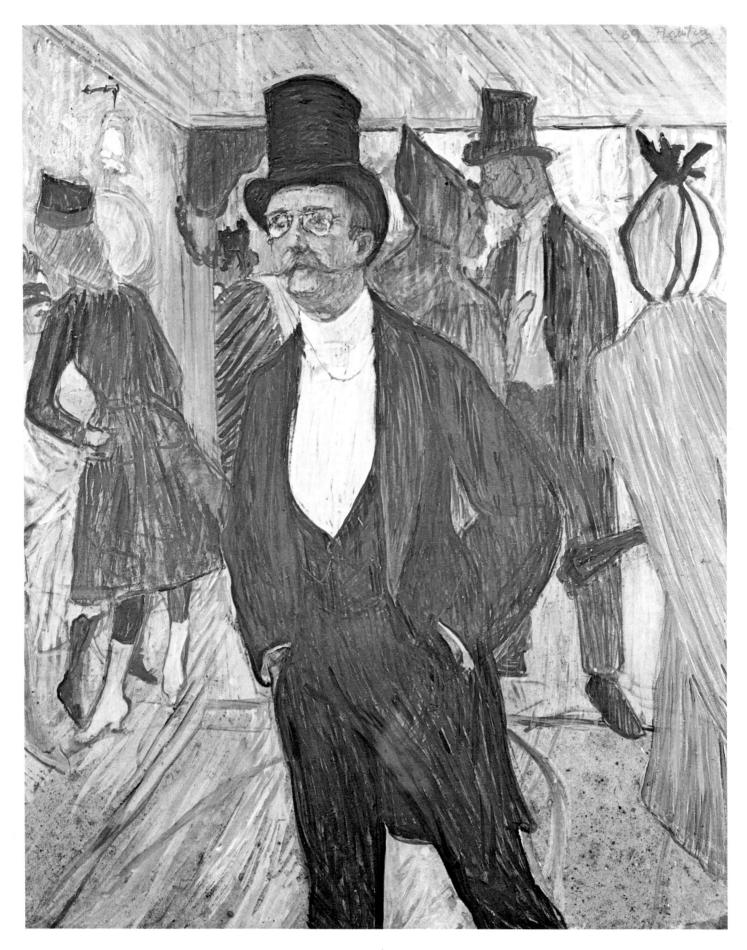

PORTRAIT OF MONSIEUR FOURCADE, 1889

cardboard, 77 \times 63 cm (30¹/₄ \times 24³/₄ ins) Museu de Arte, São Paulo

This portrait, in the way the sketchy colour is applied, shows a characteristic of Toulouse-Lautrec's mature style which at this stage was only just beginning to emerge. In later work, and especially on posters, whole areas of colour could exist without contours or outlines to contain them. Lautrec's manipulation and mastery of the overall design was so tight that a slight discrepancy between contour and colour (the feeling that the colour somehow does not fill the outline and belong to the person or object) gives the image greater movement.

THE BED, *с*. 1892

board, 54×70.5 cm $(21\frac{1}{4} \times 27\frac{3}{4} \text{ ins})$ Jeu de Paume, Paris

After 1892 Toulouse-Lautrec produced a considerable number of works in a variety of media depicting the everyday lives of prostitutes. At one time he actually resided in a brothel in the Rue des Moulins (see page 179). This is one of many showing the lesbian relationships which frequently developed between the prostitutes and which he portrayed in his characteristically unsentimental manner.

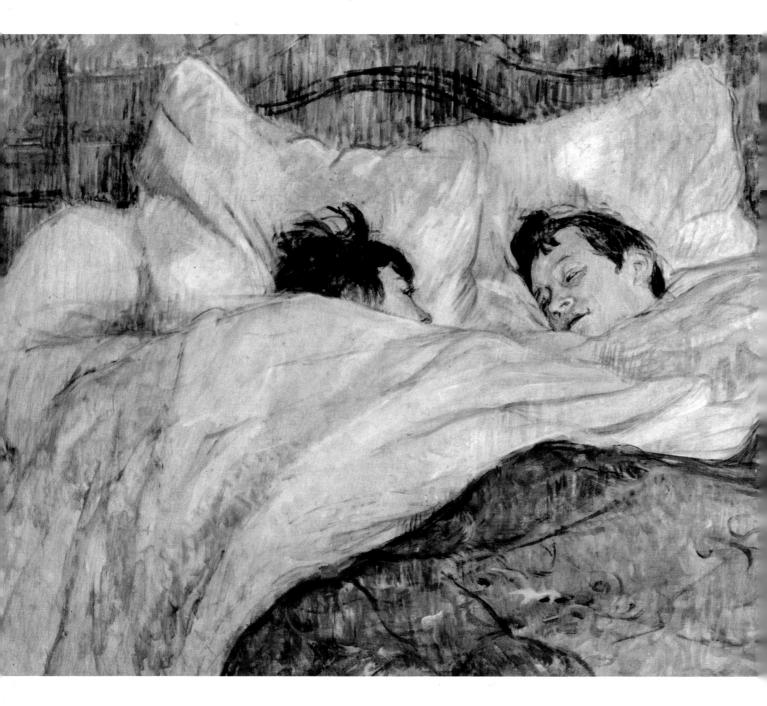

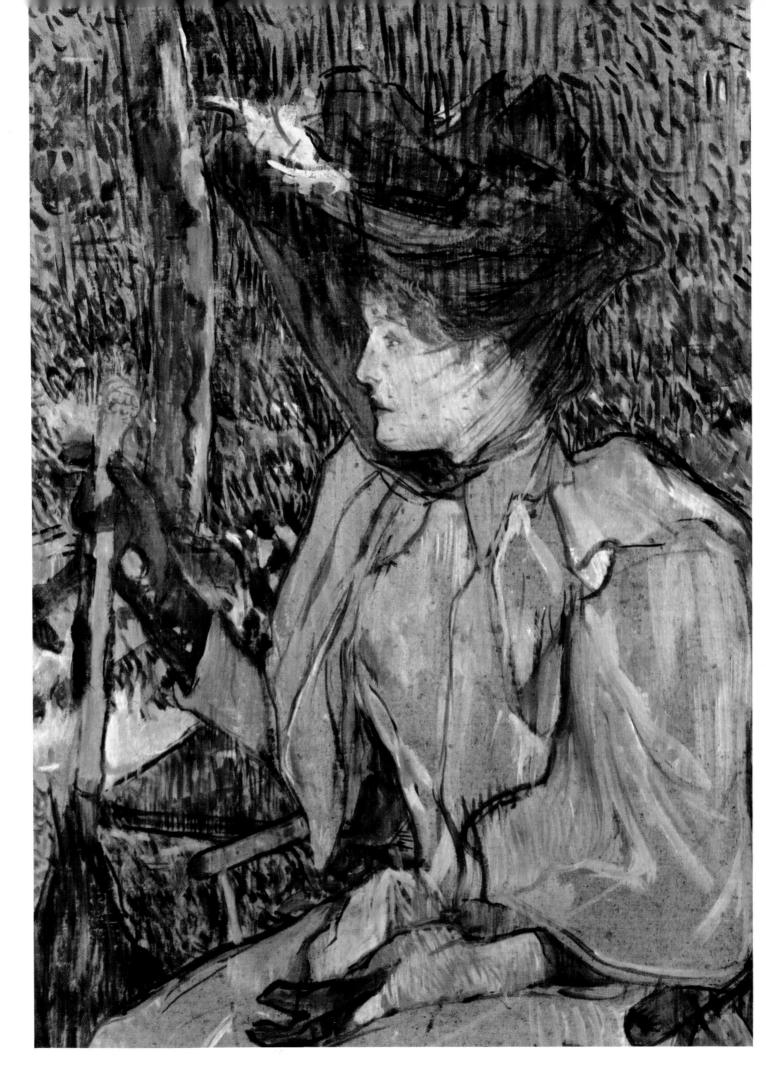

WOMAN WITH GLOVES, 1891

cardboard, 54×40 cm $(21\frac{1}{4} \times 15\frac{3}{4} \text{ ins})$ Jeu de Paume, Paris

Toulouse-Lautrec executed this portrait in oil on cardboard, which was one of his favourite mediums, for it suited perfectly the quick and sketchy way in which he worked. The cardboard is here left uncovered in many places and used as an element in the painting.

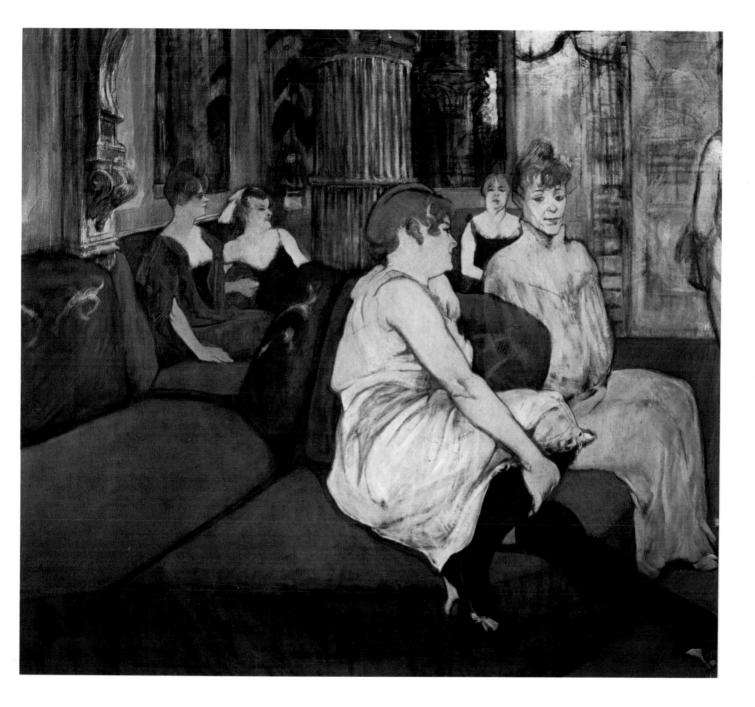

IN THE SALON AT THE RUE DES MOULINS, 1894

canvas, 111.5 × 132.5 cm $(43\frac{3}{4} \times 52 \text{ ins})$ Musée Toulouse-Lautrec, Albi

'The professional model is always like a stuffed owl. These girls are alive.' So Toulouse-Lautree described his subjects in this painting, one of many he executed in the brothels in Paris.

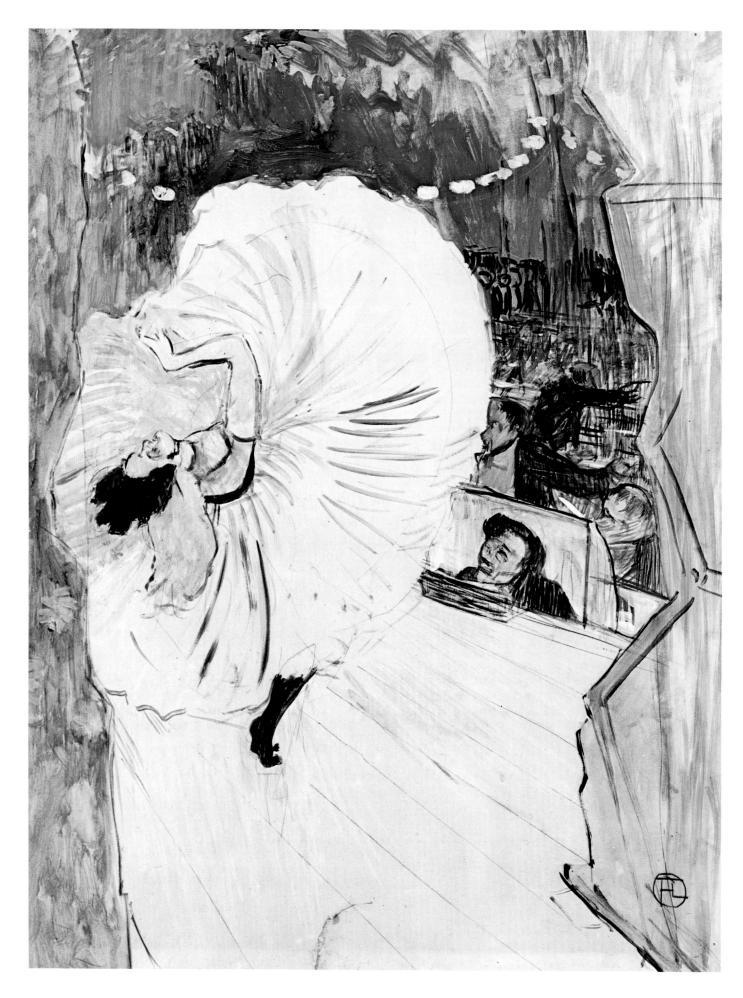

THE BALLERINA LA ROUE, 1893–4 lithograph, published in the 'Figaro Illustré' *Museu de Arte, São Paulo*

Lithography is a medium ideally suited to an artist such as Toulouse-Lautrec who liked to work quickly and in a sketchy manner. The artist draws directly onto the stone with chalk, pen or brush, and a wide range of effects is possible while maintaining the spontaneity of the artist's hand. Lautrec's control of the surface design of his lithographs was such that the large areas he leaves blank acquire an activity and movement which are greater than in the more worked-on sections. He forces the spectator's eye to complete both the blank areas and the areas of plain flat colours, thus producing a far livelier result than if he had filled the picture with a mass of detail. Lautrec had said: 'All I want to do is paint what I see. Anybody can finish off a painting.'

Overleaf

A CORNER OF THE MOULIN DE LA GALETTE, 1892

cardboard on wood, 100.3 × 89 cm (39¹/₄×35 ins) National Gallery of Art, Washington Chester Dale Collection

Toulouse-Lautrec was an *habitué* of such Parisian dance-halls as the Moulin Rouge and the Moulin de la Galette. This painting summarizes the principal characteristics of his technique and subject-matter: his use of outline, areas of flat colour and general lack of shadows come from the decisive influence of Japanese prints. His subjects are not posed models but the regular visitors to the Moulin. The main figures appear detached, as in Degas' *Absinthe* (page 78) and there are obvious affinities between the unsentimentally observed subjects of

both artists. The figures in this painting have been kept in the foreground and one head is lost off the edge of the picture, which gives a sense of immediacy to the group.

Page 183

PANELS FOR LA GOULUE'S BOOTH, 1895 canvas, 298 × 316 cm $(117_2^1 \times 124_2^1 \text{ ins})$ and 285 × 307.5 cm $(112_4^1 \times 121 \text{ ins})$ *Jeu de Paume, Paris*

Toulouse-Lautrec painted the dancer Louise Weber, known as 'La Goulue' (the glutton), on numerous occasions. These two panels were painted as decorations for her booth at the Foire du Trône; a contemporary photograph shows them either side of an oriental entrance

to the stage where she performed after her decline into obesity and alcoholism ended a glittering career. The first panel (top) shows her past: formerly an Alsatian laundress, 'pretty and attractive to look at in a vulgar way', as the entertainer Y vette Guilbert described her, she became a performer in the Cirque Médrano, which Seurat features in his *The Circus* (page 189), the Moulin de la Galette and the Jardin de Paris, and eventually starred at the Moulin Rouge for five years from 1890. Lautrec shows her in this setting, with Valentin le Désossé ('boneless', or double-jointed Valentin, the stage name of Jacques Renaudin) about to do the splits. The second, more contemporary panel (below) has her performing a lively Moorish belly-dance, with a harem of attendants. Among those who have been identified in the painting are the pianist Tinchant, the photographer Paul Sescau, the portly figure of Oscar Wilde, although it has been suggested that it is actually a representation of M. Sainte-Aldegonde, the dancer Jane Avril, whom Lautrec frequently painted, in back view, the

diminutive figure of Lautrec himself and the strange profile of the art critic and defender of the Neo-Impressionists, Félix Fénéon. One of the owners of the panels cut them up. When they were acquired by the Louvre in 1929 (the year of the death, in destitution, of La Goulue) they were reassembled but the joins can be clearly seen.

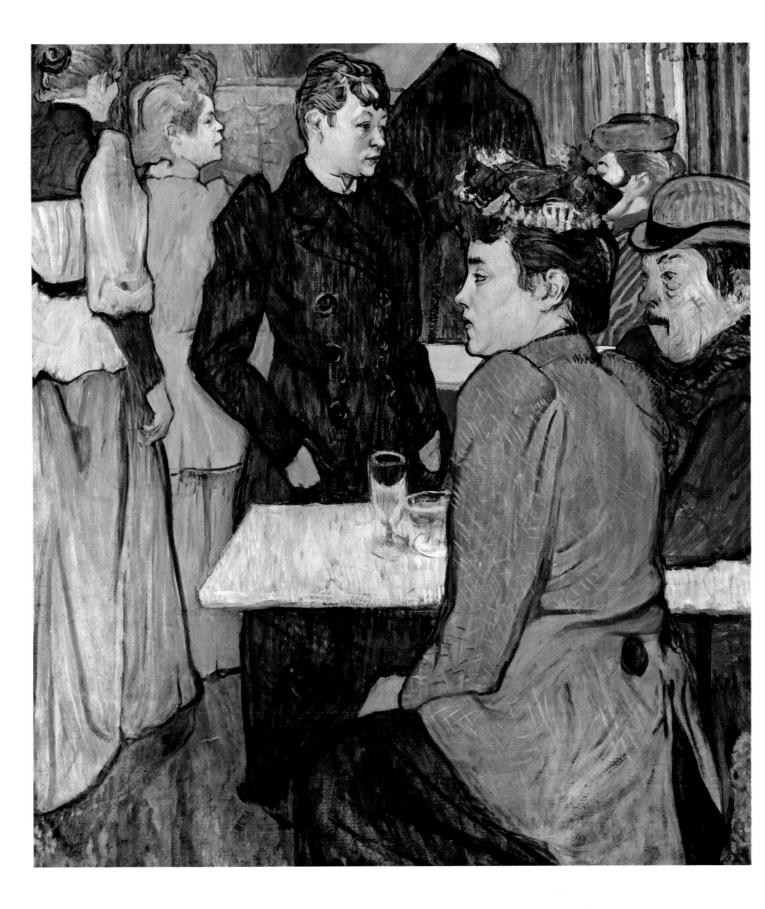

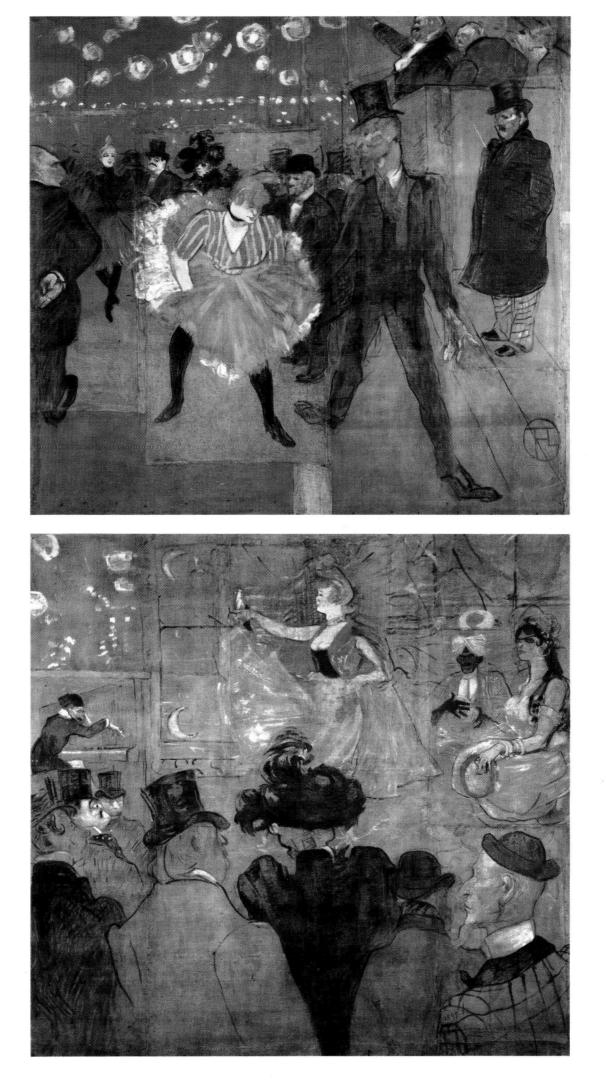

GEORGES-PIERRE SEURAT (1859–91)

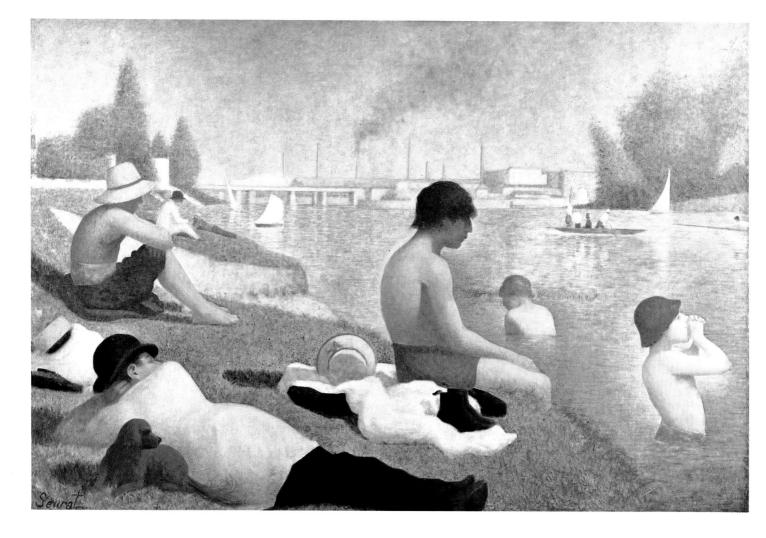

BATHERS, ASNIÈRES, 1883–4

canvas, 201 × 300 cm (79 × 118 ins) National Gallery, London

Seurat's huge painting, his first to be shown in public, was composed from a number of sketches made on the spot and completed in the studio – a departure from conventional Impressionist practice. Seurat's work was based on his studies of light and colour, including the colour 'wheel' or disc of O.N. Rood which indicated the complementary of all colours so that an artist could juxtapose any two to achieve greater luminosity. 'Chromoluminarism' was the name preferred by Seurat for what came to be called 'Neo-Impressionism'. Also, unlike the Impressionists except perhaps Guillaumin, Seurat chose a subject which included an industrial landscape with working-class bathers. He later reworked parts of the canvas in his more familiar 'divisionist' or pointillist style.

STANDING MODEL, 1886–7

panel, 25×16 cm $(9^3_4 \times 6^1_4 \text{ ins})$ Jeu de Paume, Paris

This is a study for Seurat's larger work, *The Models*, in which three women (actually the same woman three times) are viewed against a background which includes part of Seurat's painting, *Grande Jatte* (page 186). It was painted partly to confound those critics who declared that divisionism was unsuitable for painting figures, but despite Seurat's success it is in its composition a tribute to such classical predecessors as Ingres. Seurat's technique after *Grande Jatte* was to apply vast numbers of tiny dots painted to a precise formula to achieve 'optical mixture'. These were applied over broad areas of thin, even colour, so that the under-colour, rather than the white canvas, appears through.

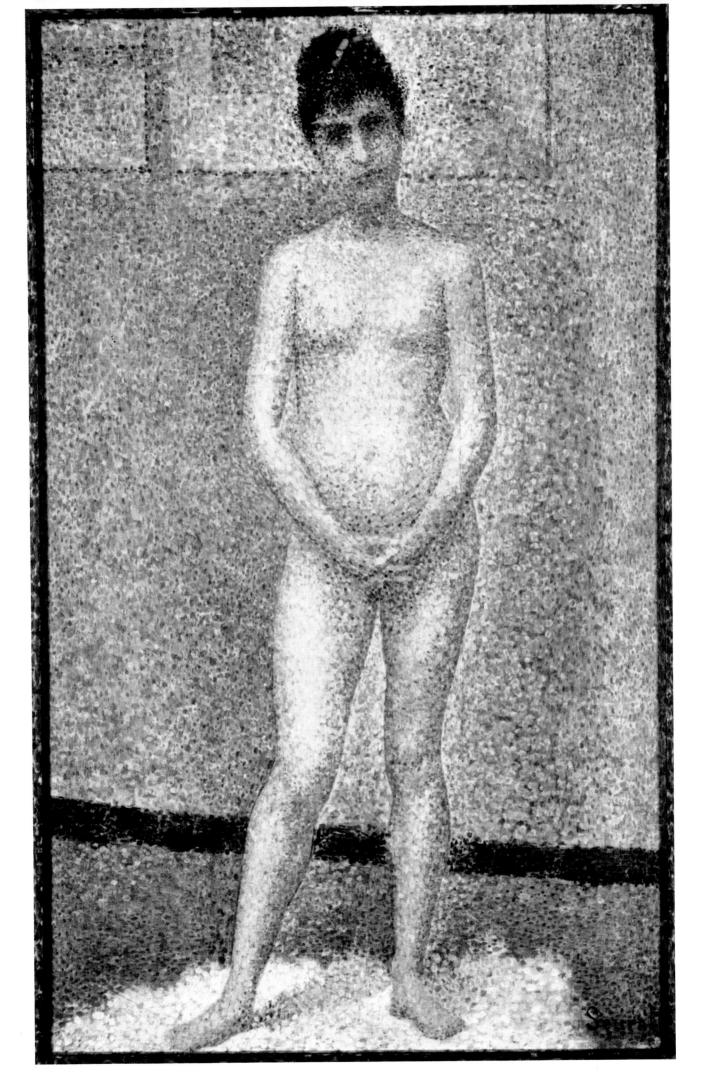

SUNDAY AFTERNOON ON THE ISLAND OF LA GRANDE JATTE, 1884–6

canvas, 205×281.7 cm $(81 \times 110^3_4 \text{ ins})$ Art Institute of Chicago

Seurat's most famous painting and that which best embodies the principles of the Neo-Impressionist school, *Grande Jatte* has been subjected to innumerable studies and

interpretations since it was first shown at the eighth and last Impressionist exhibition in 1886. Although it is predominantly a divisionist work, it displays certain Impressionist techniques, as did Seurat's many sketches and studies for it, some of which were shown before the painting itself was completed at the Société des Indépendants' exhibition of 1884. Seurat may have 'borrowed' certain elements of his great work from contemporary fashion plates and derived portions of the composition from classical paintings. The result is highly complex, based on a curious dual perspective: the couple on the right and the man with a pipe in the foreground are apparently viewed from the right, while the rest of the painting extends from a central point; if the foreground zone is viewed from the middle, the people in it become impossibly large. Like his Bathers (page 184), it is a huge canvas and occupied Seurat for almost two years. There are many stories of his obsessive concern with it and his apparent obliviousness to his friends and disregard for meals while he worked non-stop. Pissarro met Seurat as the painting neared completion and he and his son Lucien, as well as a number of other young artists, immediately adopted the divisionist style. Pissarro insisted on the inclusion of Seurat and his associate Signac at the final Impressionist exhibition, despite the objections of other members of the group. Their work, including Grande Jatte which was poorly displayed, was exhibited in a room separately from the rest of the Impressionists, and received the storm of criticism formerly directed at them. However, some were attracted to the apparent logic of Seurat's 'scientific' art and attempted to explain it to the largely bewildered public. Sadly the painting has undoubtedly been subjected to considerable fading since it was produced, and it is difficult today to imagine the impact its brilliant colour and revolutionary technique must have had upon those who first saw it. One, the critic Jules Christophe, recorded his impression of the work in an article in Men of Today (1890), particularly emphasizing the success of the Neo-Impressionist method in rendering the effect of bright sunlight, a problem that had preoccupied the Impressionists during the previous two decades: Under a blazing midafternoon summer sky, we see the Seine flooded with sunshine, smart town houses on the opposite bank, and small steamboats, sail-boats and a skiff moving up and down the river. Under the trees closer to us many people are strolling, others are sitting or stretched out lazily on the bluish grass. A few are fishing. There are young ladies, a nursemaid, a Dantesque old grandmother under a parasol, a sprawled-out boatman smoking his pipe, the lower part of his trousers completely devoured by the implacable sunlight. A dark-coloured dog of no particular breed is sniffing around, a rust coloured butterfly hovers in mid-air, a young mother is strolling with her little girl dressed in white with a salmon-coloured sash, two budding Army officers from Saint-Cyr are walking by the water. Of the young ladies, one of them is making a bouquet, another is a girl with red hair in a blue dress. We see a married couple carrying a baby, and at the extreme right appears a scandalously hieratic-looking couple, a young dandy with a rather excessively elegant lady on his arm who has a yellow, purple, and ultramarine monkey on a leash.'

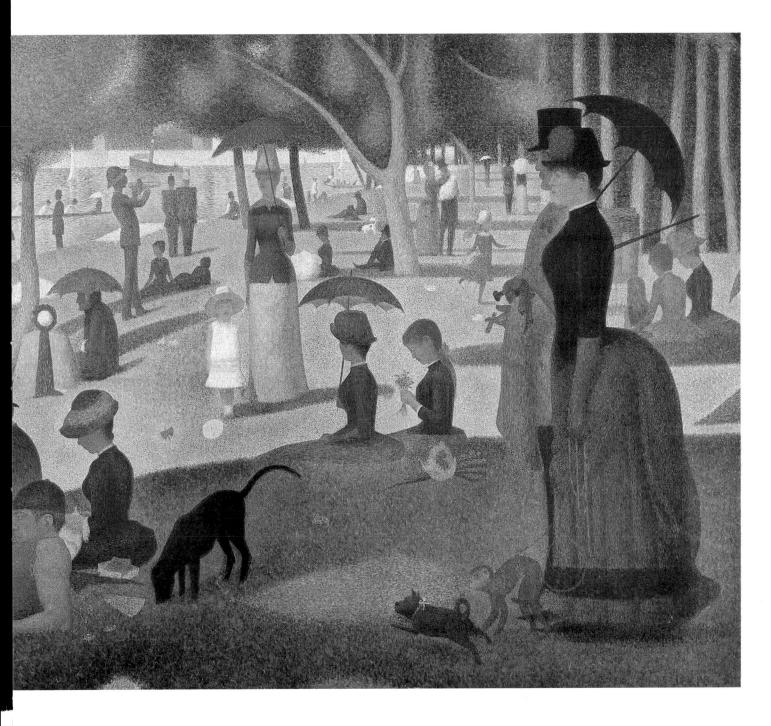

PORT-EN-BESSIN. THE OUTER HARBOUR, HIGH TIDE, 1888

canvas, 67×82 cm (26½×32¼ ins) Jeu de Paume, Paris

The tranquil harbour of Port-en-Bessin in Normandy was introduced to Seurat by Paul Signac, who had painted there in 1883. The divisionist technique was particularly suited to depicting the brilliance of the sunlit sea, though the shining luminosity of some of Seurat's work may in fact have been reduced by fading that has occurred during the past 90 years. Seurat's works were little appreciated until the inter-War period. Paintings sold at his death for a few hundred frances then fetched many thousands, while this painting, bought by the Louvre in 1951, reached almost 17 million frances.

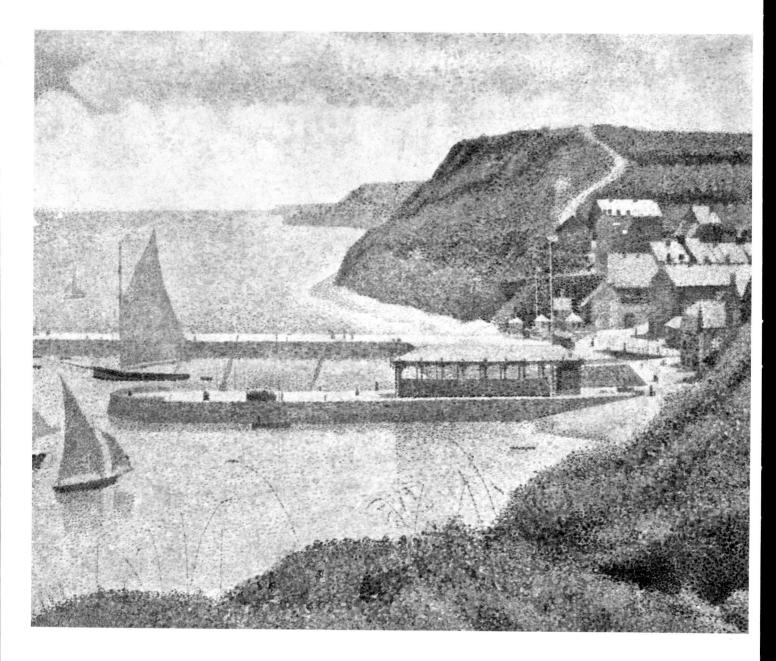

THE CIRCUS, 1891

canvas, 185 × 152.5 cm (73 × 60 ins) Jeu de Paume, Paris

This painting indicates the direction in which Seurat was developing: from his static *Bathers* and *Grande Jatte* he was beginning to depict movement and to apply the theories of Charles Henry on the expressive effects of line – evident here in the slanted, almost oriental expressions of the spectators and recurring 'V' motif which in Henry's aesthetic denotes happiness. The circles, spirals and ellipses on which the painting is based anticipate Art Nouveau and its lack of depth presages Cubism.

PAUL SIGNAC (1863–1935)

HARBOUR MOUTH, MARSEILLES, 1911

canvas, 125 × 135 cm (49 × 53 ins) Musée d'Art Moderne, Paris

Marine subjects dominated Signac's work, which was influenced by Turner – 'the great Turner', as he described him, recommending his work as 'the most useful painting lesson there is'. From 1892 to 1911 he spent part of every year painting in the St Tropez and Marseilles area where he continued to work in a modified Neo-Impressionist style. There he was visited by Matisse and Derain, the founders of the Fauve school, and by this route the legacy of Impressionism was carried on into modern art. This painting is an example of Signac's Impressionist approach to his subject rather than his divisionist style with the close dots and geometric lines.

INDEX

Numbers in italics refer to illustrations

Académie Française 6, 7, 10, 11, 24 Académie Suisse, Paris 15, 17, 21 Alexis, Paul 25-6 Alma-Tadema, Lawrence 22-3, 24 André, Ellen, Degas' painting of 78 Argenteuil 24, 25, 28, 59, 91, 93, 94, 95, 127 Arosa, Gustave 31 Astruc, critic 51, 52, 65 Barbizon school 11, 14, 18, 23, 25 Baudelaire, Charles 14, 19, 21, 51, 52, 64, 66 Bazille, Frédéric (1841-70) 7, 17, 18, 19, 21, 22, 44, 65 Family Reunion 12, 19, 63 View of the Village 19 Bernard, Emile (1868-1941) 38, 146, 160, 164 Boisbaudram, Lecoq de 20 Bonington, Richard Parkes 13 Bonnard, Pierre 39 Boucher, François 13 Boudin, Eugène 14, 17, 19, 21, 23, 127 Braque, Georges 38 Bruyas, Alfred, collector 19 Cabanel, Alexandre, Birth of Venus Café Guerbois, Paris 12, 16, 19, 20, 26, 65, 77 Caillebotte, Gustave 31, 91, 96, 104, 115, 123 Callias, Nina de, Manet's portrait of 58 Cassatt, Mary (1844-1926) 19, 27, 31, 32, 33, 35-6, 42, 81 Girl Arranging Her Hair 86 Castagnary, Jules 28 Cézanne, Hortense, Cézanne's portrait of (Madame Cézanne in a Yellow Armchair) 141 Cézanne, Paul (1839-1906) 7, 8, 13, 14, 15, 17, 21, 22, 24, 25, 26, 27, 28, 29, 31, 32, 33, 34, 36, 37, 38, 39, 41, 42, 121, 123

Apples and Oranges 144

Bathers 38, 146 Card Players 38, 143 The Château Noir 147 L'Estaque 139 Farmyard at Auvers 137 The House of the Hanged Man 25, Madame Cézanne in a Yellow Armchair 141 A Modern Olympia 134 Mont Sainte-Victoire 140 The Poplars 138 Portrait of the Artist 136 Portrait of the Artist's Father 21 Road on the Plain, with Houses and Trees 148 Still-Life with a Plaster-cast 145 Woman with a Coffee Pot 142 Chailly, Impressionists at 17-18 Champfleury, Jules 11, 64 Charigot, Aline see Renoir, Aline Charpentier, Georges 33, 109 Chevreul, Eugène, colour theories of 10, 12, 35, 151 Chocquet, Victor, collector 29, 31, 38, 104 Constable, John 13-14, 23 Corot, Jean Baptiste Camille 14, 15, 17, 18, 19, 21, 28, 127 Courbet, Gustave 11, 12, 14, 15, 17, 18, 19, 20, 21, 24, 25, 64, 88, 127, 130 Cubists 37, 38, 144, 146, 188 Daubigny, Charles 14, 18, 22, 23, 28, 29 Daudet, Alphonse 109 Daumier, Honoré 53 David, Jacques Louis 10 Degas, Edgar (1834-1917) 6, 9, 14, 21, 22, 25, 26, 27, 29, 30-31, 33, 36, 37, 38, 40, 42, 65, 86, 162 Absinthe 78, 181 At the Races, in front of the Stands 74 At the Stock Exchange 80 The Bellelli Family 69 The Cellist Pillet 71 Combing the Hair 84 Cotton Exchange 25 Dance Foyer at the Opéra of the Rue Le Peletier 72-3

Dancers Practising at the Bar 42 The Dancing Class 76 Four Dancers 85 The Pedicure 75 Portrait of Diego Martelli 81 Semiramis Building Babylon 21, 70 The Star or Dancer on Stage 79 The Tub 83 Women Ironing 82 Delacroix, Eugène 10, 11, 13, 14, 17, 19, 20, 21, 29, 34, 39, 51, 152 Fantin-Latour's Homage to Delacroix 8, 20, 30, 64 Derain, André 38 Desboutin, Marcellin 78 Diaz de la Peña 14, 18 divisionism 35, 41, 124, 125 Doncieux, Camille see Monet, Camille Durand-Ruel, Paul, art dealer 24, 25, 29, 33, 34, 35-6, 39, 41, 71, 99, 117 Duranty, Louis Edmond 12, 30, 31, 64, 81 La Nouvelle Peinture 30 Duret, Théodore 24, 26-7, 28, 29, 41-2, 120, 121, 132 The Impressionist Painters 31-2 Ecole des Beaux-Arts, Paris 15, 17, 20, 21, 24, 32, 34 Fantin-Latour, Henri (1836–1904) 7, 9, 14, 20-21, 22, 51 Homage to Delacroix 8, 20, 30, 64 The Studio in the Batignolles Quarter 8, 65 A Table Corner 66 The Toast 20 Faure, Jean-Baptiste 129 Fauves 37, 38, 39, 45 Fénéon, Félix 181 The Impressionists 35, 36, 37 Folies-Bergère, Manet's painting of 34, 62 Fragonard, Jean Honoré 13, 107 Franco-Prussian War 7, 21, 22, 24, 25, 63, 90, 120, 121, 129, 139 Fry, Roger 37

Gachet, Dr Paul 134, 135, 159 Van Gogh's portrait of 40, 155 Gauguin, Aline 168 Gauguin, Paul (1848-1903) 17, 31, 32, 33, 34, 35, 36, 37, 38-9, 40, 44, 121, 124, 126, 136, 138, 153, 157 The Alyscamps at Arles 161 'And the Gold of their Bodies' 175 Arearea 165 La Belle Angèle 163 Breton Village in the Snow 167 Harvest in Brittany 160 Мапоа Тираран 167 Nave, Nave, Moe 170-171 'Nevermore' 39, 173 The Schuffenecker Family 164 Self-Portrait 166 Vairumati 172 Vision after the Sermon 39, 160, 162 Where do we come from? . . . 39, 168-9, 172 The White Horse 174 Gérome, Jean Léon 26, 28 Giorgione, Concert champêtre 49 Giverny (Monet in) 34, 98, 99, 101 Gleyre, Charles 17, 18, 19, 29 Goncourt, Edmond de 82 Gonzalès, Eva 19 Goya, Francisco 13, 40, 51, 54 Majas on a Balcony 57 Nude Maja 52 The Third of May 54 El Greco 13 La Grenouillère 18, 23, 25 Guichard, Joseph 19 Guillaumin, Armand 7, 28, 33 Sunset at Ivry 133 Guillemet, Antoine 34, 56 Hals, Frans 13, 25, 26 Havermeyer, H.O. 27, 36 Henry, Charles 188 Hessling, Andrée (Jean Renoir's wife) 119 Hoschedé, Ernest 30, 31, 34, 97 Hôtel Drouot, Paris, sale of paintings at (1875) 29, 104 Hunt, William Holman 34 Huysmans, Joris-Karl 32, 33, 36 Impressionist exhibitions 29, 31, 32, 33, 38, 67, 77, 83, 111, 113, 123, 124

first (1874) 6, 7, 13, 27–8, 92, 104

James, Henry 29 Japanese prints/art, influence of 38-9, 42, 55, 58, 71, 83, 88, 90, 157 Jongkind, Johann 17, 19, 21 kaleidoscope 12 Kandinsky, Vasily 43, 99, 172 Kirchoff, Gustav 12 La Goulue (Louise Weber), Toulouse-Lautrec's painting of 183 Lawrence, Sir Thomas 23 Le Coeur, Jules 18 Legros, Alphonse 64 Le Roux, Hughes 88 Leroy, Louis 6, 7, 13, 92 London 22, 23-4, 90, 102, 120 Lopez, Nini, model 104 Mallarmé, Stéphane 29-30, 41 Manet, Edouard (1832-83) 7, 8, 9, 13, 15, 19-20, 21, 22, 25, 28, 29, 30, 31, 33, 36, 64, 65, 70, 89, 91, 96 The Balcony 19, 56 A Bar at the Folies-Bergère 34, 62 The Barricade 24 The Blonde with Bare Breasts 60 Le Bon Bock 26, 36 Claude Monet in his Studio Boat 59 Le Déjeuner sur l'Herbe 20, 44, 49 Emile Zola 55 The Execution of the Emperor Maximilian 12, 20, 54 The Fifer 53 Gare Saint-Lazare 57 Lady with Fans 58 Lola de Valence 50 Music in the Tuileries Gardens 19. 51, 106 Olympia 20, 42, 49, 52, 54, 134, 173 Spanish Guitar Player 19 The Waitress 61 Manet, Eugène 113 Martelli, Diego, Degas' portrait of 81 Martin, Père, dealer 104 Matisse, Henri 38, 39, 45 Maupassant, Guy de 35, 109 Meissonier, Ernest 22, 26 Melbye, Fritz 15 Millet, Jean François 7, 11, 14, 17, 19, 152 Monet, Camille (née Doncieux) 23, 32, 88, 89, 94, 95, 97 Monet, Claude (1840-1926) 7, 9, 10, 13, 14, 17-18, 19, 20, 21, 22, 23-4, 25, 27, 28, 29, 30, 31, 33, 36, 37, 38, 42-3, 59, 65, 105, 126, 127, 148 The Boat at Giverny 98 The Cathedral of Rouen, Harmony in Brown 100 A Field of Poppies 95 Gare Saint-Lazare 30, 96 Haystacks at Sunset 99 High Tide at Etretat 88 The Houses of Parliament 102

Ingres, Jean 11, 19, 21, 26, 34, 83

Impression, Sunrise 6, 92 Lavacourt. Winter 97 The Lily Pond, Harmony in Pink 101 The Luncheon 94 Madame Monet on the Couch 89 Palazzo da Mula, Venice 103 Railway Bridge at Argenteuil 93 Regatta at Argenteuil 91 The Thames Below Westminster 23. 90 Women in the Garden 18, 19, 63, 87 Monet, Jean (son) 88, 94, 95 Moore, George 83 Morisot, Berthe (1841-95) 7, 19, 21, 22, 25, 26, 28, 29, 31, 32, 33, 41, 56, 113 The Butterfly Hunt 68 The Cradle 67 Morisot, Edma 67, 68 Moulin de la Galette, Paris 106, 149, 180 Murer, Eugène 32 Nadar (Félix Tournachon) 6, 27 Napoleon III, Emperor 20, 44 Neoclassicism 10, 11, 12, 44 Neo-Impressionists 9, 35, 36, 37, 41, 103, 124, 138, 186 New York, Impressionist exhibition in 36 Nieuwerkerke, Count 11, 34 optical mixture 9, 13, 35 Paris Commune (1871) 24, 90 Péguy, Charles 101 Perrot, Jules, Degas' painting of photography 9, 12-13, 37, 42, 63, 138 pictorial symbolism 38 Picasso, Pablo 38 Piette, Ludovic 22, 28 Pissarro, Abraham 15 Pissarro, Camille (1830–1903) 7, 9, 13, 15-17, 21, 22, 23-4, 25, 26, 27, 28, 29, 31, 33, 36, 37, 38, 41-2, 99, 135, 159, 186 The Church of Saint-Jacques at Dieppe 126 The Côte des Boeufs at L'Hermitage 122 Garden and Trees in Blossom, Springtime at Pontoise 123 Lordship Lane Station (Lower Norwood) 23, 120 Paris, The Boulevard Montmartre at Night 125 The Red Roofs 121 Woman In a Field 124 Pissarro, Lucien 36 plein-air (open-air) painting 9, 14, 21, 63 pointillism 35, 40 Pont-Aven, Brittany 36, 38-9, 160, 162, 164 Pontoise (Pissarro and Cézanne in) 16, 24, 25, 28, 30, 121, 122, 123, 135 Post-Impressionism 36, 37-40, 41, 103

Poussin, Nicolas 13, 139 praxinoscope 12 Rafaëlli, Jean François 33 Raimondi, Marcantonio 49 Raphael 119 The Judgement of Paris 49 realism 11, 12 Rembrandt van Ryn 83 Renoir, Aline (née Charigot) 114 Renoir, Auguste (1841-1919) 7, 9, 10, 13, 14, 17, 18, 20, 21, 22, 23, 24, 25, 26, 27, 28, 29, 31, 32, 33, 36, 37-8, 43, 58, 65, 68, 83, 89, 91, 148 Banks of the Seine at Champrosay 109 The Bathers 119 Dancing at Bougival 117 La Loge 104 Luncheon of the Boating Party 33, 114-15, 117 The Moulin de la Galette 31, 106, 113 Nude in the Sunlight 108 Path Climbing through the Long Grass III Portrait of Claude Monet 105 Railway Bridge at Chaton 113 Richard Wagner 116 The Rower's Lunch 112 The Swing 31, 110, 113 The umbrellas 34, 118 Woman Reading 107 Renoir, Edmond 104, 117 Renoir, Jean 42 Reynolds, Sir Joshua 23 Rimbaud, Arthur 66 Rivière, Georges 106 Romanticism 11, 12, 44 Rood, O.N., colour theories of 35 Rossetti, Dante Gabriel 64 Rousseau, Theodore 14 Royal Academy of Arts, London 24 Rubens, Sir Peter Paul 13, 119 Salon (of the French Academy) 6, 8, 10, 11, 14, 15-16, 17, 18, 19, 20, 21, 22, 25, 26, 27, 29, 31, 32, 33, 34, 35 Salon d'Automne 38 Salon des Refusés 15, 20, 21, 26, 49 Sand, George 14 Sargent, John Singer 30 Schuffenecker, Emile 39, 164 Schuffenecker family, Gauguin's portrait of 164 Sérullaz, Maurice 111 Seurat, Georges (1859–91) 9, 17, 32, 33, 34-5, 36, 37, 124, 172 Bathers, Asnières 35, 184, 186 The Circus 181, 189 La Grande Jatte 35, 36, 83, 184, 187 Port-en-Bessin, The Outer Harbour. High Tide 188 Standing Model 185 Signac, Paul (1863-1935) 13, 17, 33, 34, 35, 36, 103, 124, 186, 188 Harbour Mouth, Marseilles 190

18, 22, 24, 25, 28, 29, 30, 31, 32, 33, 36, 65 The Flood at Port-Marly 30, 130 The Regatta at Molesey 129 The Seine at Suresnes 132 Snow at Louveciennes 131 Square at Argenteuil 127 The Village of Voisins 128 Société Anonyme 6, 27, 28 Société des Indépendants (1884) 35, 186 stereoscope 12 Strindberg, August 29 synthetism 38-9 Tissot, James 27 Titian, Venus of Urbino 52 Toulmouche 17 Toulouse-Lautrec, Henri de (1864–1901) 36, 40, 138, 149 The Ballerina La Roue 180 The Bed 177 A Corner of the Moulin de la Galette 182 In the Salon at the Rue des Moulins 179 Panel for La Goulue's Booth 183 Portrait of Monsieur Fourcade 176 Woman with Gloves 178 Tréhot, Lise 18 Turner, J.M.W. 13, 23, 120, 190 Rain, Steam and Speed 120 Valadon, Suzanne 117 Valéry, Paul 42, 67 Valentin le Désossé (Jacques Renaudin) 181, 183 Van Gogh, Vincent (1853–90) 17, 36, 37, 38, 39-40, 45, 133, 160 Caravans 152 The Church at Auvers-sur-Oise 40, 158 A Cornfield, with Cypresses 156 Cottages at Cordeville 159 Lillies in a Copper Vase 150 The Moulin de la Galette 149 Portrait of Dr Gachet 40, 155 Self-Portrait 154 Sunflowers 153 The Tea Garden 151 Van Gogh, Theo 36, 39, 135, 136, 151, 154, 157, 159 Velasquez, Diego Rodriguez de Silva 13, 52 The Drinkers 54 Vellay, Julie 16, 22 Venturi, Lionello 96, 143 Verlaine, Paul 66 Vollard, Ambroise 21, 34, 38, 42 Wagner, Richard, Renoir's portrait of 116 Watteau, Jean Antoine 13 Whistler, James 21, 64, 88, 90 Wolff, Albert 29, 34, 109 zoetrope 12, 13 Zola, Émile 15–16, 21, 29, 31, 37, 52, 55, 65, 82, 91, 109 L'Assommoir 82

L'Oeuvre 38

Sisley, Alfred (1839–99) 7, 9, 17,